SHARED SPACE

The Joseph M. Cohen Collection

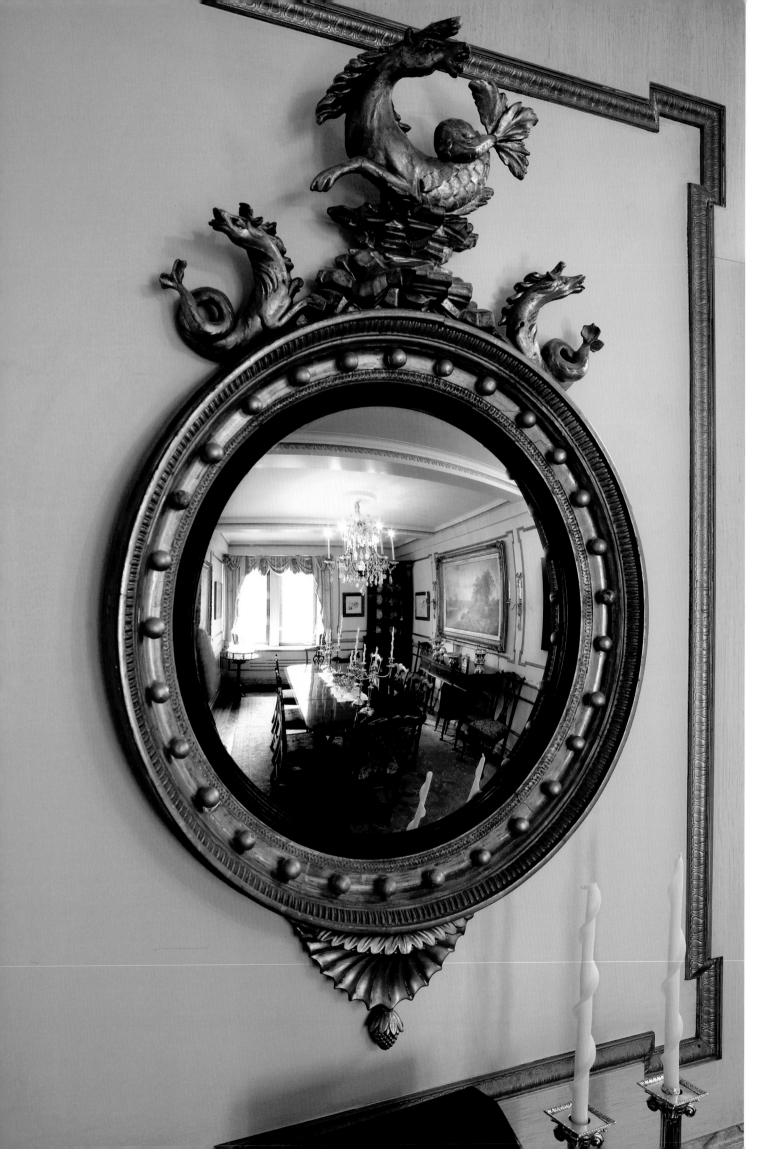

SHARED SPACE

The Joseph M. Cohen Collection

Edited by Ray Merritt

Contents

INTRODUCTION

010 Shared Space *Ray Merritt*

PAINTINGS & DRAWINGS

074 Gentileschi's Genius *R. Ward Bissell*

080 A Tale of Two Paintings *Ray Merritt*

086 Artists and Models *Roger Ward*

106 Ladies in Armchairs *Sabine Rewald*

SCULPTURE

120 A Saddled Horse – Tang Dynasty Art *Robert D. Mowry*

134 Renewal and Sensibility *Robert C. Morgan*

PHOTOGRAPHY

166 Reluctant Icon *Ray Merritt*

178 Lost Once More *Malcolm Daniel*

204 Picturing the Self *Sarah Greenough*

268 Cool, Calm and Collected *Marvin Heiferman*

SUNDRY

280 Afterword *Joseph M. Cohen*

284 About the Artists *Diane Dewey*

322 About the Authors

328 Acknowledgments *Ray Merritt*

332 Index of Artists

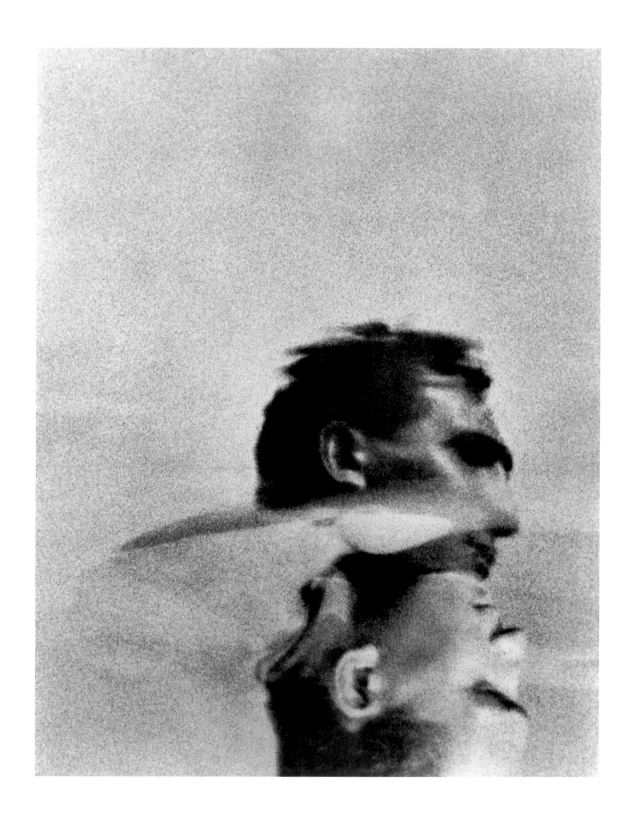

André Kertész, 1919

Shared space

"The world is so full of a number of things,
I'm sure we should all be as happy as kings."

Robert Louis Stevenson's couplet, penned over a hundred years ago, captures that almost childlike awe of the thrill of collecting. That emotion can turn into a consuming obsession and is often viewed that way. Collecting is frequently the vessel by which we navigate the shoals between work and leisure, public enterprise and private pursuits, and generosity and possessiveness. In reality, collecting has been one of the urges of thinking creatures since their creation, and it is much more than a squirrel's propensity to harvest excess nuts.

Humankind has been gathering assorted things for a very long time. A collection of unique pebbles was found in an 80,000-year-old French cave, and later during the Upper Paleolithic Era, shells, fossils and quartz were considered prized possessions. From that time on, there has been no stopping *Homo sapiens*. Man no longer simply hunted and gathered for subsistence; saving was no longer only for survival. Ceremonial garb, jewelry and brassware helped reinforce identity, and that in turn elevated one's collection into a personal pantheon of pleasure and desire. This custom evolved from a quest for the transcendent and the sublime to one for the surprising and the unexpected — those things that hold us in rapture. So when my friend and colleague Joseph Cohen asked me to create a book on his art collection, my immediate response was affirmative. He is a friend and he asked for a favor — no issue, no discussion. In fact, I looked forward to it. I have always enjoyed reading about art and viewing art and I find the company of artists rewarding and engaging. Thus I welcomed the opportunity to help a friend with a project that was very important to him.

Yet I began to feel a certain trepidation. I knew from past experience that art criticism is a difficult subject, remembering Clement Greenberg's admonition that it is "the most

It is true that collections have shape, contour and expression, as does an individual work of art, and any time a work of art joins a collection, it reveals new things about the artworks it has come to live with.

Andrea Woodner

Ralph Gibson, Park Avenue, NY, 1995

Leo Castelli once told me that some artists are more creative than others, some gallerists are more creative than others and some collectors are more creative than others. With this in mind I turned my thoughts to Joe Cohen's collection and realized that, although he is not without his advisers, his collection reflects his needs and perceptions to the extent that one could call this body of work "A portrait of Joe Cohen."

Ralph Gibson

Ralph Gibson, Wall Street, NY, 2007

ungrateful form of writing and the most challenging." Joe's collection is very diverse. It contains art that spans a period of well over a thousand years and includes antiquities, paintings, drawings, sculptures and photographs on a wide range of subjects, representing a dizzying array of styles. More than three hundred objects would be involved, many in mediums I am not familiar with, much less versed in. To present them in a cohesive, intelligent and interesting manner would be a daunting endeavor. It would require immersing myself in the unknown and then attempting to put order and rationale to the chaos of Joe's collection. I choose the word "chaos" purposefully and with no hint of disdain or condescension, but more about that later.

Despite (or perhaps because of) these challenges, I accepted the invitation. The task seduced me, for works of art are often irresistible sirens and this was an opportunity to get up close and personal with some of the most alluring.

Before you can get to know a collection, you have to know the collector. That would not be difficult in this case. I have known Joe Cohen for almost fifty years, in many capacities — as a friend, client, colleague and partner. Our professional careers followed similar trajectories. We are both the same age, both New Yorkers with homes in the Hamptons, both professionals involved in the world of Wall Street — I as a lawyer, he as an investment banker. Joe is highly intelligent and well-schooled. He did his undergraduate studies at the University of Pennsylvania's Wharton School of Business and his postgraduate studies at the Columbia Graduate School of Arts and Sciences. Those achievements made our professional engagement stimulating as well as challenging. As attorney and client, we spent parts of every day in contact — countless meetings, countless phone conversations. This persistent contact led to mutual respect and admiration and evolved into an intimacy that comes with shared experiences.

Yet, surprisingly, we spent little time conversing about a subject we both enjoyed — the arts. Art provides a calming and stabilizing balm for those whose days are filled with the tumult and tension of Wall Street and we both grabbed every opportunity to take advantage of that. Its presence smoothes out the rough edge of the hard-wired world of high finance. So now at the point in time when both of us are edging off the boil of our respective businesses, it seems opportune to engage each other in our shared interest in art.

An art collection is as much about the hunter as it is about the prey. Collectors end up as proud parents, but before basking in the radiance of their collections, they must engage in the hunt. To do so, a true collector has to be a serial lover of inanimate things, loving the one he has until the next one comes his way. For a self-confessed omnivore, there is never enough. The reason may be that, as the renowned French writer Henri Focillon once observed, a collector "creates from the genius of others a nectar which belongs to him alone." It is the addiction to that nectar that drives the collector. The hunter takes the blood of his prey and wants more.

A collector's pursuit of his personal idée fixe can indeed dominate his life for there is a little Noah in all of us. But for the impassioned collector, "two of every sort" will never do. Yet collectors are in a way Noah's spiritual progeny for they all adhere to the

gospel that preaches that things of beauty cannot be allowed to perish or be forgotten. Preserving art and antiquities becomes part of their life's labor, and often it is what helps them perfect their own humanity.

Collectors — the tender lovers that they are — fawn over their collections in almost erotic ways. Never satiated by their conquests, they do not simply pine away like Don Quixote, but morph into that other "don," the lover of Seville, and set off in lust for their next conquest. They often convince themselves that their acquisitions were created just for them.

Samuel Johnson proclaimed that "the pride or the pleasure of making collections . . . produces a pleasing remission after more laborious studies [and] furnishes an amusement not wholly un-profitable." For the passionate collector, Johnson simply and strikingly missed the mark. "Pleasing remissions" and "amuse-ments" are not remotely appropriate in describing the attributes of such collectors. For them, the chaotic quest is a way of life and a process that infuses the very essence of their being. It is much more than pleasure; it is an unruly, raging obsession.

Cocteau once observed that art is the "marriage of the conscious and the unconscious." If that is so, then the collecting of art is best described as an "affair of the conscious and the unconscious" — often fervent, not quite rational, but always very personal and

intimate, and it is from the heat of that affair that the collector's persona emerges. Often a collector cannot explain where this passion comes from. It is a hunger that cannot be satisfied; a thirst that cannot be quenched; an itch he cannot resist scratching. Even a collector as serious and reflective as Joe is hard-put to offer a cogent explanation. When asked, he often resorts to inscrutable non-responses: "I don't know. I just like it." What he cannot disguise, however, is his excitement.

For over thirty years, Joe has been collecting significant art. His quest has been successful principally because of the single-mindedness of his endeavor and his quiet confidence. Those qualities are the same ones that have served him so well in his chosen profession. He presided over the Wall Street investment firm Cowen & Company, a highly regarded investment banking and capital market firm that provided distinctive service to a multitude of institutions and corporate and private investors. As Chairman, he was responsible for over 1,600 employees, including 150 principals, located in ten offices over two continents. The firm's growth during the thirty-year period from the seventies until the sale of its assets to Société Générale in 1998 was dramatic. Under Joe's leadership, the company was transformed from a small boutique firm into a leading international financial services and investment banking company. Yet during this period, Joe always found time for philanthropic activities. He served as a director of the Manhattan Theatre Club, a director of the Jackson Laboratories, a

major genetic resources foundation, and, for the last seven years, as president of Citymeals-on-Wheels, an organization that during his tenure provided millions of meals to homebound New Yorkers. In addition, he served as a director of the Glaucoma Foundation, The Whitney Museum's Photography Committee, The Norton Museum of Art Photography Committee and The National Gallery Collectors Committee and on the Chairman's Council of the Metropolitan Museum.

Joe applied the same energy and confidence that he brought to his business and charitable endeavors to collecting art, simply adding a few more dollops of passion. As in his business, he made the process of amassing a collection an integral part of his life — a life that has not always been filled with art. The courtship started slowly. His parents were not collectors. Nor was he a fledgling collector in his youth — no coins, baseball cards, stamps, comic books, butterflies or Slinkys. Neither schooled in art appreciation nor gifted with artistic talent, he began the accumulation of art like so many of our generation by buying the best he could then afford. The art posters in his college dorm were replaced with etchings, lithographs, reproductions and works of emerging artists. In 1965, Joe married Barbara Lion Weinberg. She became the most important person in his life. When it came to their art, they bought what they liked among that they could afford. His early approach was not tutored or particularly intellectual, but rather visual and visceral. Fortunately for Joe, Babs was a willing

partner in his early art quests. She brought a well-grounded sense of art into the mix, having studied art appreciation at Connecticut College. By the seventies, their walls were covered. An early Chagall print and a Vasarely lithograph soon gave way to a Balthus, a Twombly, a Dubuffet, an Arp and a Picasso. By the end of the eighties, Joe added his Gentileschi. At that time, he also began buying sculptures, often the works of young artists. Later he began to amass sculptural works by major artists — Moore, Cragg, César, Rickey, Stella, Hicks and Flanagan. Even later in the process, he became taken with photography. His first acquisitions were again purely impulsive — works by Ralph Gibson, Michal Rovner and Ken Marcus — a surrealist, a conceptualist and a romantic. He bought them, he says, simply because he liked them, not thinking about the diversity of his selections.

To say that a man's collection represents the quintessence of his desire is another art truism. The works in the collection in fact reflect much more than desire. They reveal relationships and often confound us with seeming contradictions. Joe's collection is no exception. What one immediately notices about the art Joe has assembled is its vast variety and complexity. That is not to suggest that it is encyclopedic. It is, in fact, very selective and personal. To locate its essence, it is helpful to understand his collecting methodology. Some collections are formed by a theme. Henry Buhl collects images and sculptures of hands. Joseph Baio collects photographs of children. What these collectors and all good collectors have at their core is that inner passion. As Baudrillard said, "a collector invariably collects himself." So in delving into Joe's collection, one has to get very personal. That can be hard to do with a friend. It is too late in the process, however, for me to stop. So we begin by simply looking at the man and trying to discern something that will help us understand.

I once read that the collector assumes a thousand faces — the initiator, the autodidact, the student, the addict, the satyr, the connoisseur, the eclectic, the pleasure-seeker, the investor

and lastly the lover. Joe is not all of those but he does love his art. He's possessive about it, protective and proud of it. Just like he is with his two sons, two daughters-in-law and six grandchildren. They are all he could have hoped for and more, and he loves having them around. His sons work with him in their family office. Each lives close by and their families often spend the weekends with him. They are a big part of his life and he enjoys sharing his art with them.

Another way to learn about a collector is to observe him in his quest — to be part of his hunt. A recent example was Joe's purchase of a William Christenberry barn sculpture. These fastidiously handmade replicas of barns that Christenberry photographs rarely come to market. Joe happened upon one by accident during a gallery visit. He immediately locked onto it and took it out of circulation by advising the dealer that he wanted it. This decision was made before a price had been established — a practice I try hard to break him of. Fortunately, the dealer in this case was honorable. It was hard to suppress a smile when I saw sheer enchantment cover Joe's face. For a moment, he was filled with that certain grace one has as a child. It was a joy devoid of greed and there was no evidence of covetousness. Perhaps the purchase was sparked by a memory. Walter Benjamin, the great German critic, observed, "ownership is the most intimate relationship one can have to objects. . . . Not that they come alive [in the collector]; it is he who lives in them." I was admittedly a bit envious. I wondered if these moments serve as palliatives for Joe's equilibrium. He has experienced several major events in his life — the sale of his business, the loss of his beloved wife, Babs, and serious problems with his eyes. Throughout these travails, he has maintained his composure and his signature optimism. I suspect that it was his immersion in his collection that helped him bolster and maintain his spirits. His collected objects become part of his family. Joe will make room for them, no matter how many more are to come.

Joe Cohen is one of those collectors who, like the best explorers, relies upon his instinct and intuition. The decisions he makes quickly – in seconds actually – are his best, as he allows his eyes and mind to work together to form a two-pronged, fast-acting acquisition committee rivaled by none.

Peter MacGill

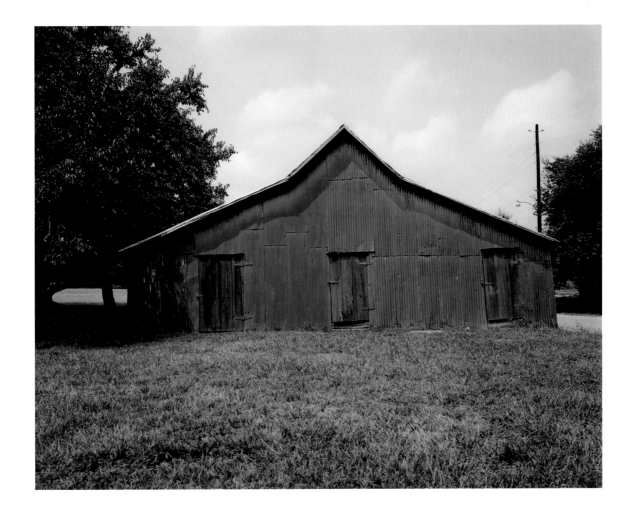

William Christenberry, Green Warehouse, Newbern, Alabama, 1978

The best thing about being sixty-eight is having the flexibility to move past traditional boundaries and go from drawing to sculpture and of course to photography.

I like it when people ask, "What is Christenberry? Is he a painter, photographer, or a sculptor?" I see it all as one piece.

William Christenberry

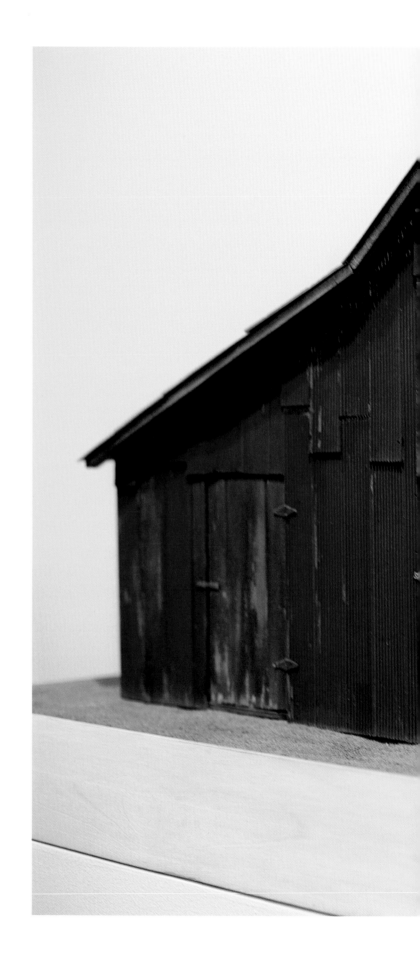

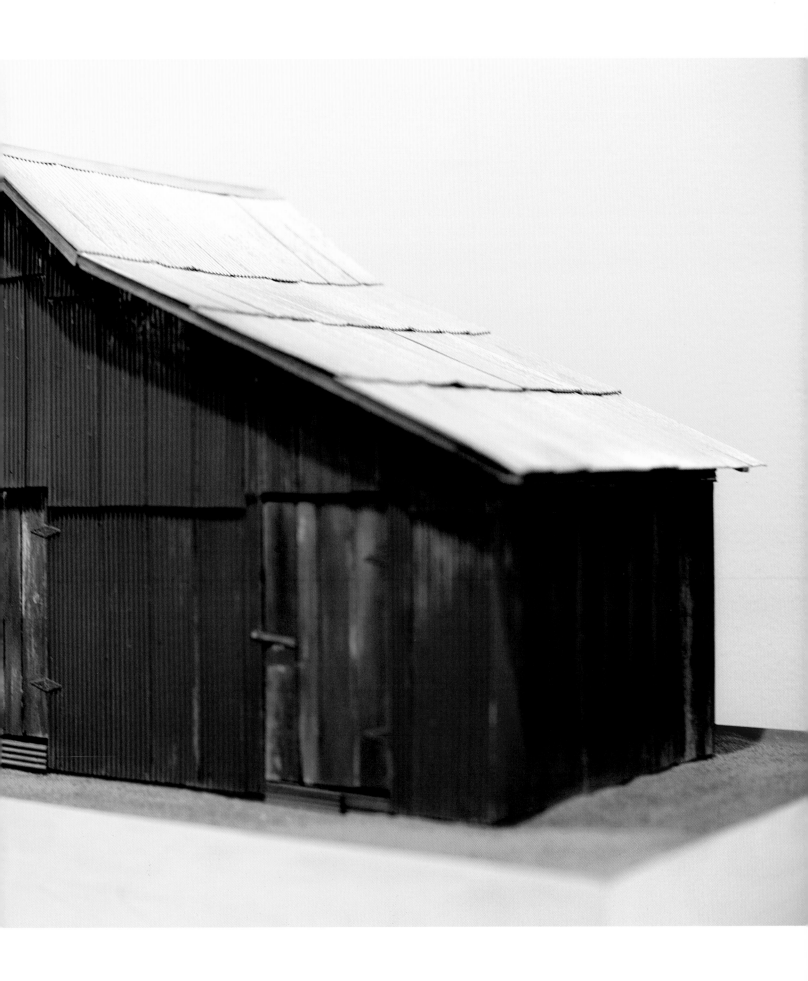

William Christenberry, Green Warehouse, Newbern, Alabama
(handcrafted sculpture), 1995

23

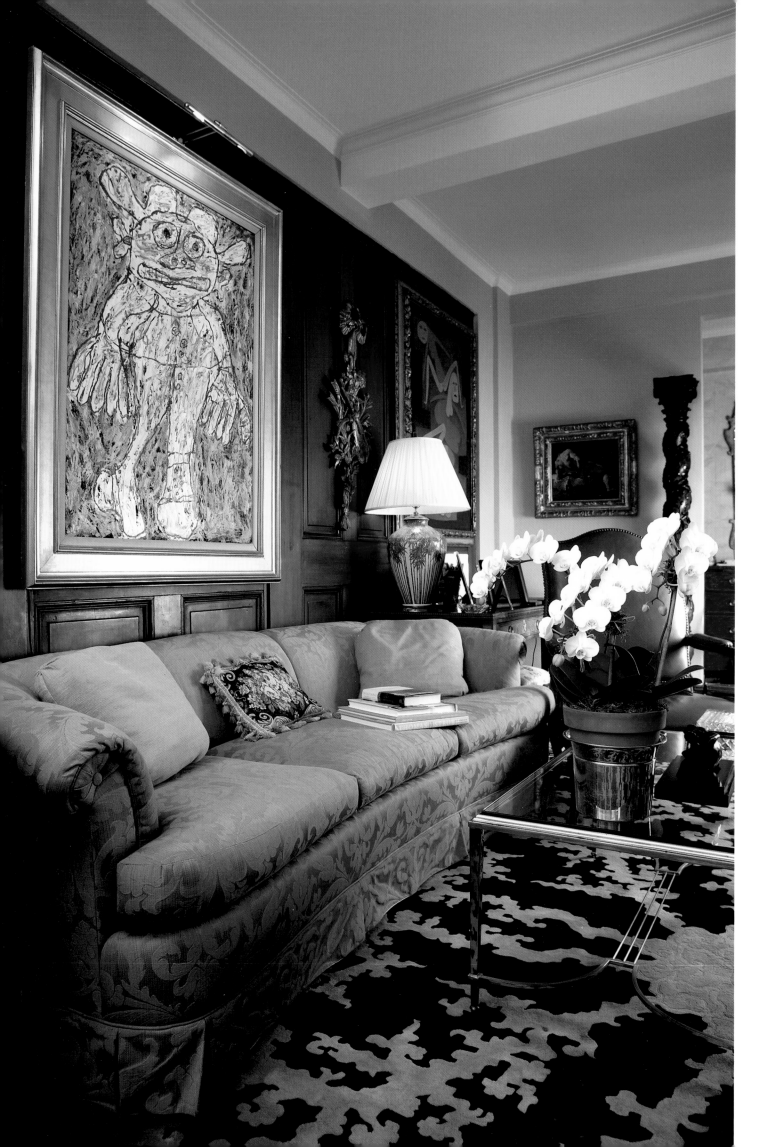

Perhaps the best way to understand the collection is to see it in context, to experience it in situ. That would begin with a visit to Joe's apartment in New York. Babs and Joe bought it in 1973 and it has remained his principal abode. Later, Joe acquired an adjacent apartment to hold more art and guests. The building and the apartment itself are quite understated. When you arrive, what you find is not the stylized domain of designer-name artists who populate the dwellings of so many New Yorkers. You find no body parts floating in formaldehyde, no recycled excrement, no self-conscious replicas of kitsch, no decorator-chosen *objets d'art* selected primarily for their compatibility with a client's color schemes. What you do find instead is an inviting personal abode — clearly the handiwork of the inhabitant.

In the living room, a Regency chest rests comfortably alongside a pair of two-hundred-year-old George II mahogany side chairs, while a three-hundred-year-old George I gilt-wood mirror peers into the room. Two baroque Solomonic columns, carved from walnut and complete with winged cherubs, stand guard. The fireplace boasts a Louis XV marble mantelpiece with a serpentine molded shelf and a pair of Louis XVI gilded bronze andirons. On the chimneypiece, a Renaissance revival mantel clock sits contentedly, having previously made Joe's parents' Cedarhurst house its home. It is sometimes joined by a Henry Moore sculpture of a reclining woman. Nice company.

As the centerpiece of this room, hanging over the fireplace, is Orazio Gentileschi's striking masterpiece, *Joseph and Potiphar's Wife*. It was acquired in 1990 when Joe swapped art, including an Arp, a Twombly and a Dali — a handsome ransom but well worth it. This four-hundred-year-old oil is a smaller version of the painting that belongs to Her Royal Highness and traditionally hangs in Hampton Court. The Cohen version, according to the renowned expert Marco Grassi, is in excellent condition from its support structure to its surface finish. X-ray radiography confirmed that the canvas has retained its original size and attests to

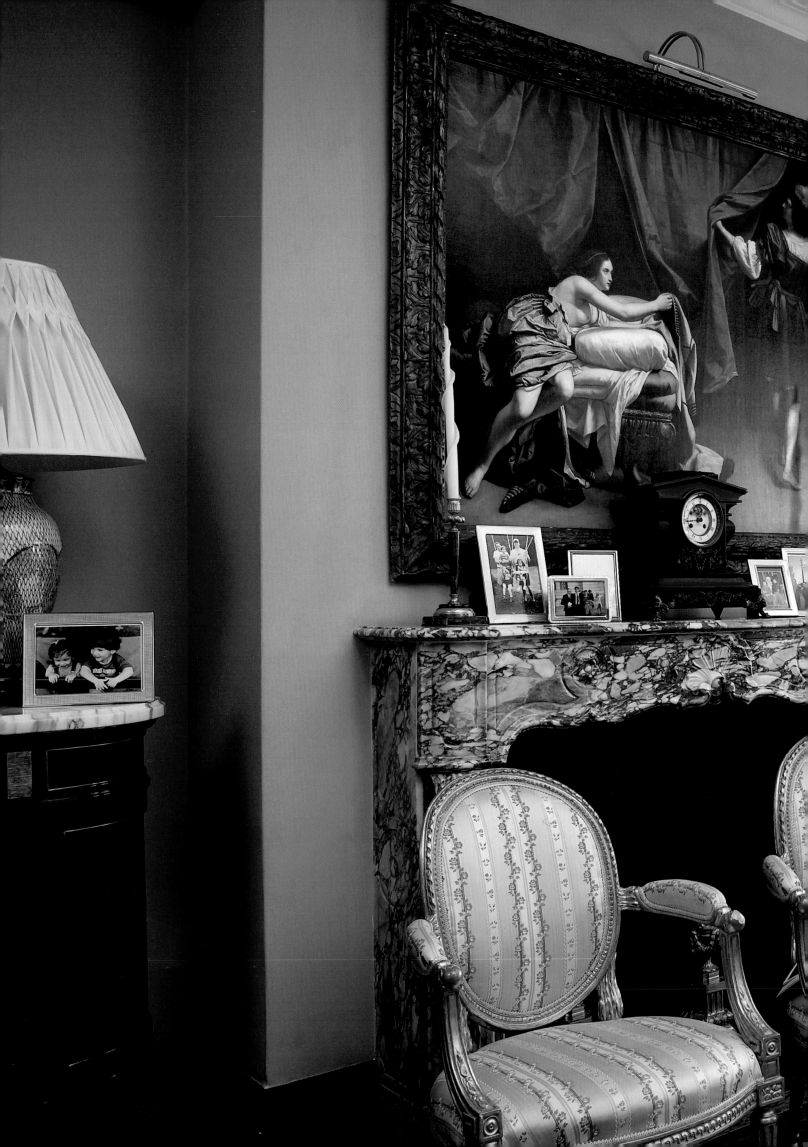

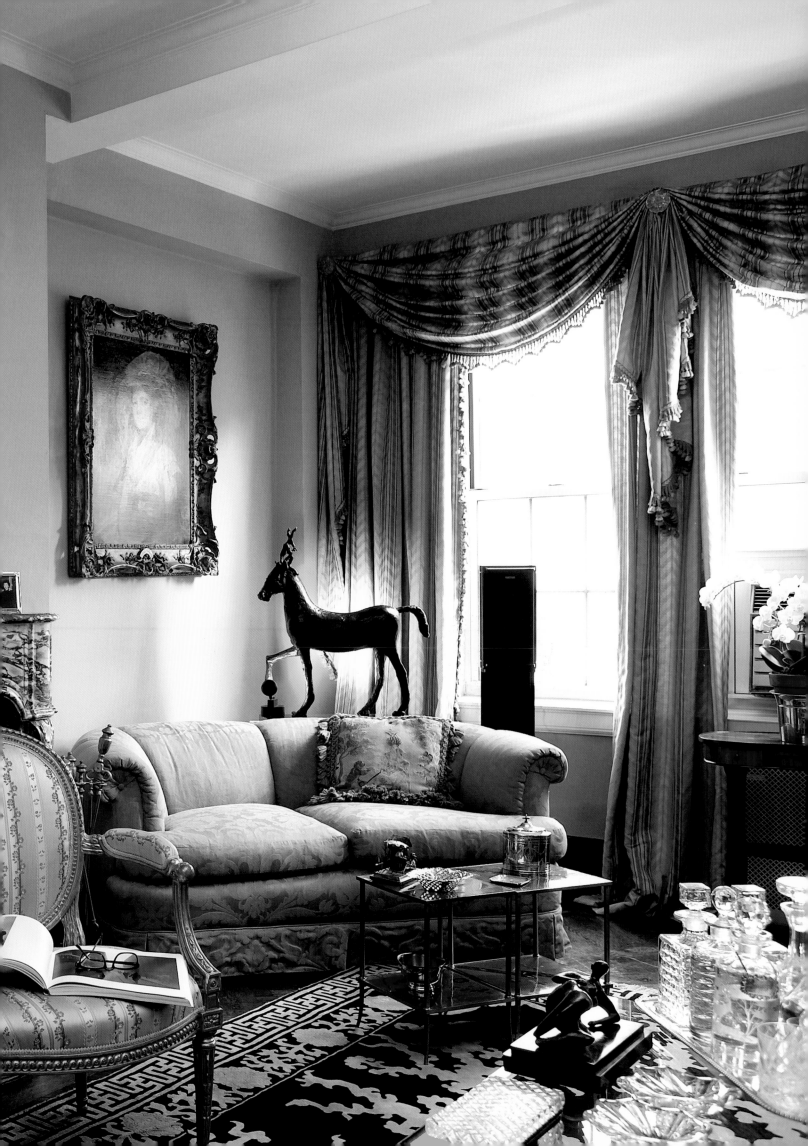

the lack of any significant fragmentation or loss. Even a layman senses its majesty — the chiaroscuro technique resonates with deep and varied shades of color. It demands your attention as soon as you enter the room. This grand painting is clearly the patriarch of Joe's collection. To fully understand why, it is necessary to digress. The story of the artist and his seminal work is relevant to explaining the essence of the Cohen Collection.

Orazio Gentileschi (1562-1639) was a famed Italian Baroque painter who was a disciple of, and strongly influenced by, Caravaggio. His art was also influenced by the events of his life. He taught his daughter, Artemisia, his trade. She took to it so well that she gained recognition as the dominant post-Renaissance woman painter and is now considered by many to be the matriarch of the art of painting. Her personal story was not without trauma. Her father's close friend and colleague Agostino Tassi raped Artemisia. Gentileschi was understandably outraged — his daughter deflowered, her honor denigrated. Tassi offered to

Marco Grassi, X-ray radiograph, 2006

marry her; he even hired an assassin to kill his wife. Fortunately for Tassi's wife, the hit man ran off with the money, failing to fulfill his assignment. It didn't matter because Artemisia wasn't interested. Her father insisted that Tassi be subjected to a public trial for humiliating his daughter. She later married a man of her choice and raised a family — all the time pursuing her career as a master painter in her own right.

Gentileschi then went on to paint one of his signature works, *Joseph and Potiphar's Wife*, perhaps in response to his daughter's plight. (He was not alone in using this story as the subject of a work of art. Many artists, including Rembrandt, did, but Gentileschi did it best.) Like so many of the grand paintings of that era, the work was based upon a biblical story — this one found in Genesis. And, yes, we are talking about the same Joseph we all know for his coat of many colors. It seems he was Jacob's "son of his old age" — Jacob being ninety-one when Joseph was born. This last son was very special. He possessed powers

My illustrious lordship, I'll show you what a woman can do.... As long as I live I will have control over my being.
 Artemisia Gentileschi

normally not within the grasp of other mortals. He incurred the wrath and envy of his older brothers, who proceeded to sell him to passing merchants who, in turn, sold him to Potiphar, the Pharaoh's military commander. The prospect of a lifetime of servitude seemed bleak indeed, but God had other plans for Joseph. He grew up to gain such respect that his master made him the head of his household. Unfortunately, Potiphar's wife had her own designs on Joseph. She attempted to seduce him. He resisted, and in his haste to leave, he left her holding his cloak in her hands. Frustrated, she falsely accused Joseph of attempted rape, using his cloak as evidence. In order to avoid family humiliation, Potiphar had Joseph sent to prison, but even there, Joseph prevailed. He became renowned for his ability to interpret dreams. When the Pharaoh's wise men failed him, he sought out Joseph, who succeeded in satisfying the Pharaoh's need. From that point on, he rose within the royal household until he was named the Secretary of State of all of Egypt, second only to the Pharaoh himself — an unlikely position for a humble Jewish slave. The story of Joseph lives on; the story of Potiphar's wife died off. The next time we hear about her is in Dante's *Inferno*, where she is spotted in the Eighth Circle of Hell. For her perfidy, she apparently was condemned to suffer a burning fever for all of eternity.

Gentileschi's masterpiece captures the essence of this Midrashic fable by utilizing his genius to express eroticism and stoicism and making a compelling statement about man's ability to rise above temptation. There would seem to be little question that his career was in part shaped by the violation of his daughter. The events depicted in this painting and the events of the artist's life will play a part in explaining the essence of the Cohen Collection. Suffice it to say for now, however, that both Joseph and Artemisia succeeded in life. Each of their stories tells a tale of the human condition, which ultimately is the story of this collection, but more about that later. Back to our site tour.

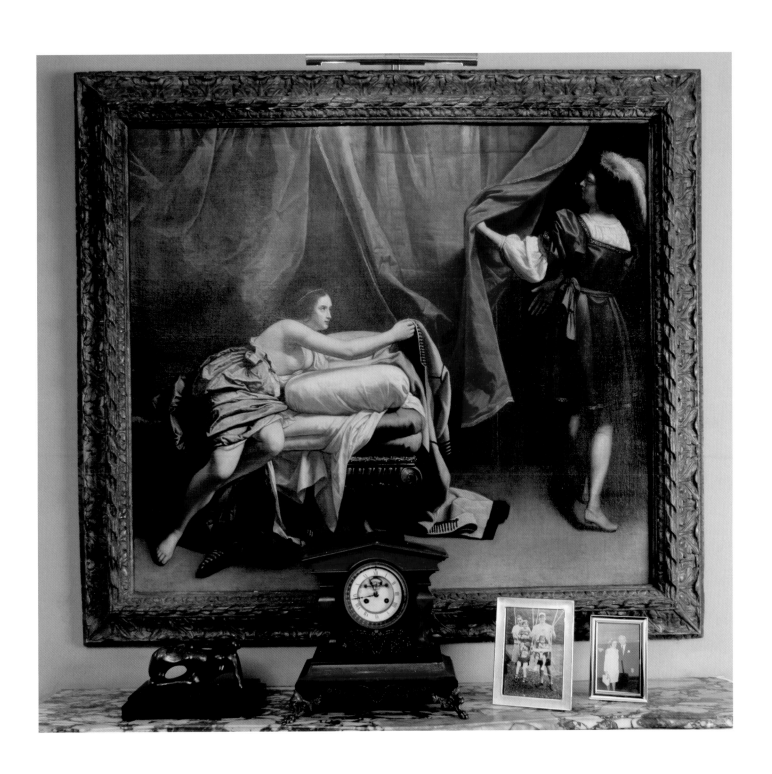

Orazio Gentileschi, Joseph and Potiphar's Wife, c. 1635

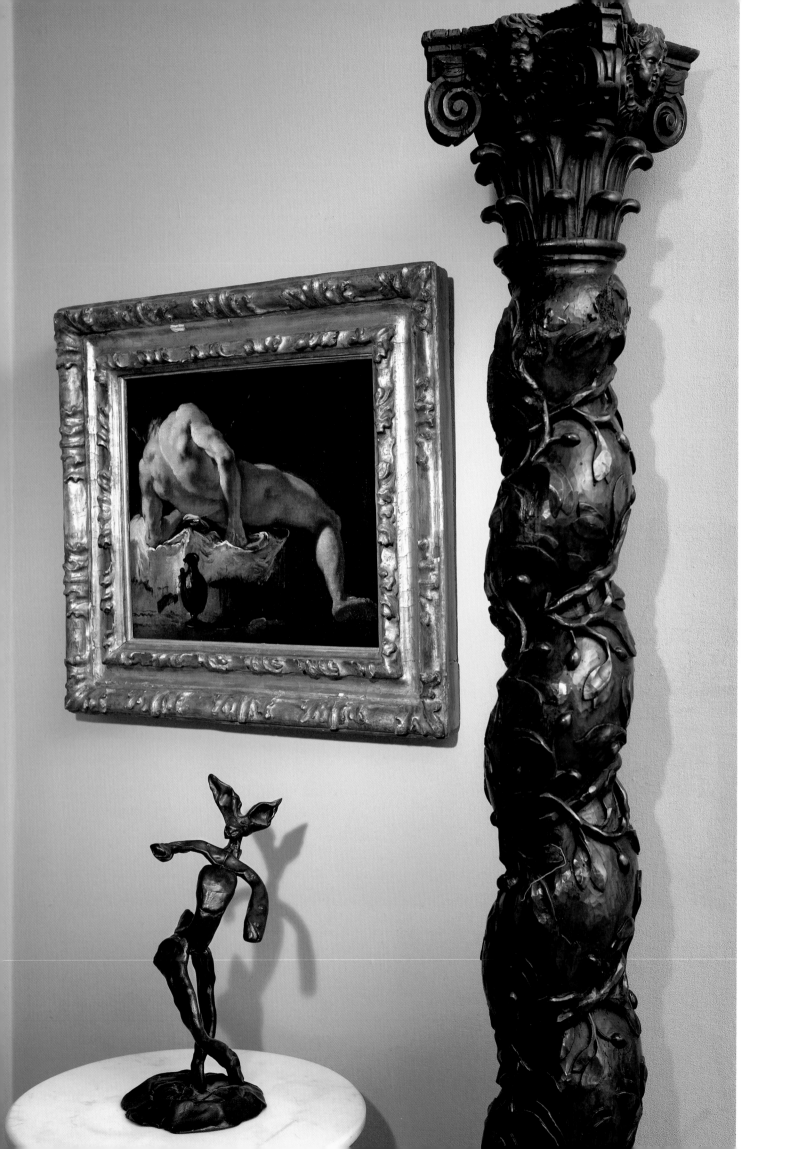

The living room at first glance is best described as assembled chaos. I say that not disrespect-fully, for all good collections at their core are infused with chaos. Behind this appearance, however, there is a logic. The collector knows it but he won't enunciate it. Yet it might be possible to soothe the seas of this chaos and in the calm find that logic. It won't be easy. The different mediums and various sizes, colors and textures of the works of art, which casually mingle with the antiquities, also contribute to the lovely sense of discordance. Flanagan's hares have to find amusement among Dubuffet's clown and Gentileschi's saint and sinner, while a rare Tang dynasty glazed horse over a thousand years old tirelessly fixes his stare on a gaggle of small Otternesses while perpetually hoping to ward off an errant umbrella that might lop off his tail. Paying no attention, Picasso's *Trois Femmes* frolic across from a Tiepolo male nude.

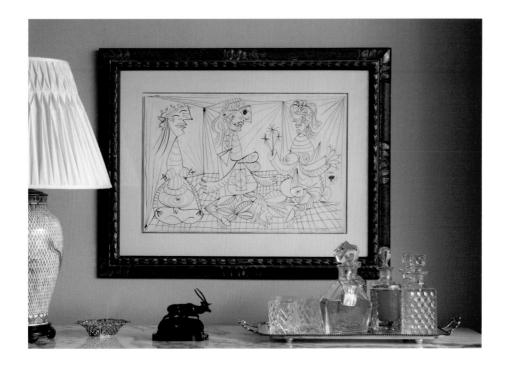

Pablo Picasso, 1938, Antoine-Louis Barye, c. 1838
Left: Giambattista Tiepolo, c. 1715
Barry Flanagan, Dancing Hare, 1989
Solomonic column, c. 1850

Babs always liked animals, particularly cats. You'll see that I have many birds, horses, dogs and, of course, Flanagan's hares. There is something very human about them.

African artifact, n.d.

Nicola Hicks, 2004
Joan Mitchell, 1974

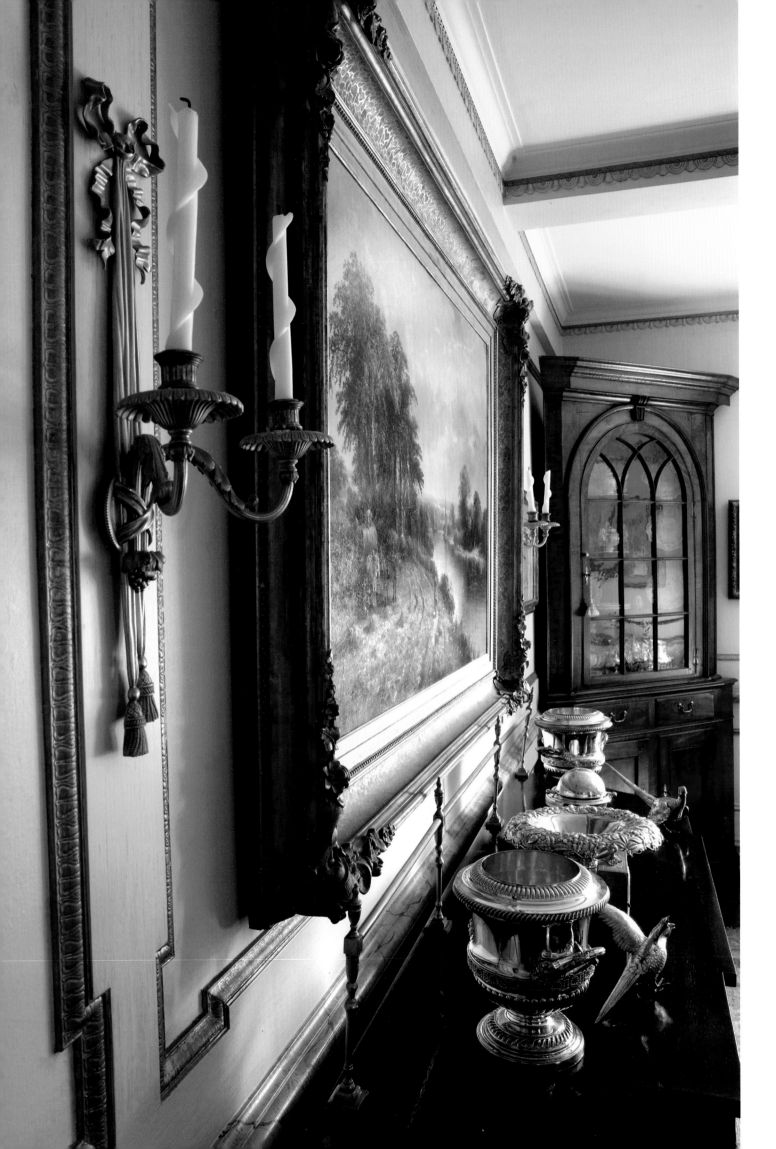

The dining room is more serene and pastoral. Joe likes to call it the "ladies room," for its walls boast of Balthus's enigmatic portrait of Betty Leyris, Matisse's *The Picnic*, Henry Moore's *Sheep*, Balthus's study for *The White Skirt* and a large 1844 oil by John Wilson of farm wives toiling in the field, all surrounding a George III mahogany triple-pedestal dining table with matching chairs and a few American Chippendale side chairs thrown in for good measure. In one corner, a mahogany wine table holds a collection of eighteenth-century cut glass decanters while in another an eighteenth-century American Chippendale cupboard from Pennsylvania protects a nineteenth-century painted porcelain Rockingham dessert service, all under the watchful eye of a Regency gilt-wood convex mirror. Of course, the room is not without its pets — a Flanagan unicorn dances mirthfully and Jasmine, one of Babs's favorite cats, spends most afternoons here to catch the afternoon light.

Moving now into the private quarters, we find a large Ellsworth Kelly keeping company with a Demuth, a Moholy-Nagy, a Eugène Atget, an Irving Penn and a Jaromir Funke. Again, the company could not be better. Off to Joe's personal study, we find a cornucopia of books on art — a wall of books with a vast wealth of knowledge in them. Two works dominate this room — Maurice-Quentin de La Tour's eighteenth-century portrait of Louis de Silvestre le Jeune and Eric Fischl's twentieth-century painting of a woman on the beach. His second

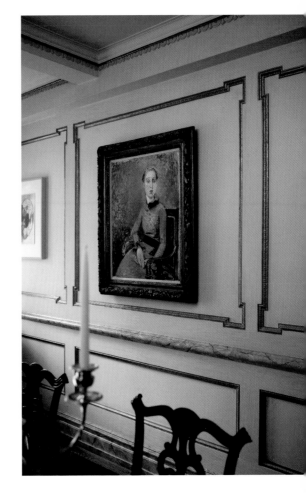

Balthus, Betty Leyris, c. 1933
Left: John H. Wilson, Gathering Hay, 1844
Following pages: Henry Moore, Reclining Woman No. 1, 1980

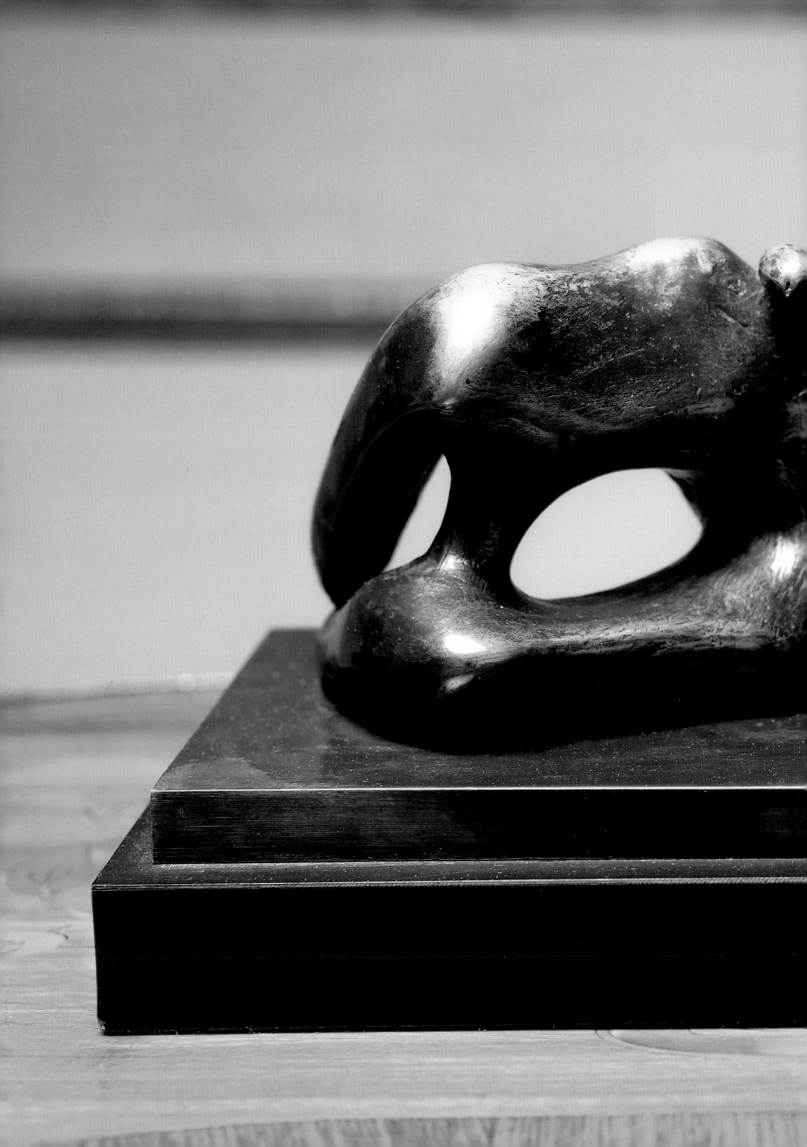

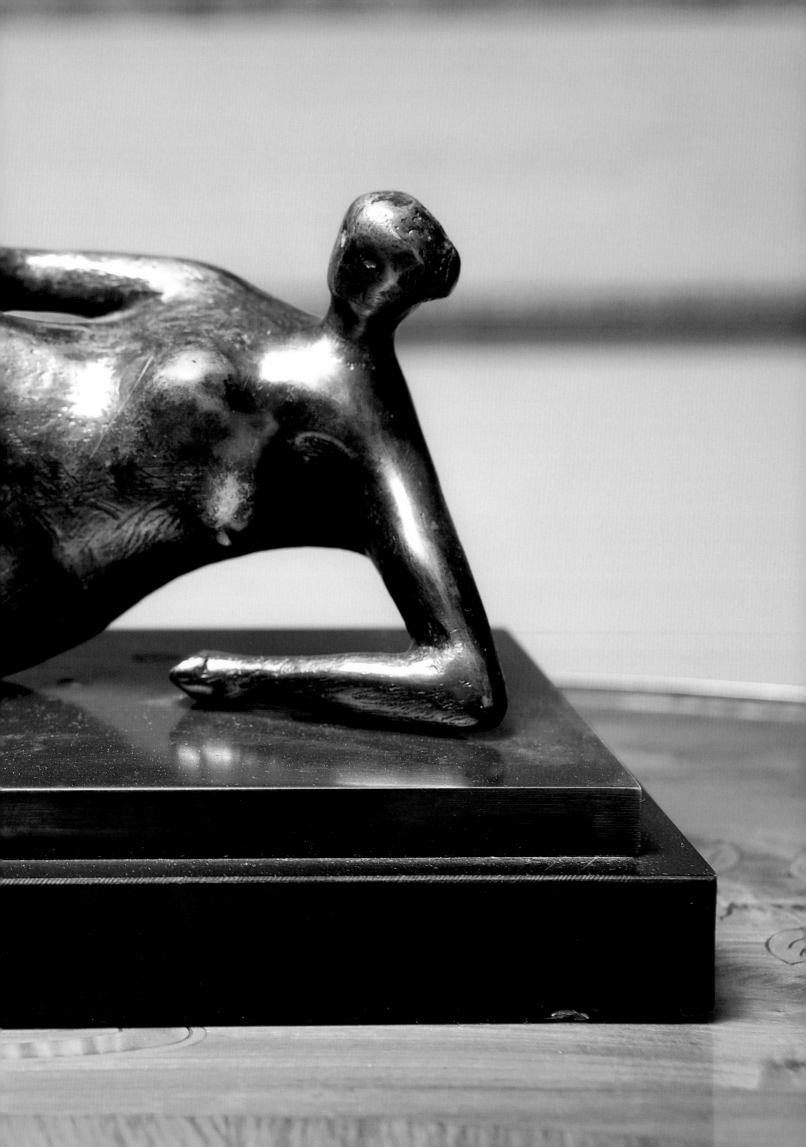

study, used more for work than pleasure, features a wall-mounted relief sculpture by Frank Stella, a dazzlingly colorful array of chaos. Not quite lost in the mix are scores of family photos, some dating back fifty years. They will not lose their preeminent place. They have an advantage: they are original family; the other images are all adopted.

Things calm down as we move to Joe's bedroom. Edgar Degas, *Nude Getting into Bath*, is framed by an Anglo-Indian four-poster bed. Next to it stands an eighteenth-century French table and under it an eighteenth-century footstool with a needlepoint cover depicting a cat on a cushion. A Roy Lichtenstein interior brings his signature calmness of a peaceful kingdom of human habitation to the room.

Before we move on to the guest apartment, it is worthwhile to pause and consider the exuberant chaos we have just viewed. Joe's comfortable domain in fact reflects the genius of craft and art over the last millennium, with combinations perhaps never seen before. This fresh and unorthodox perspective creates explosive effects. It is obvious that Joe is a collector without borders; his passion extends beyond the predictable. Another thing seems clear: Joe's treasures are not buried away in an armory of precious things. His cabinet of curiosities has tumbled out for all to see and he genuinely likes what he has gathered. One can sense that his collection speaks to him. When he talks about his collection, especially in its presence, his eyes and voice soften. He speaks of it as he would of one of his grandchildren.

That in turn brings us back to the place of memory in collecting. Deny it as Joe does, every collection acts in part as a theater of memories, a *mise-en-scène* of personal recollections — a remembered childhood, fleeting adolescence, a lost love, better days, worse days. Art helps ensure that those memories are not lost. That process borders on alchemy. Through daily communion with one's works of art (and their history), they become part of us.

For a collector like Joe, each acquisition spurs a rebirth. The collection lives for the collector and the collector lives through and in it — the two merge. Joe's art and antiquities work on his mind and they please his eyes and fan his urge to conserve them for posterity. Understandably, they fuel his pride in exhibiting them. Perhaps for Joe it is more than that. Perhaps in his case the alchemy leads to discovery. Enough analysis. I'm on dangerous ground here.

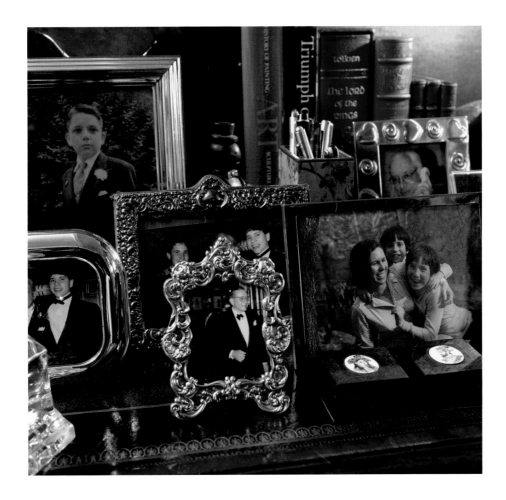

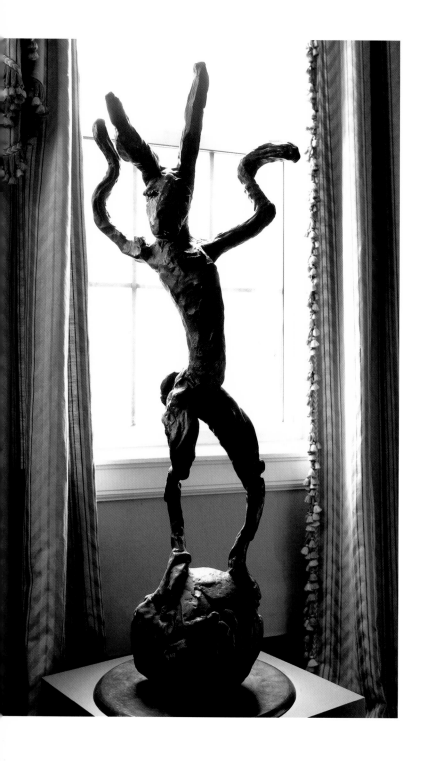

Thematically, the choice of the hare is really quite a rich and expressive sort of mode; the conventions of the cartoon and the investment of human attributes into the animal world is a very well-practiced device, in literature and film, etc., and is really quite poignant, and on a practical level, if you consider what conveys situation and meaning and feeling in a human figure, the range of expression is in fact far more limited than the device of investing an animal – a hare especially – with the expressive attributes of a human being. The ears, for instance, are really able to convey far more than a squint in an eye of a figure, or a grimace on the face of a model.

Barry Flanagan

Barry Flanagan, Hare with Ball, 1994
Right: Robert Mapplethorpe, 1988
Barry Flanagan, Unicorn and Oak Tree, 1989

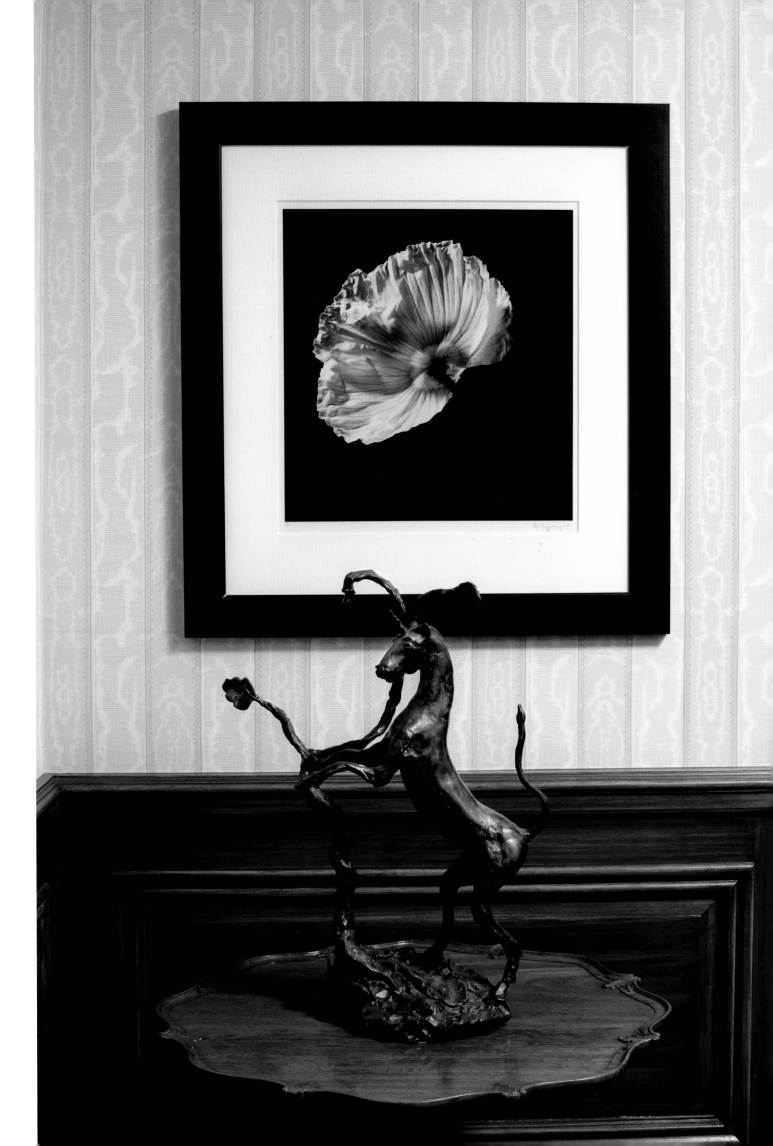

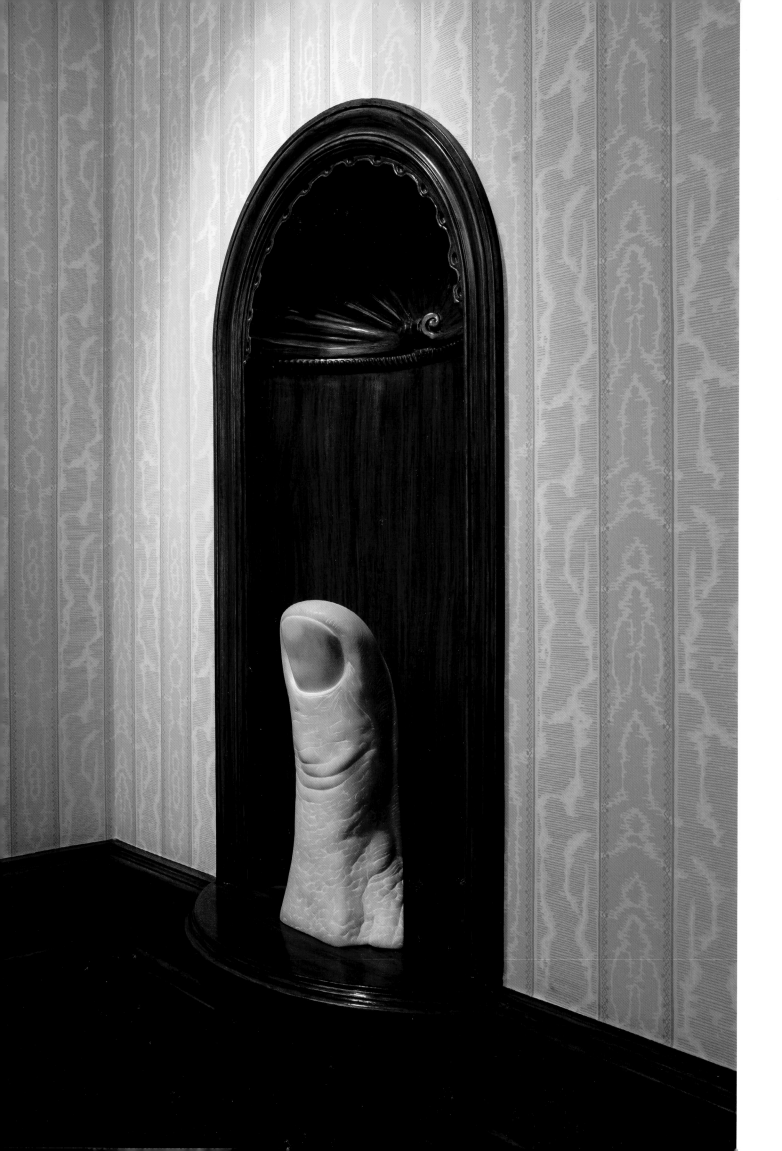

Across the hall is Joe's guest apartment. There order reigns. As you enter the foyer, a mahogany enclave holds César Baldaccini's *Le Pouce*, a large marble thumb affirming life. To its right hangs Jennifer Bartlett's painting of Saint Martin at dawn, flanked by soothing Mapplethorpe flowers, in both silver prints and color dye transfer. Nestled in the corner on a nineteenth-century walnut work table sits a George Rickey, a horse by Flanagan and a bronze genie by Antoine-Louis Barye. Everything is in order; everything is in its place.

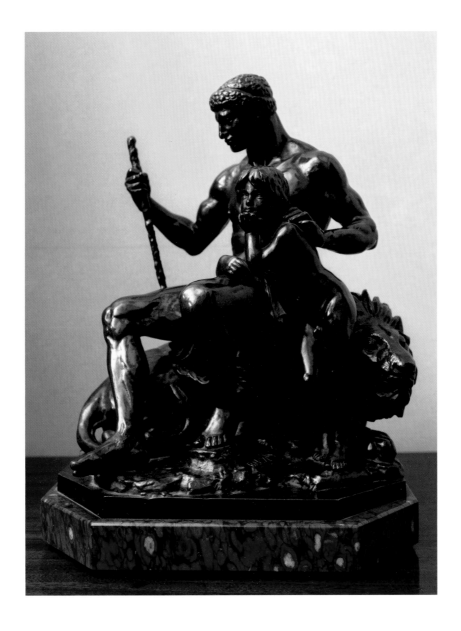

Antoine-Louis Barye, Genie la Force, c.1840

Left: César Baldaccini, Le Pouce, 1982

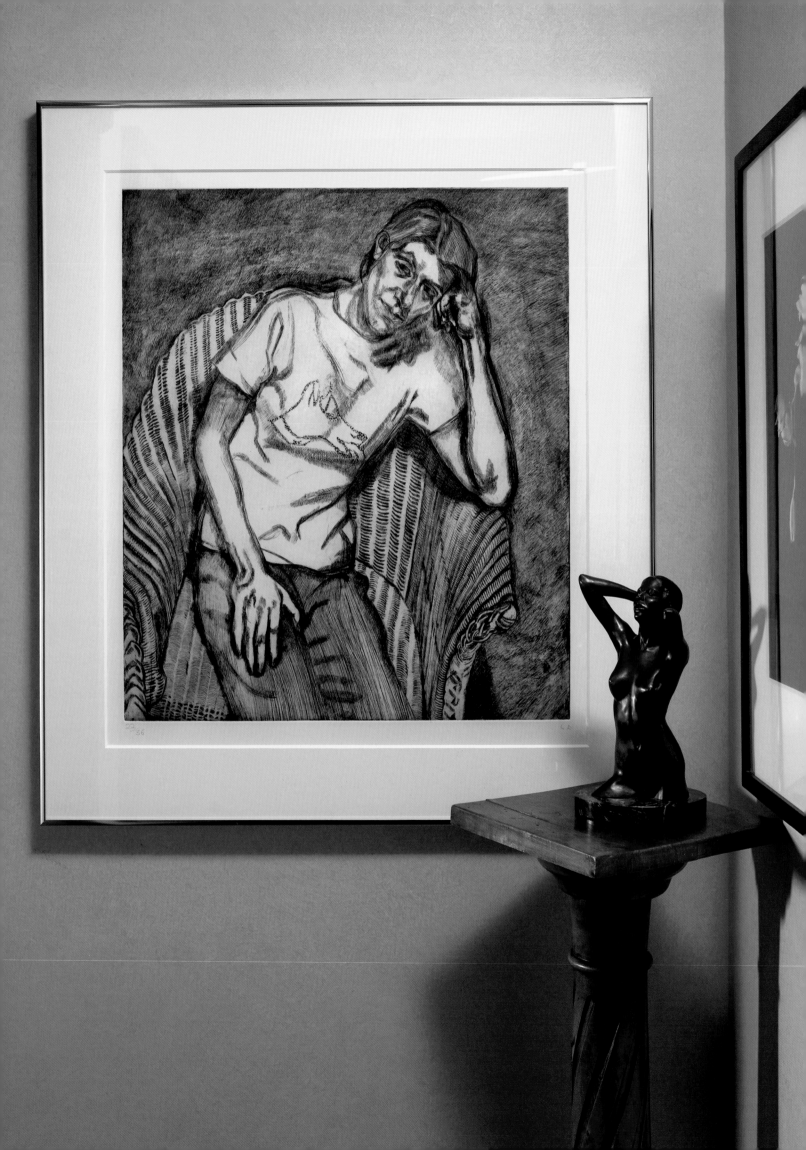

A friend in London introduced me to the work of Lucien Freud. Although she explained rather convincingly its importance, I was not drawn to it. Several years later I came across a work of his that intrigued me. There was a story in it. I'm not sure what it was, but it is this kind of image that concerns the human condition that really appeals to me.

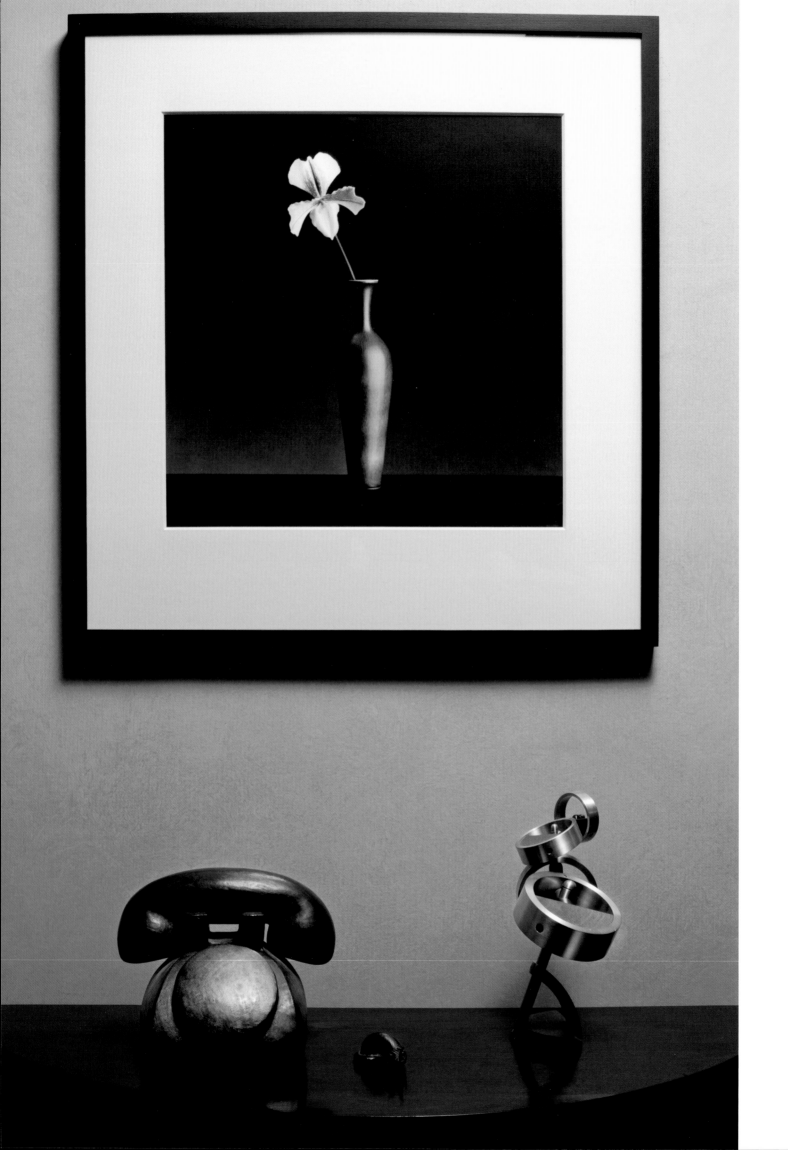

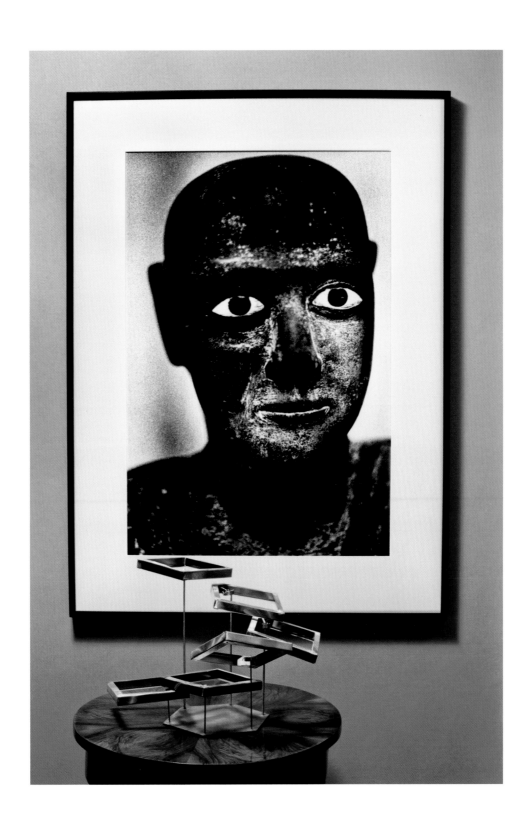

Ralph Gibson, 1992 and George Rickey, 1966
Left: Robert Mapplethorpe, 1988,
Tom Otterness, 1986 and Pedro De Movellan, 1997

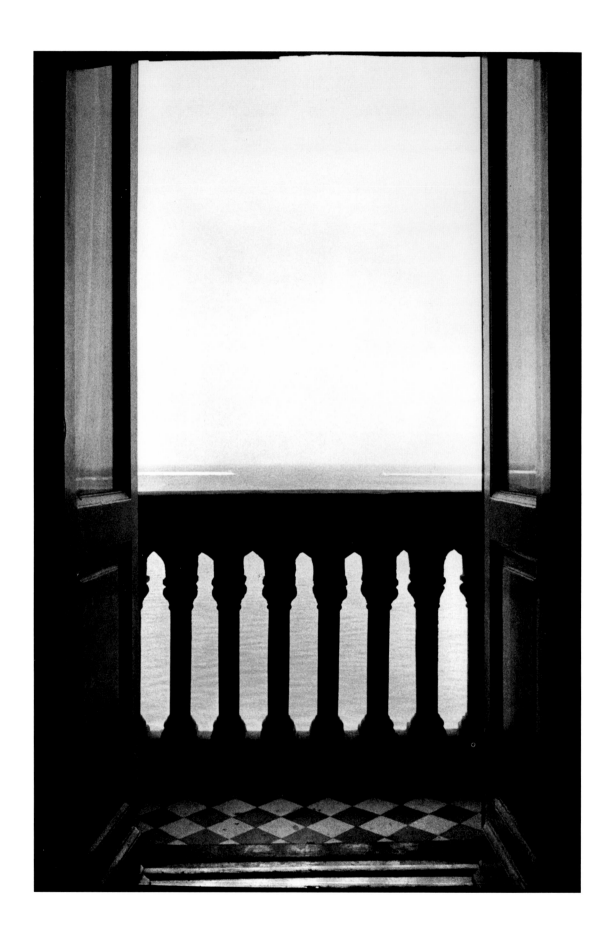

Ralph Gibson, 1992

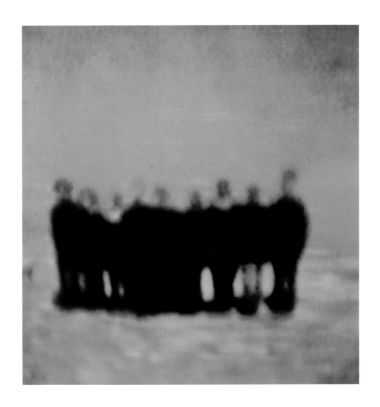

I remember a quote from Duane Michals. He said that "photography deals exquisitely with appearances, but nothing is what it appears to be." I think of that when I look at Michal Rovner's blurring images of people gathering and Ralph Gibson's empty balcony. I was attracted by the mystery of these photos and they did not disappoint me. It turns out that Rovner's image was taken in the desert and Gibson's balcony in the room where Lawrence Durrell wrote his Alexandria Quartet. Each refers to aspects of humanity. That's what I have come to admire in them.

Michal Rovner, 1997

Not far from these apartments is the family office where Joe and his sons Jarrod and Jon work. It is a well-appointed business environment, complete with all the technology and staff needed to operate their many business and charitable endeavors. What sets it off and makes it special is an abundance of photography occupying every available wall space. The collection is of a breadth and quality that would make any museum happy.

Collecting photography as an art form is a relatively recent phenomenon when compared to collecting sculpture and painting and other works on paper. Photography is less than two centuries old, but in that time it has quickly taken its place on the stage of fine art. Its magnetic allure attracted Joe and for the last three years, it has been predominant in his purchases. Joe loves the process of discovery. After really looking at works of photography, he buys those that inspire his empathy and resonate with a kind of poetry. Those emotional draws can be found everywhere and Joe is prepared to travel great lengths in his pursuit.

Here in his office we do not find the merry mix of mediums on display in Joe's personal space, with the exception of a large Mark Francis painting, two whimsical three-dimensional sculpture paintings by Patrick Hughes and three movable kinetic sculptures by Rickey, De Movellan and Fré Ilgen. Here art photography rules supreme. In Joe's own office, two Thomas Struths and a Richard Misrach predominate, each with very different energy. The large-scale Misrach photograph of a crowded beach extracts the energy, camaraderie and humanity from the crowd. Across from that, Struth's *Shanghai* conveys the polar opposite. Frenetic people abuzz with the travails of ordinary life crowd the street, each making his way with little seeming concern for the others. Between those two is Struth's ode to quietude as he captures the serene image of Vermeer's *Woman with a Lute* when it was on view at the National Gallery in London. The other works, while not as imposing, are equally important. A seminal Walker Evans Depression picture, an Edward Weston self-portrait,

Jarrod and Jon Cohen with their father, 2008
Patrick Hughes, 1994
Hiroshi Sugimoto, Napoleon, 1999 (obscured)
Fré Ilgen, 1997 (on table)

a Harry Callahan, a Richard Avedon, a Helmut Newton and an Edward Steichen fill out the room — works by the Brahmins of twentieth-century photography.

The Steichen image is worth a sidebar. It is his famous portrait of the renowned tycoon J.P. Morgan. Steichen initially intended this image to simply be a visual aid for his friend, portrait painter Frederick Encke, but the banker-financier was imperially impatient. The dagger in his hand tells it all. Of course, it is not really a dagger but sunlight hitting the arm of the chair. A lucky shot? A touch of genius? Steichen demurs, claims pure accident. This is one of those magical instances before Photoshop robbed us of those moments of truth that were the hallmark of earlier photo giants.

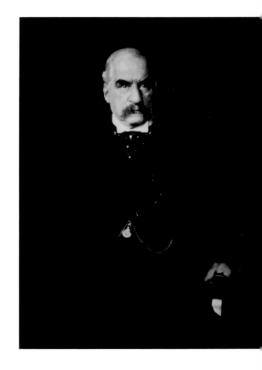

As you exit Joe's office, you are met by the delights of Ralph Gibson, Duane Michals, Irving Penn, Sally Mann and Adam Fuss, to name a few. When you enter the conference room, you find Fazal Sheikh's blind Afghan brothers working their prayer beads and a seemingly young woman enshrouded in her burka, while across the conference table are two classic Kertészes. The remaining walls host an enigmatic Dieter Appelt, an energetic Patrick Hughes and an evocative Desiree Dolron. From there one could cross the reception area to the other side of the suite and would most certainly pause to take in Sugimoto's *Napoleon* and Hiro's hauntingly empty space suits, while diCorcia's brother trolls the refrigerator for nourishment. All this is taking place under the

Edward Steichen, J.P. Morgan, 1903
Left: Vera Lutter, 135 LaSalle Street, Chicago, 2001

anxious eyes of Rineke Dijkstra's self-portrait. Around the corner, it is all business. Vera Lutter's mammoth Frankfurt Airport series dominates the west hall — commerce as seen through a pinhole camera, which imbues those images with a solarized serenity.

The tour goes on. Rauschenbergs and Newmans are joined by works by Orozco, Edgerton, Wall, Rovner, Araki, Gilpin and Muniz — fifty-eight images in all and still counting. Albeit a diverse group, Joe's photographs do have a common unifying core: they all reveal something of the human condition. The only possible exceptions are the ones ensconced in the small conference room away from the madding crowd. Robert Polidori's *Grand Central*, Candida Höfer's *Bourse du Travail Calais* and Lynn Davis's *Iceberg, Disko Bay, Greenland* stand stoically apart. Only the Davis work presents a place perpetually devoid of human presence — an infrequent occurrence in Joe's collection.

In today's image-saturated world, it is not surprising that Joe would find his way to art photography. As photography's sage, Marvin Heiferman, aptly put it, "photographs serve as arbiters of beauty, vehicles of celebrity, agents of propaganda, definers of desires, icons of aspirations and souvenirs of memory." But for Joe there may be more to it. When he was young, Joe had a darkroom, which he later turned over to his brothers, Fred and Dan. But Joe did not rely on that rudimentary knowledge of process when he decided to collect. He approached that quest with his

Harold Edgerton, 1957
Vik Muniz, 1997
Right: Vera Lutter, Cargo Field, Frankfurt Airport, 2001

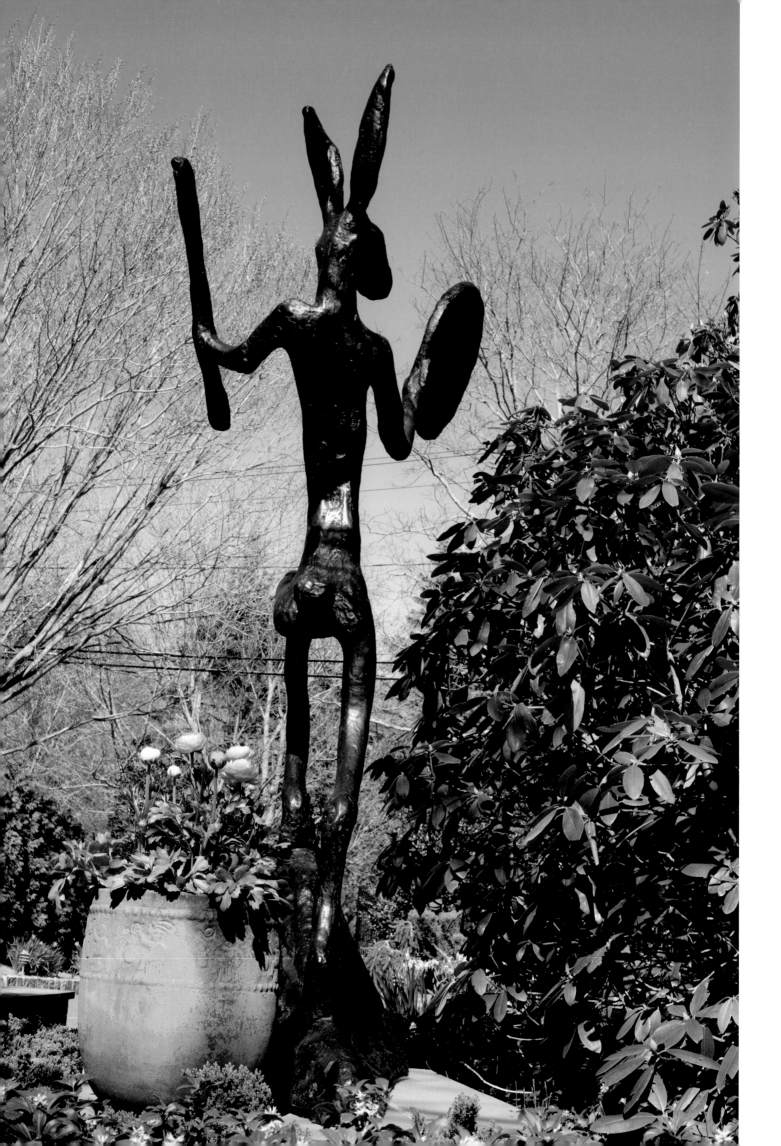

signature devotion. He frequents galleries, visits museums, cultivates dealers, attends photo fairs and serves on numerous museum committees. He travels widely in search of art — to Miami, London, Paris, Germany, Switzerland and Spain. Joe is unflagging in his hunt. Auction catalogues are dissected; photographers are sought out. He often takes an extra step and makes the artists his friends, visiting their studios and engaging them at dinner. He gets to know the creator of his prey. Ralph Gibson, Fazal Sheikh, Vera Lutter and Desiree Dolron are in that group.

When it comes to collecting photography, Joe does not have a Noah complex. He is rarely satisfied with just two. As of last count, he had 30 Gibsons, 20 Sheikhs, 19 Rauschenbergs, 12 Penns, eight Polidoris, five Newmans, three Drtikols, six Kertészes, three Appelts, Normans and Michalses, six Struths, ten Rovners and Mapplethorpes, and five Lutters, Dolrons, Rosenblums and Misraches. And, alas, he does admit to only two each of Stieglitz, Leibovitz, Weston, Callahan and Strand. One would think enough, perhaps; not Joe. There is always room for more. The new Christenberrys have arrived and the other works gladly accommodated them.

Finally, we finish our trek at Joe's weekend home in the Hamptons. In 1982, Joe and Babs acquired a two-hundred-year-old barn that had previously been in the venerable Halsey family for five generations. A year later, they acquired two additional abutting acres, creating a unique and inviting pastoral patch. They immediately began filling the house with art and antiques. Nurturing it carefully over the last quarter century, they created a perfectly balanced aggregation of favorite things. The lush acreage opens itself to a dazzling display of sculpture. You are greeted by a Hicks dog and welcomed with verve by a Flanagan hare. This is not the mad March Hare of old. This long-eared jackrabbit beats a different drum. He stands at the ready, drumstick in paw, waiting for the performance to begin.

Observing all this is César's owl and a coven of cats, including Hicks's cat woman and one nineteenth-century terra cotta feline that Joe found at a Palm Beach art fair. He couldn't resist it; Babs loved cats.

These are not decorative statues placed to accent well-manicured lawns. They are highly respected works, with dynamic energy and jubilant spirit. Barry Flanagan, the renowned Welsh sculptor, created his jovial jackrabbit to celebrate human whimsy — that spontaneous emotion we share with animalkind. The same could be said about the vital animal creatures that English sculptor Nicola Hicks creates. In Joe's garden, they hold their own with the more formal works by César, Stella and Shapiro. They are more — much more — than merely entertaining, for as Robert Morgan observes, they "express the universe of the human spirit at large."

But the grounds have not all gone to the dogs and cats. In rather stark relief, three Tony Craggs in yellow, green and red are strategically arranged in a large open expanse behind the house, placed in perfect symmetry between a tennis court and a sylvan pond. Cragg's deeply conceptual work is essentially made from objects that he transforms into ingenious bronze forms. Cragg, born in England, now lives in Wuppertal, a suburb of Dusseldorf, where Joe visited his studio. He was clearly impressed by this Turner Prize winner, as are a whole younger generation of post-formalist sculptors. The urban archaeology of these works is surprisingly at home with Flanagan's and Hicks's fanciful whimsy. In turn, those works are all complemented by the kinetic metal sculpture of American George Rickey. As you walk with Joe through his gardens, you can sense a paternal pride in his sculptures. He is stimulated by their powers and rewarded by his discovery of them. He has created a stage, choreographed by nature, with his favorite Rickey serving as its conductor, bringing all the works to order with the constant twirling of its stainless steel batons. It is time to go inside.

Once there, you are embraced by the warmth of this two-century-old abode and by the scores of artworks that reside there. To the side, a mammoth serigraph printed on copper, by the Spanish artist Cristina Iglesias, hangs quietly. At the entrance, a Mark di Suvero shares space with a Richard Deacon wall sculpture. In front of the fireplace, a Fletcher Benton block construction zigzags for attention. Then you are confronted by two large Thomas Struths — one shows the Prado Museum filled with children, depicting the multigenerational pull of art. The other, a crowded cathedral, does the same for spirituality. An eerily quiet Vera Lutter shows New York in the stark relief that only pinhole photography can achieve. Images of exotic places, including Polidori's Cuba and Lynn Davis's China, cover the remaining walls. In the hall, a Strand plays a duet with a Gibson while a shy Desiree Dolron looks down from on high. All in all, over one hundred images and sculptures mingle with ease in the company of sterling silver, cut glass and leather couches.

As you ascend to Joe's study, you cannot help but notice the sly smiles on the faces of the Sopranos, in Annie Leibovitz's photographic riff on da Vinci's *Last Supper*. They seem to know that an offer has been made that Joe can't refuse. In an Orwellian sense, Joe's "objects of desire" — the inhabitants of his expansive and curious cabinet — have taken over the barn, or at least moved in to stay. And Joe is content with that. He is happy to share his home and life with those he loves. Together they share the space.

Fletcher Benton, 1996
Right: Richard Deacon, 2007, Jamie Burt, 1990, Mark di Suvero, 1994
Following pages: Vera Lutter, Grace Building, 2005
Thomas Struth, Iglesia de San Francisco, Lima Peru, 2003

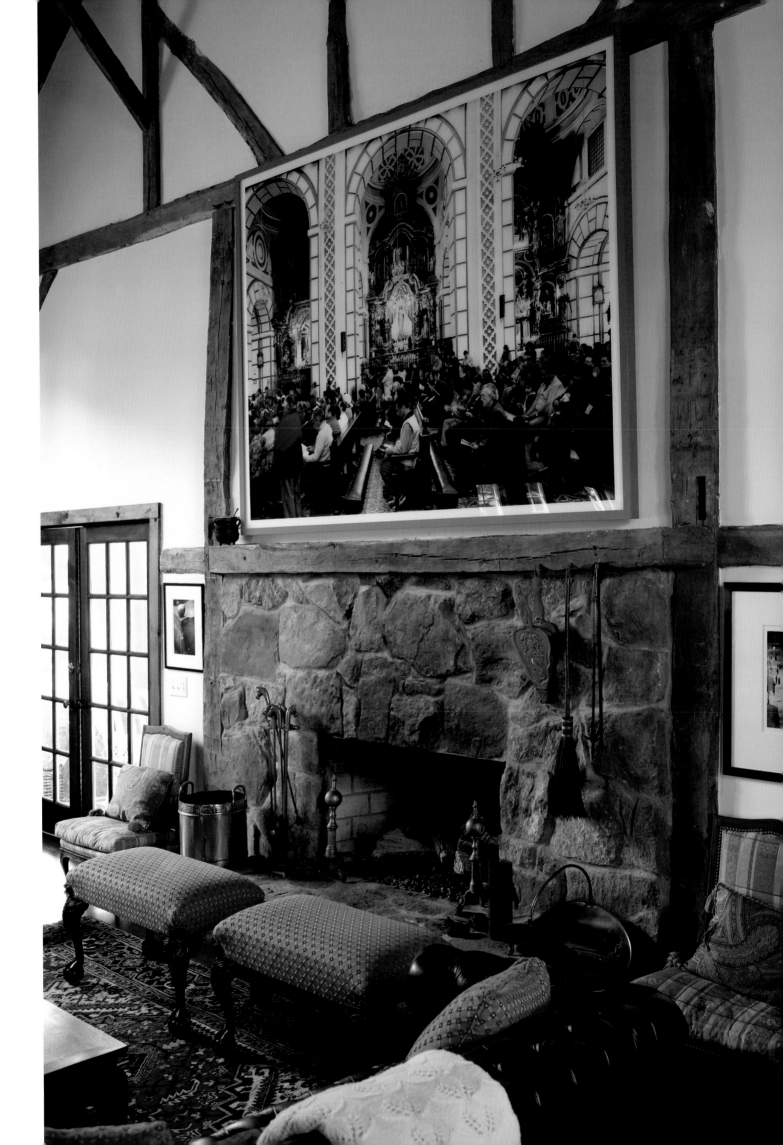

Cristina Iglesias, 2005

The most difficult challenge for me as the editor of this book was to find a title that captured Joe and his collection. I struggled mightily even though many options came to mind. At first, I thought to call it "The Eclectic Collector." But "eclectic" suggests something off-beat, which would be inappropriate in this case. In the more classical sense, from the Greek *eklektikos*, the word means choosing the best. As an approach to collecting, it implies that one does not hold rigidly to a single paradigm or set of assumptions. That is certainly true in Joe's case. The works in his collection reflect a multitude of artistic approaches and resist any attempt to lump them into one discipline. It is rich in aesthetics and ripe in emotion, whether the works are traditional, figurative or abstract. Yet neither meaning really captured the essence of the collection or the core of the collector.

I then considered "The Passionate Collector," for certainly passion plays an important role in Joe's approach. The objects of his desire are thankfully often less fickle than most people; they are perfect lifelong mistresses. But that title raised other problems.

Perhaps the title should reflect and reference the collection. If so, "Elective Affinities" would convey the fact that these works stand together solely because of the collector's choice. Here Joe has assembled with his keen eye his personal vision of the human condition. But using an elegant term of artspeak to describe it would again be inappropriate. "A Book of Memories" might work. The works in fact deal not only with his memories — but with his perceptions and ideals.

I then toyed with "A Private Collection," for the unique attribute of a collection that lives with you is the intimacy it offers — no guards, no ropes, no strangers and no closing time. You can touch it; you don't have to be quiet. You can talk to it as often and loudly as you want. It's yours when you want it and you don't even have to dress.

Indeed, titling any book is difficult. The philosopher Maimonides thought long and hard before titling his masterpiece. He finally settled for *Moreh Nebuchim* — "The Guide for the Perplexed." I was even more perplexed than that medieval sage until I realized that I was looking in the wrong place. Rather than trying to characterize the collector or label the collection, I decided that it was best to name the book for the result of Joe's efforts. In the luxury afforded me in creating this book, I began to see that indeed there is order in what at first appeared to be chaos.

To discern that order, you have to decipher its code. Begin with the collector. He is, at his core, a vibrant, roving intellect, with protean talent and an outsized generosity. He is also a "people person" — a devoted family man who extends that embrace to include friends and associates. Then we move on to the collection. If you carefully consider it, you will notice that over 80 percent of all the works are of or about people. It starts with Gentileschi's depiction of the travails of Jacob's son — Joe's namesake most likely. Then look at Dubuffet's clown, de La Tour's teacher, Flanagan's lanky hare, Avedon's little boy, the portraits of Dijkstra, Dolron, Gibson and Sheikh, the whimsy of Weegee, the de rigueur of Drtikol, the elegance of Newton and the knowing innocence of Mann.

They all tell us about the human condition. Even those without human presence tell man's story. They are about places humans

Artist unknown, c. 1845

inhabit. Polidori's elegant but rusting Cuba, Gibson's empty balcony, Höfer's empty bourse and Hiro's empty suits. They all tell us of the human experience.

Michel de Montaigne said over four hundred years ago that "every man carries with him the entire form of our human condition," and I would suggest that every work of art, regardless of medium, does the same. Joe's collection is, to borrow a phrase, about the audacity of hope and the zest for life. It reflects Joe's personal vision, his optimism and his humanity. Ralph Gibson observed that "Joe's collection is in and of itself a portrait of the collector." I would agree, but suggest it might well be more. I think the collection can speak to any of us who look and listen.

That, I suspect, is what Joe wants for himself, his family and his friends. What is so pleasing is that the collection, as he has framed it, steers clear of categorization, allowing all ages and all movements equal stature and equal place. His collection reflects our age, which itself is enriched by its contrasts, tensions and contradictions. And because of that, I discern on Joe's part an attempt to make a personal statement if only to himself. I have always believed that collecting is based on one's own rules. I am not sure I fully understand what Joe's rules are and I am not sure he does either. But they are there and they are at work. Those rules determine the art he acquires. His vision puts a personal gloss on the works.

Nicola Hicks, 1991

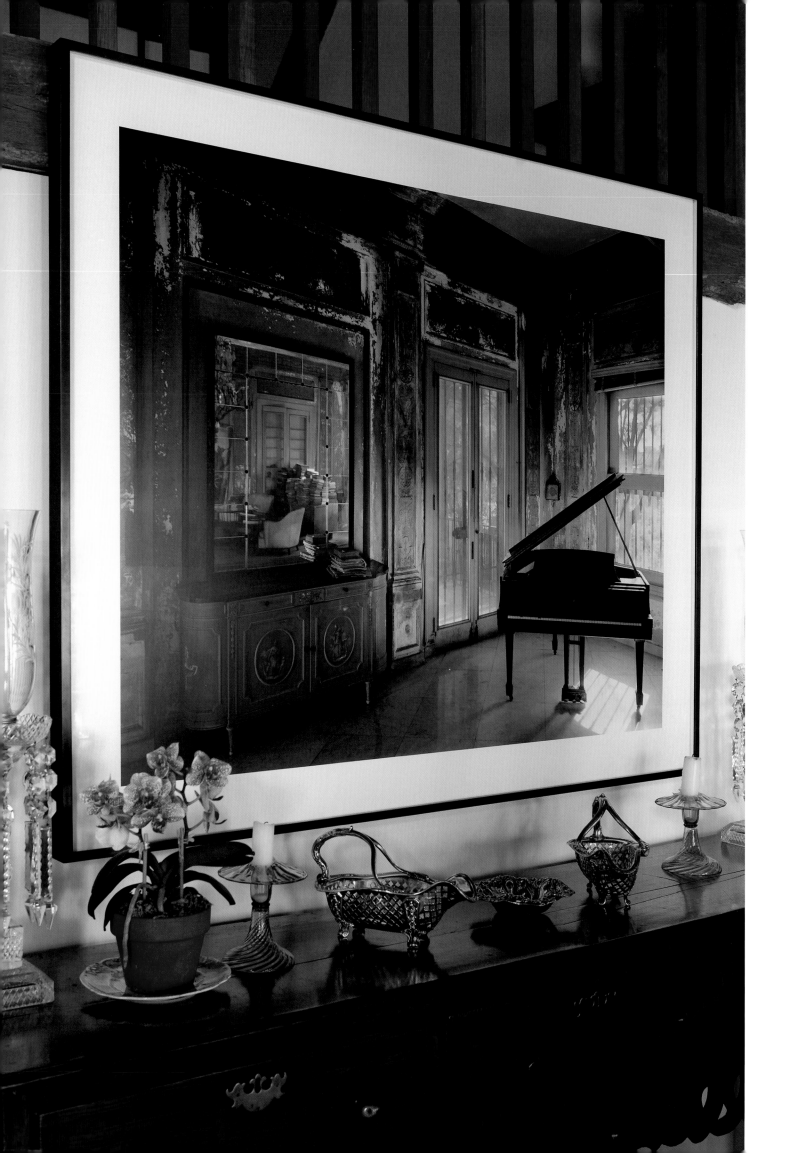

I sense in Joe a bit of the romantic, for I believe he feels the need to leave for his progeny something antidotal and restorative and magnificently conceived. That he is doing. Eric Fischl's view of art is applicable here. He suggests that we "think of art as a glue — a cultural and social glue. It is one of the means that serves to show the things we believe in and the things we celebrate. It serves to reinforce our relationship to each other." That is what I think Joe is doing.

His collection permits him to live in a world of art masters. Those works he invites into his lair know that they will never lose their welcome. And they will be in heady company, for Joe's spaces house an extended family of works of extraordinary imagination, beauty and genius. For him, at least metaphysically, they come to life, if only as his surrogate companions. There are those who believe that works of art have souls and breathe new life into those that live among them. To that extent, Joe's homes may be haunted or, to be more accurate, indelibly inhabited. Together in their shared space, the works in his collection resonate with the past and the present and will permit him to keep his best memories, forge new ones and perhaps see a bit into the future. Everyone (and everything) seems at ease with one another.

It was at this point that I realized I had the perfect title — *Shared Space* — for it best encapsulates what Joe's embracive life, including his collection, is all about.

Ray Merritt

Paintings & Drawings

Gentileschi's genius

Those artists who are most attuned to the work of a revolutionary master are often the most original among that master's adherents. So it was with Orazio Gentileschi and Michelangelo da Caravaggio, although nothing in the former's beginnings pointed in that direction. Until the late 1570s, when Orazio Lomi Gentileschi, the son of a goldsmith and brother of the painter Aurelio, arrived in Rome from Pisa, where he was born on July 7, 1562, his artistic education had apparently been limited. Indeed, it is not until 1588 that his name first appears in connection with painting, and then simply as part of a vast crew embellishing the Biblioteca Sistina in the Palazzo Vaticano. Of his seven known commissions before 1600, three were under Vatican control and four were collaborative projects. Under such conditions, visual unity counted more than artistic individuality, and in fact scholarly opinion differs as to the precise identification of Gentileschi's contributions. Further, the new official church requirements for religious art (as set forth, for example, by the Council of Trent), while demanding intelligibility, the priority of subject matter over "the charms of art" and — as it were — realism, also imposed strict rules of decorum that did not inspire artistic innovation. Those early frescoes (among them the *Presentation of Christ in the Temple*, ca. 1593, in the nave of Santa Maria Maggiore in Rome), and those canvases (such as the lost *Conversion of Saul*, 1596, for San Paolo fuori le Mura) that can confidently be assigned to Gentileschi are rather pedestrian essays in late Mannerism, with elements of the complexity of that style, and also of its sophistication in the case of his cabinet pictures (including the *Saint Francis Supported by an Angel* in a private collection in New York), which were tailored to a different clientele.

Soon after the beginning of the seventeenth century, however, Gentileschi's painting began to respond to the progressive vision of his friend Caravaggio. Seizing first upon external features of the master's canvases — lateral lighting, directly observed detail — Gentileschi worked to come to grips with Caravaggio's daring notions regarding the symbiosis of art,

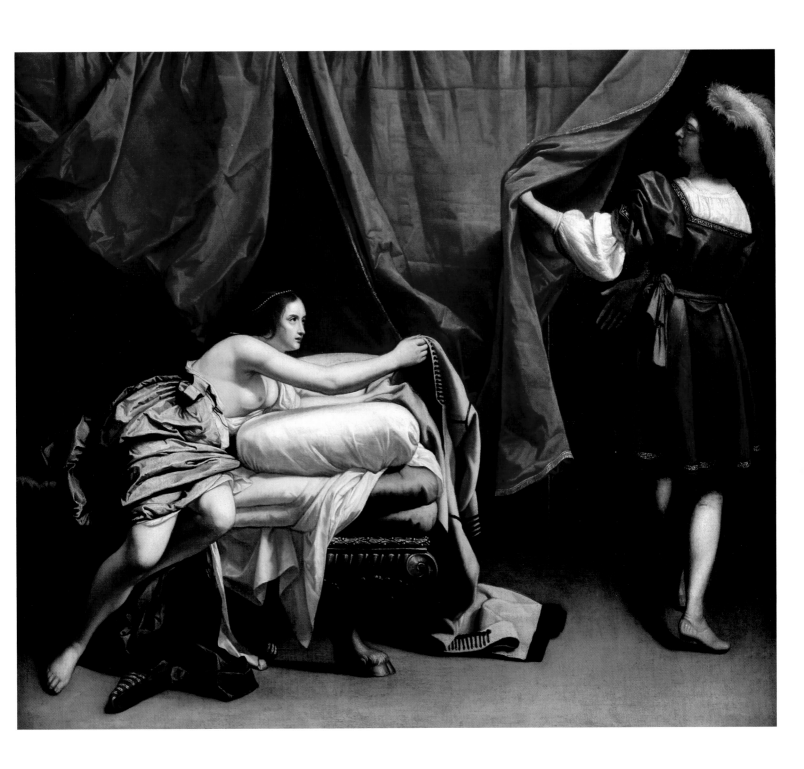

Orazio Gentileschi, Joseph and Potiphar's Wife, c. 1635

reality, religion and the commonplace, his poetic bent initially inclining him toward the lyrical expression and gentler effects of light and color of Caravaggio's youthful pictures. Gentileschi's lovely *Saint Francis Supported by an Angel* in the Palazzo Barberini is in all likelihood indicative of this moment. Recognition came from his peers in the form of his election in 1604 to the Roman artists' Accademia di San Luca and in 1605 to the Congregazione dei Virtuosi, with its seat at the Pantheon, and shortly thereafter from patrons through commissions for major altarpieces — the *Baptism of Christ* in Santa Maria della Pace in Rome, the *Circumcision of Christ* (for the Chiesa del Gesú at Pinacoteca Comunale), the *St. Michael Overcoming the Devil* in S. Salvatore at Farnese, and the *Vision of Saint Cecilia* for Santa Cecilia in Como (Milan, Brera).

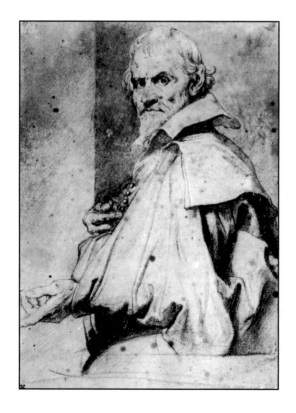

I traded some art, including an Arp, a Twombly and a Dali, for the Gentileschi. I hated parting with them, but I really loved the painting. I had no choice.

Anthony van Dyck, Portrait of Orazio Gentileschi, c. 1632

Caravaggio's forced departure from Rome in 1606 having relieved him of an intimidating presence, Gentileschi began to produce more emphatically Caravaggesque works, characterized by a greater monumentality and, for a while (as in the *Way to Calvary* in the Kunsthistorisches Museum in Vienna and the *David Slaying Goliath* in the National Gallery of Ireland in Dublin), by both decorative restraint and more explicit drama. Then, in his paintings of the first five years of the second decade, Gentileschi effected a brilliant synthesis of pictorial authority, an intimate view of life, and continued dedication to superb craftsmanship. In the *St. Cecilia (Young Woman Playing a Violin)* in the Detroit Institute of Arts and the *Young Woman Playing a Lute* in the National Gallery in Washington, Gentileschi, to quote Benedict Nicolson out of context, "abolishes the boundaries dividing different departments of life, by gently lowering religion to the plane of reality and bringing triviality up to meet it, so that all activity takes place on common ground."

From 1613 to 1620, given shifting artistic tastes in Rome, possible repercussions from the bitter trial of Agostino Tassi in 1612 for having deflowered Gentileschi's painter-daughter Artemisia, and patronage opportunities, Gentileschi devoted his major efforts to works for churches in Fabriano, in the Marche region of Italy. His art now assumed a pronounced idealism and aristocratic elegance, which Gentileschi expressed in his incomparable way with intricately arranged, multi-textured fabrics and his subtle manipulation of color values — to all of which the *Vision of Santa Francesca Romana* (Urbino, Galleria Nazionale delle Marche) offers stunning testimony. The ever-increasing hold of Bolognese classicism, most likely that of "the divine" Guido Reni in particular, and a renewed acquaintanceship with the beauty of the Tuscan landscape during his trips to Florence, helped determine this new emphasis. In 1621, the master accepted an invitation to Genoa, where in 1623 he produced for Carlo Emanuele, the Duke of Savoy in Turin, the *Annunciation*, a majestic canvas that calls to mind Giorgio Vasari's praise of Donatello's *Annunciation Altarpiece* (perhaps one of

Gentileschi's points of departure) for its combination of virtuoso craftsmanship, grace, decorative effects and meaning.

After leaving Rome, Gentileschi worked almost exclusively on canvases intended for the private enjoyment of the nobility and the courts, first in Northern Italy, then in France for Marie de Medici (1624-1626), and finally in England, to which he had been called by the Duke of Buckingham and King Charles I and where he died on February 7, 1639. In London, Gentileschi, to judge by Anthony van Dyck's portrait drawing of him, appears to have assumed the airs of the aristocrats with whom he had close contact. Certainly his English pictures, which seem to have been more to the aesthetic preferences of Queen Henrietta Maria than to those of King Charles, breathe the political/cultural atmosphere that also inspired the court masques and Caroline poetry. For the Queen's House at Greenwich, Gentileschi produced nine canvases set into the ceiling of the Great Hall. Transferred less than a century later to Marlborough House in London, these paintings, much like court theater, served to strengthen and perpetuate the carefully constructed image of an English utopian state at a time of political turmoil, when the need to reinforce the mystique of an ideal realm, peaceful and prosperous, was more desperate than ever.

Other reflections of the court scene may be observed in the *Joseph and Potiphar's Wife* in the Cohen Collection, a smaller and

Orazio Gentileschi, Joseph and Potiphar's Wife, c. 1635 (detail)

slightly varied version of the canvas now at Hampton Court but once at Greenwich. Here, Joseph's refusal to indulge the woman's lust evokes the unending stream of protestations of morality, in particular the accent on platonic love found in the royal entertainments. Notwithstanding, the artist may also have embraced the subject as an excuse for indulging in its inherent sensuality. The painting recalls those verses containing elegant descriptions of sexual excitement: thus Robert Herrick in "Delight in Disorder" professed that "A sweet disorder in the dresse / Kindles in cloathes a wantonnesse" and was titillated by "A winning wave (deserving note) / In the tempestuous petticote," while in "Still to be neat," Ben Jonson had been stimulated by "robes loosely flowing, hayre as free."

The exaggerated gestures in the *Finding of Moses*, once on display at Castle Howard, and the especially elaborate costuming and spellbinding illusions of diverse materials in the version of that theme in the Prado in Madrid, again conjure up English stage productions of that period. Under these circumstances Gentileschi sometimes pushed his art to affectation and hyperrefinement. When he stepped back from such extremes, however, as in the *Rest on the Flight into Egypt* in the Louvre in Paris, or even when the unabashedly ornamental was called for by virtue of subject and function, as in the *Diana the Huntress* in the Musée des beaux-arts at Nantes, Gentileschi approached his highest achievements.

Along the way, from Rome to London, Gentileschi's art exerted a pan-European influence. Artists from Italy, Flanders, Holland and France assimilated elements of his pictures in ways that were compatible with their own traditions and tastes. It was once fashionable among critics to view Orazio Gentileschi as merely a technician whose art never went much deeper than the tip of his brush. The many painters who were inspired by him knew otherwise.

R. Ward Bissell

A tale of two paintings

In every book that surveys the works in a collection, one piece seems to stand out. The reasons vary. David Ross, the former director of the Whitney Museum, once commented that Roy Lichtenstein's work was always the hardest to exhibit in a group show — it would invariably take "all the oxygen out of the room, leaving none for any of the other works." In a sense, that is what the work of Orazio Gentileschi does in the Cohen Collection. It is the oldest of the paintings, its subject matter the most intriguing, its lineage the most royal.

As a matter of diligence and scholarship, Joe Cohen and I traveled to Scotland to see the Queen's version. This Gentileschi has been in the Royal Collection for all but eleven years

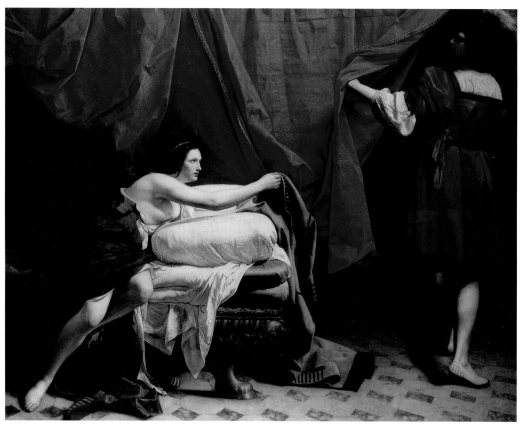

The Queen's Version

Orazio Gentileschi, Joseph and Potiphar's Wife, c. 1632

(1649–60) of its existence — that being when Charles I was assassinated, the monarchy abolished, the painting along with all other royal art sold. Contemporary records confirm the sale of the royal Gentileschi for £50. Fortunately, the King's son, Charles II, was able to recover much of the art during the Restoration, including *Joseph and Potiphar's Wife*. The Gentileschi has remained in Hampton Court ever since. For the first time ever, it was recently sent, along with the other Italian masterpieces owned by the Crown, to the Queen's Gallery at her palace at Holyroodhouse in Edinburgh. It took the preeminent place in the show, which included over seventy pieces, including two newly discovered Caravaggios as well as works by da Vinci, Michelangelo, Raphael, Tintoretto, Titian, Bernini and Poussin.

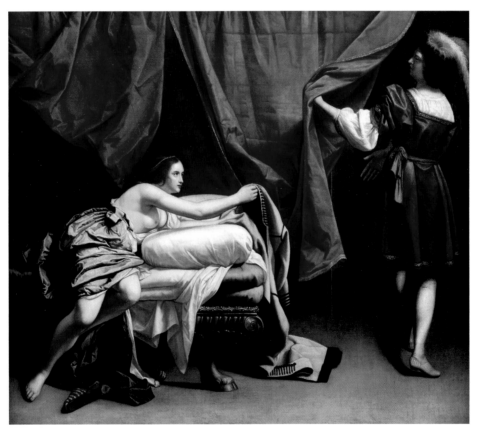

The Cohen Collection Autograph Version

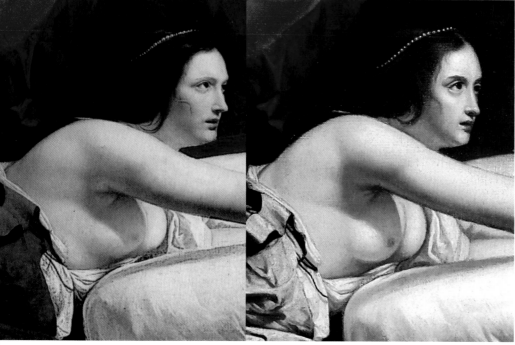

The Queen's Version The Cohen Collection Autograph Version

She caught him by the garment saying, 'Lie with me!'
Potiphar's Wife,
Genesis: 39

The Queen's version of *Joseph and Potiphar's Wife*, which measures 81" x 103", is very impressive, although it appears to have suffered from perhaps too much care. Experts believe that it was subjected to over-cleaning between 1837 and 1854. An X-ray analysis of the painting a century and a half later revealed that Gentileschi's rendering on the canvas showed Potiphar's wife's breasts demurely covered. Later, perhaps by over-painting, the artist exposed both of them for more dramatic effect. He used actors clad in contemporary clothing to strike poses of two strong-willed people thrust into a scene of dangerous seduction.

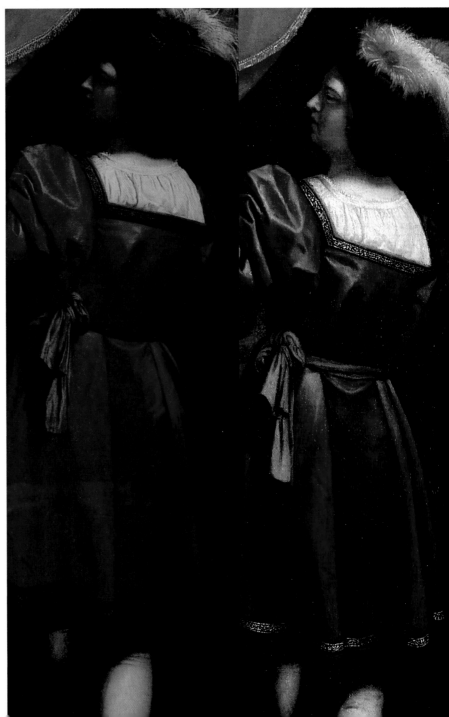

With me in charge, my master does not concern himself with anything in the house; everything he owns he has entrusted to my care. No one is greater in this house than I am. My master has withheld nothing from me except you, because you are his wife.

Joseph,
Genesis: 39

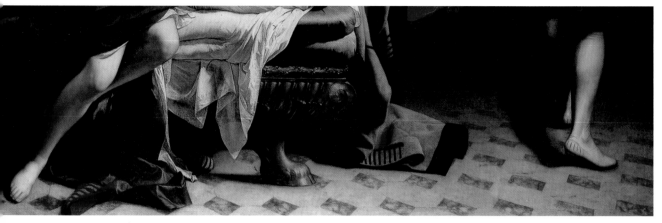

The Queen's Version

Upon our return to New York, we carefully observed the Cohen Collection version. It is smaller, measuring 41" x 48". It should be noted that it was not uncommon for artists of Gentileschi's generation to make variants and duplicates of their works (often dubbed "autograph replicas"). Since he did not work from separate sketches and drawings but rather applied his hand directly to the canvas, it would be necessary for Gentileschi to have easy access to the original. That was certainly the case with *Joseph and Potiphar's Wife*, since Gentileschi spent his later years in England and was very close to Queen Henrietta Maria, King Charles I's wife.

According to R. Ward Bissell's definitive treatise, it appears that the artist made autograph versions or variants of at least six of his masterpieces; only a few are known to remain in private hands. Each variant is different from the original, not only in composition but also in condition. That is certainly true of the two versions of *Joseph and Potiphar's Wife*. In the Queen's version, the painting appears to have been cropped. Experts speculate that it was trimmed to fit the frame. As a result, Joseph's hat is partially cut off. Also, Potiphar's wife's flesh appears creamy and flat — perhaps the consequence of overzealous cleaning. In the Cohen version, Joseph is shown in full and the seductress's skin is luminously natural. (Gentileschi used Venetian amber varnish to give her flesh areas a lustrous effect. Over-cleaning

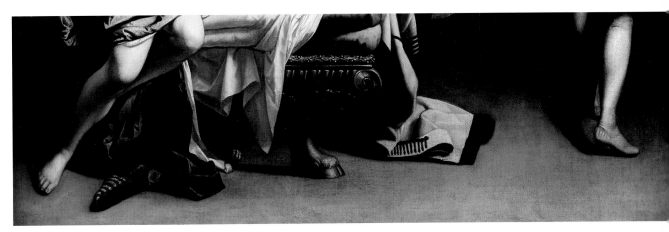

The Cohen Collection Autograph Version

would likely diminish that effect. X-ray radiology reveals clearly that the Cohen version has not been trimmed at the edges and, therefore, retains its original size.

According to Mario Grassi, the renowned New York conservator and art expert, past cleanings have not visibly dulled or abraded the painting in the Cohen Collection. He believes that conservative procedures performed in the last several decades rendered the surface free of older varnishes. As a result, the colors possess a high degree of saturation, which was enhanced by a clear covering varnish. The result is evident even to a nonprofessional. The picture's warm and harmonious coloring and precise detailing create a striking effect.

Both versions are masterpieces. They demand your attention. You sense their grandeur. Orazio Gentileschi may have first been viewed as simply a competent practitioner of the elegant style of classical painting, but further scholarship has shown that he was, like his equally famous daughter, a complex and unconventional person. He is now considered a seminal figure in the history of seventeenth-century painting and is universally recognized as a master poet of light. These biblical renderings stand as convincing testaments to his accomplishments.

Ray Merritt

Artists and models

As an art historian and curator who has never collected art except by profession, on behalf of museums, I am always intrigued by the private collections of those who choose to live with works of art. Such collections cannot help but reveal something essential about the characters and ambitions of those who formed them. The artworks with which Joe Cohen lives are remarkable for their quality, diversity, and what can only be described as a refreshing absence of ostentation, for there are none of the pseudo-ancestor portraits or efflorescent Netherlandish still lifes that obsessed New Yorkers in the 1980s, nor any of the sensational "trophy pictures" from the Gauguin-to-Warhol gamut for which widely publicized prices have been paid in more recent years. Cohen's, instead, is a collection of paintings and drawings that conveys a keen appreciation for the fusion of disciplined composition with intense color, mainly in works of domestic scale, such as Ellsworth Kelly's superb painting from about 1959, or a small but dramatically painted work by Joan Mitchell, or even David Hockney's effulgent pastel *Study for A Closer Grand Canyon III,* created in 1998.

I'm not interested in edges. I'm interested in the mass and color. The edges happen because the forms get as quiet as they can be. I want the masses to perform. When I work with forms and colors, I get the edge.

Ellsworth Kelly

David Hockney, A Closer Grand Canyon III, 1998

Ellsworth Kelly, c. 1959

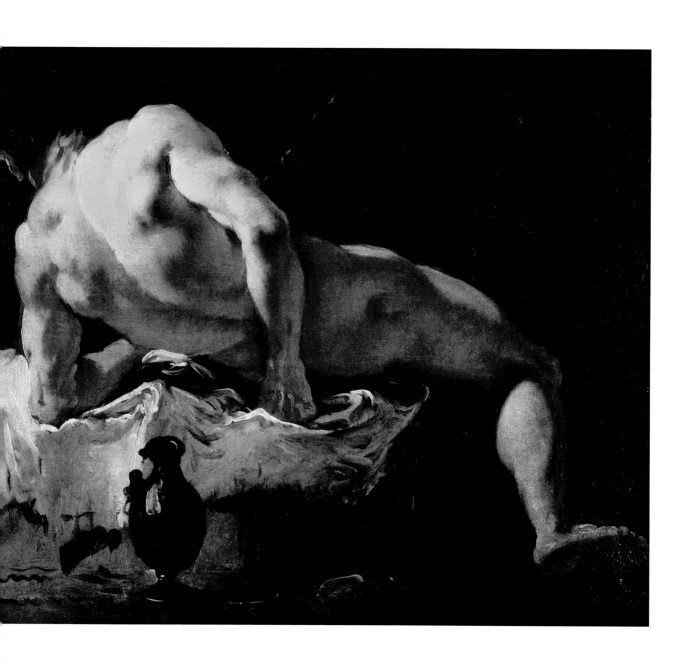

Giambattista Tiepolo, Reclining male nude, seen from behind, c. 1715

Another theme that asserts itself is Cohen's obviously passionate response to sensitive depictions of the human figure that were made not so much for public consumption as for the purpose of learning, or to express deeply felt admiration or empathy for another human being — therefore the title of this brief essay. Take, for example, the brilliant oil sketch *Reclining male nude, seen from behind* by Giambattista Tiepolo, probably still a teenager when he undertook this typical academic exercise. The work is rendered with the limited palette of his older contemporary, Piazzetta, but the handling of light and shadow, as well as the brushwork, whereby the male physique is modeled with almost reverential subtlety, betray a youthful talent of awesome promise. Comparison with a relatively late work by Edgar Degas, *Le petit déjeuner après le bain* (the domestic servant awaits with a bowl-sized cup of chocolate or tea), is compelling because the woman climbing out of a bathtub is likewise *vu de dos* or "regarded from the backside." Whereas the younger artist's goal was

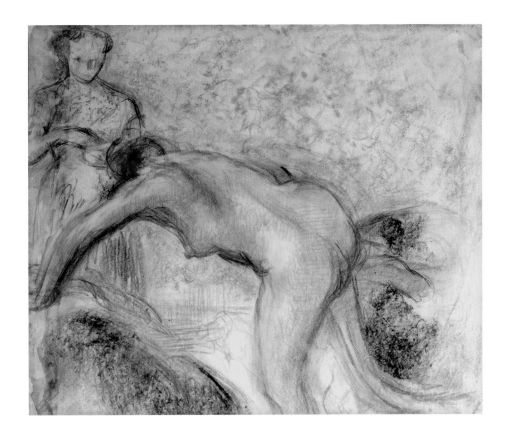

to replicate as perfectly as possible the superficial beauty of his subject, the purpose of the experienced master was to discover the formal, expressive potential of human anatomy under stress, when nothing matters so much as the instinct to restore balance and equilibrium. The supreme draftsman Degas, the old magician, makes the awkwardness of the action seem almost intentional, as if it were choreographic in nature.

Maurice-Quentin de La Tour proudly claimed that "I penetrate into the depths of my subjects without them knowing it, and capture them whole," as he succeeded in doing in about 1753 with his marvelous *Portrait of Louis de Silvestre*, one of the crown jewels of the Cohen Collection. Other painters and draftsmen had produced official portraits of de Silvestre (1675-1760), esteemed director of the Académie Royale, but none captured him so frankly and naturally as de La Tour. By ubiquitous convention of the period, artistic sitters were portrayed as if taken unawares in the midst of creativity — whether painting, writing, or composing — and therefore de Silvestre is shown without his wig and wearing his neckerchief as an impromptu turban. He gazes directly at the viewer and smiles — the smile of reason so typical of the Enlightenment, most frequently associated with depictions of Voltaire (of whom de La Tour had displayed a celebrated pastel portrait in 1735). The Goncourt brothers, the most influential art critics of the nineteenth century — who gave their countrymen permission to once again admire the art of the Ancien Régime — were

> *I saw the de La Tour in a Sotheby's catalogue. I asked Babs to go bid on it. At that time, I had no idea who the artist was. It was the sense of proportion and the subject that attracted me. Later I was happy to learn that he was one of France's best eighteenth-century pastelists. That made it even more satisfying.*

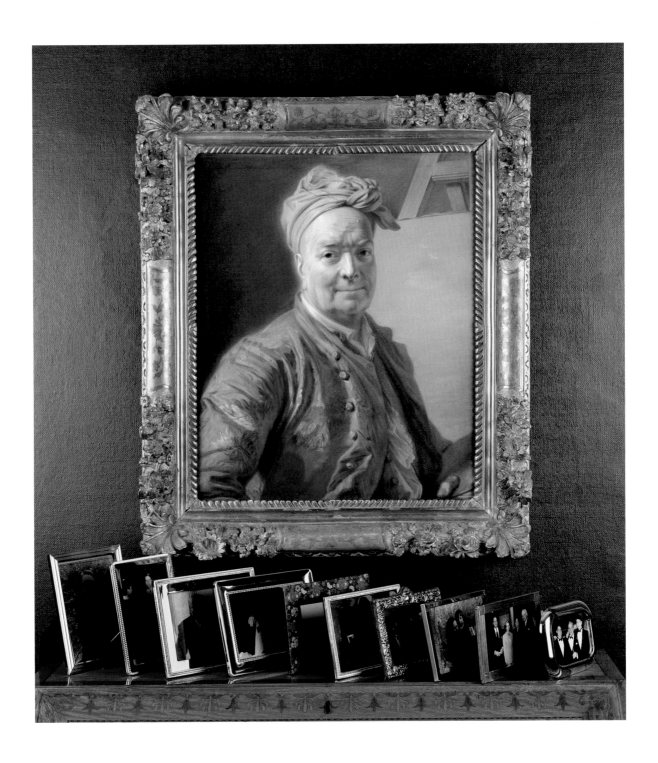

Maurice-Quentin de La Tour,
Portrait of Louis de Silvestre, 1753

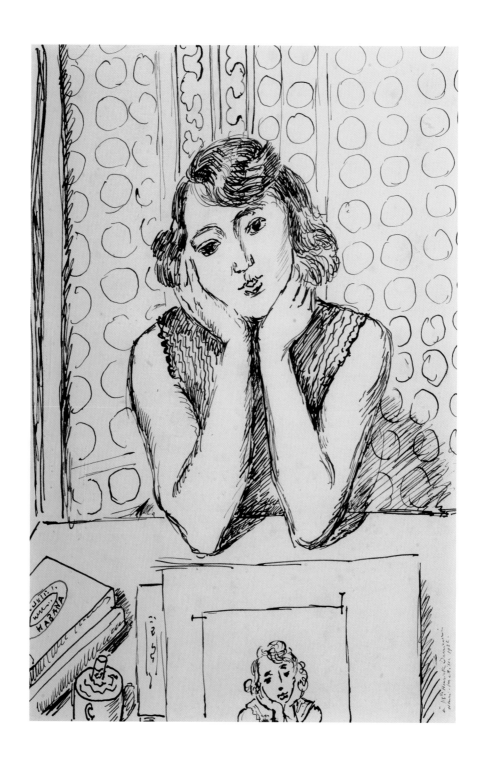

Henri Matisse, Portrait of Mademoiselle
Henriette Darricarrère, 1922

deeply moved by this portrait of de Silvestre and remarked upon "the clarity of the cold carnation of the old skin, the creases of the smile, the folds made by the passage of time; the powerful pleating of the forehead," details of the old man's physiognomy that are even more striking in the splendid preparatory drawing recently acquired by the J. Paul Getty Museum, Los Angeles.

Outstanding among numerous drawings of female subjects, which include works by artists such as Picasso and Grosz, is the *Portrait of Mademoiselle Henriette Darricarrère*, which Matisse fully signed and dated and dedicated to the sitter (born 1901) who began posing for him in the autumn of 1920. She had a background in ballet, studied violin and piano, and worked as a painter in her own right. Serving as partner to Matisse's work until her marriage in 1927, Darricarrère skillfully played the roles Matisse assigned her: ballerina, odalisque, or remote and pensive muse. He immortalized her in a series of masterpieces painted in the "Oriental alcove" of his studio, a sort of stage set equipped with a low couch, mirrors, decorative screens, and profusely patterned wall hangings, that created an atmosphere of reverie and exoticism reminiscent of the Moorish interiors he had seen in Morocco. Her elegant and long-limbed body dominates Matisse's production during this period, and she frequently figures in photographs of the artist taken at that time. Though entirely chaste, the drawing in Cohen's collection is nonetheless seductive thanks to the sitter's nonchalant pose, head in hands, which suggests a moment that is both casual and intimate. An additional element of voyeuristic interest is introduced by the inclusion of a fictive drawing within the "real" drawing, for the viewer is thereby made an observer not just of the finished work of art but of the process of making art, too.

Of exceptional rarity is an early portrait by the great Balthasar Klossowski de Rola, otherwise known as Balthus. *Woman in Green* is a regal but haunting portrayal of Betty, the

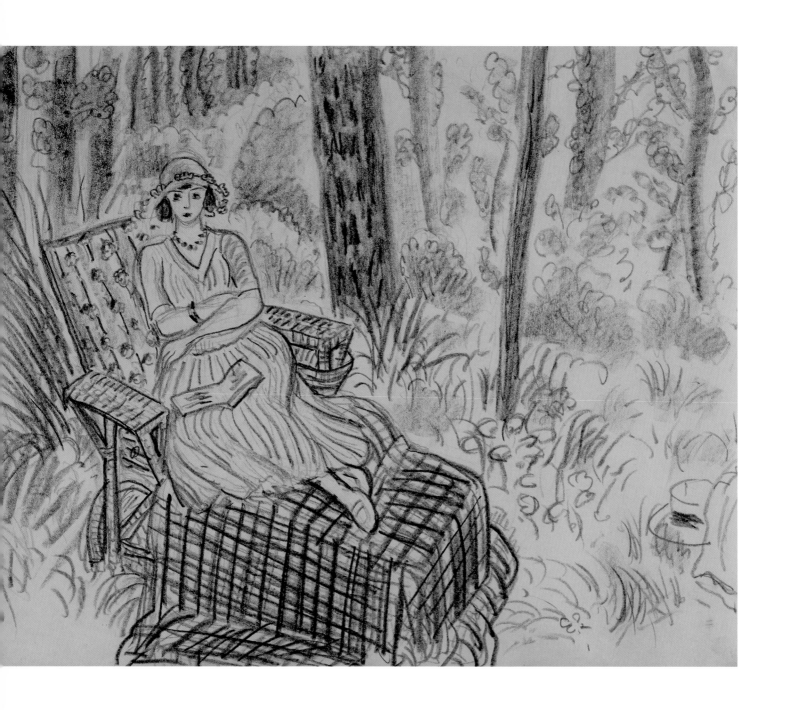

Henri Matisse, 1923

When I am finishing a picture I hold some God-made object up to it – a rock, a flower, the branch of a tree or my hand, as a kind of final test. If the painting stands up beside a thing man cannot make, the painting is authentic. If there's a clash between the two, it is bad art.

Marc Chagall

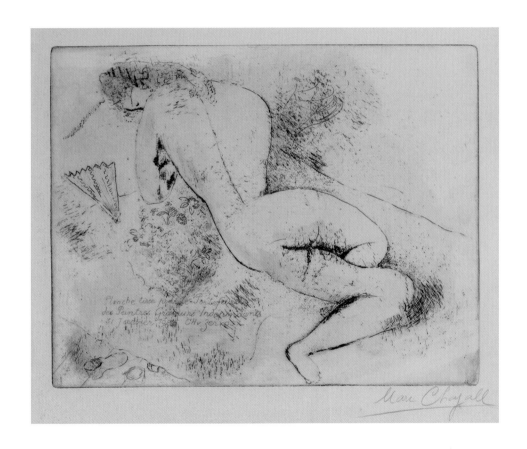

Marc Chagall, 1925

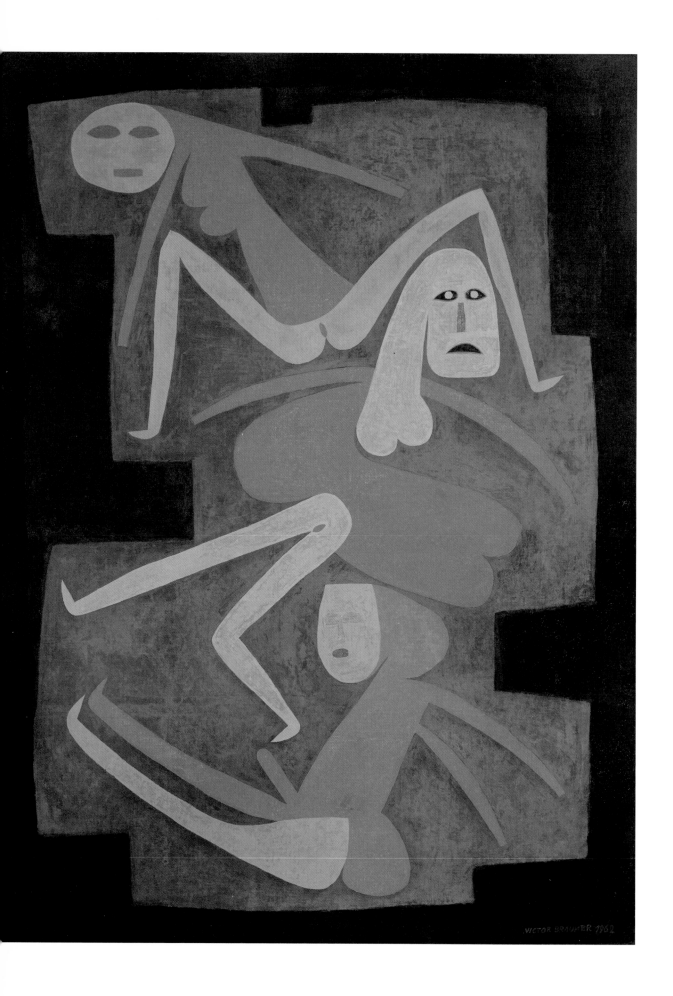

Victor Brauner, 1962

Arshile Gorky, c. 1930

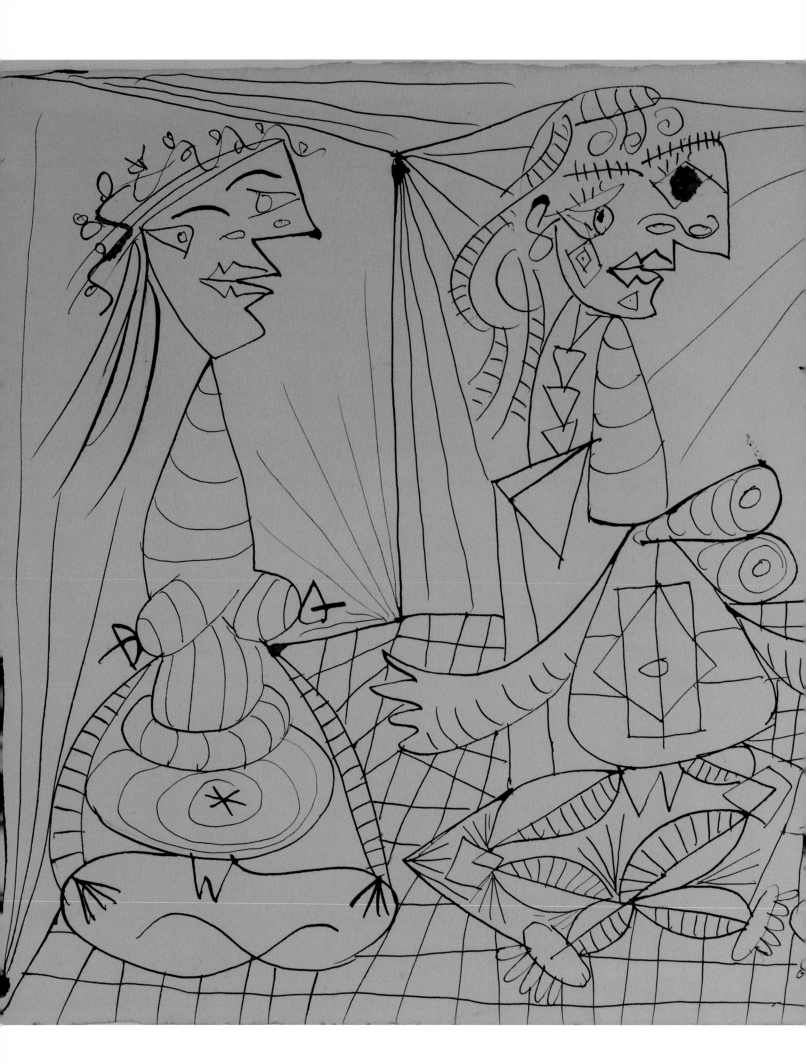

Pablo Picasso, Trois Femmes, 1938

British-born wife of Pierre Leyris, a poet and translator of the English classics who had been a schoolmate of Pierre Klossowski, Balthasar's brother. Balthus lodged with them during the winter of 1932-33, his first in Paris, and painted just a handful of pictures documenting that sojourn. In its classical composition and the comportment of the figure, this work recalls the earliest independent European portraits by artists such as Andrea Mantegna and Domenico Ghirlandaio. Compared to such obvious prototypes, however, the facial expression of Madame Leyris is unsettled by anxiety, even sadness, and thus she seems to share the tragic vulnerability of Jacques-Louis David's female sitters painted during his (and often their) exile in Brussels from 1814 to 1825.

If the Balthus portrait is somewhat disturbing, its effect is superseded by that of Jean Dubuffet's *L'Operat* of 1961, for this feverishly executed painting is a life-sized depiction of a dwarf dressed in the manner of a court jester; he is most likely *une polichinelle*: a clown in a circus or cabaret act. His grotesquely large head and appendages, especially his deformed legs, immediately conjure recollections of masterpieces by seventeenth-century Spaniards such as Jusepe de Ribera and Diego Velázquez. These artists painted dwarves, club-footed children, and even more startling anomalies of nature (such as Ribera's *Bearded Woman of Seville*) not as freaks but as singular manifestations of the diversity of God's creation. Physical abnormalities notwithstanding, such sitters were accorded a full measure of dignity by their illustrious portrayers. In the best vein of this European tradition, Dubuffet similarly demands the viewer's respect for his subject, even though the first reaction might be to look elsewhere: as the poet James Fenton wrote of Joseph Cornell, even the most devoted admirer must sometimes look away when "the pathology glints from the depths." That so powerful a work enjoys pride of place in the Cohen Collection bears witness to the owner's profound humanity and essential, abiding goodness.

Roger Ward

Jean Dubuffet, L'Operat, 1961

Frank Stella, 1982

Joan Mitchell, 1974

Julian Lethbridge, 1995
Left: Charles Demuth, c. 1915

Ladies in armchairs

In the autumn of 1932, after an absence of nearly two years, Balthus (Balthasar Klossowski, 1908-2001) returned to Paris. Most of his time away was spent in military service in Kenitra, a small town in northern Morocco. Lacking a place of his own in the city, he was glad to find refuge with his good friends the French writer and poet Pierre Leyris (1908-2001) and his English wife, Betty (1908-97), staying with them for the entire winter of 1932-33. Balthus knew Pierre Leyris through his older brother Pierre Klossowski, when both Pierres had been schoolmates at the Lycée Janson-de-Sailly in 1924-25. In December 1932 Balthus wrote to a friend: "Since my return I live with my best friend Pierre Leyris (I think I mentioned him to you already), it is just for the time being, but very nice for me. I can work well here, at least on my drawings, for painting the light is not good enough."

Even though he complained about the light not being "good enough" for painting at the Leyrises, while living with them he did create two portraits of Pierre, a double portrait of Pierre and Betty Leyris, and the portrait of Betty in the Joseph M. Cohen Collection. Pensively looking away, she sits in an elegant Louis Philippe armchair. Her perfectly oval face is expressionless. The detached haughtiness, prim pose and high-necked luminous green dress betray her upper-class English origins. The painterly, flickering taupe background and starkly simple composition might have been inspired by portraits of Jacques-Louis David that Balthus studied on his frequent haunts in the Louvre.

During my conversation with Betty Leyris in Paris in 1980, the then seventy-five-year-old Betty revealed, for the first time, that she had also posed for *Alice*, 1933 (Musée national d'art moderne, Centre Georges Pompidou, Paris), one of the five provocative paintings that Balthus presented in his first exhibition at the Galerie Pierre Loeb in Paris in the spring of 1934. The show caused what the period liked to call a "scandal." In these works Balthus took familiar subjects — a street scene, a girl at a window, in front of a mirror, at

Babs and I saw our first Balthus painting at a friend's home in 1979.
We could not afford one then. When we could, we did not hesitate.

Balthus, Betty Leyris, c. 1933
Arshile Gorky, Enigma and Nostalgia, c. 1932

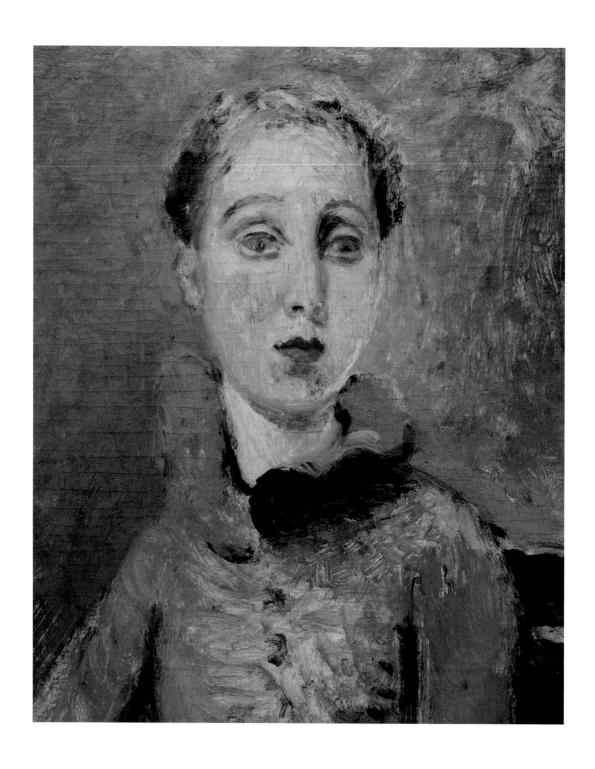

Balthus, Betty Leyris, c. 1933 (detail)

I always feel the desire to look for the extraordinary in ordinary things; to suggest, not impose, to leave always a slight touch of mystery in my paintings.

Balthus

her toilette, or taking a music lesson — and subverted them, turning them into scenes of hard-edged eroticism with a sadomasochistic undercurrent. In a sleight of hand so typical of Balthus, he had the prim and proper Betty Leyris pose as the stark, semi-naked young woman in *Alice*. Her attire consists of black pumps and a skimpy slip, with a leg raised on a chair, revealing her sex and one large breast. The woman's sexual accessibility is contradicted by the remote expression in her cloudy green eyes, similar to Betty's haughty expression in the Cohen work. In this portrait Betty sits in her apartment. In the slightly later *Alice*, she stands in the artist's first studio, a fifth-floor walk-up at 6, rue de Furstenberg where he had moved in May 1933.

Betty Leyris was an artist in her own right. She was a fine draftsman and watercolorist, and created exquisite petit-point still lifes of naïve charm that she exhibited until the 1980s. Her husband, Pierre Leyris, was one of the most respected translators of English and American literature, renowned for his translations of Shakespeare, Melville, T. S. Eliot, Yeats and Dickens, among others. Both Pierre and Betty remained close friends with Balthus until the artist joined a different social set.

The semi-dressed model lounging in the high-back Louis Philippe chair in Balthus's *Seated Woman in Armchair*, 1937, is the twenty-five-year-old Antoinette de Watteville (1912-97). The drawing is one of three studies for the large painting *The White Skirt* (currently also in a

private collection). This time around the setting is the artist's second-floor studio at 3 Cour de Rohan, near the Place l'Odéon where Balthus had moved in October 1935. He painted *The White Skirt* in 1937, the year he finally married Antoinette de Watteville, after a courtship lasting seven years. Antoinette and Robert, one of her brothers, had been friends of Balthus since the late 1920s and he stayed at their family mansion when visiting Bern. Poor, unknown, and with few prospects at that time, Balthus had little to offer as a suitor when Antoinette had become engaged to a diplomat. Fortunately for him, she broke her engagement and settled in Paris sometime in 1934. Balthus's moving attempt to win Antoinette back by writing to her comes vividly alive in their published correspondence, consisting of 238 letters spanning the years 1928 to 1937. Balthus meant his letters as "seduction." They reveal his fine intelligence, often surprising wisdom for someone so young, sensitivity, pride, sense of isolation and notions of grandeur. Antoinette comes across in her letters as a disarmingly childlike, lively and down-to-earth privileged woman. Their marriage lasted until 1946 although they did not divorce until 1966. Their marriage produced two sons, Stanislas and Thaddeus.

In the Cohen drawing Balthus rendered with bold, forceful pencil strokes Antoinette's nonchalant posture, inclined head, and outstretched long legs. Thick black cross lines emphasize her thick russet-blond tresses. When I visited Antoinette de Watteville in December 1979, she still owned the large painting of her. Seated next to it, she explained that the "white skirt" she wears in the picture was an old flannel tennis skirt that once belonged to her mother. In the drawing her open blouse reveals her naked breasts, but in the painting they are covered by a semitransparent brassiere. "I did not want my breasts exhibited in a museum," she declared emphatically, some forty-two years after posing for the picture. She then admitted that she regretted her decision.

Sabine Rewald

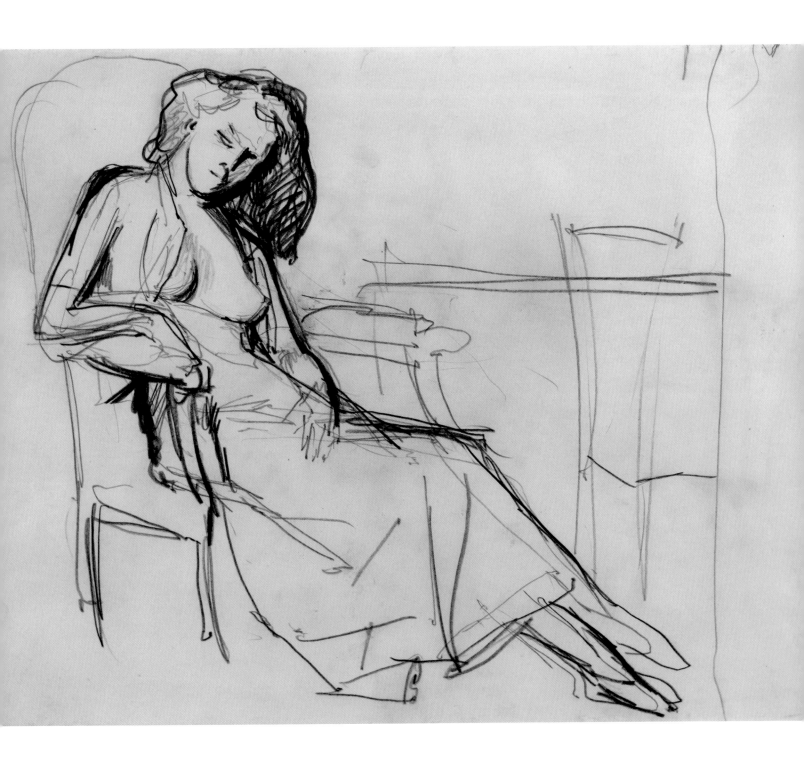

Balthus, 1937

111

Eric Fischl, 1990

Art deals with issues of what it is like to be human on the most compelling and highest level. Photography and painting, however, approach it quite differently. A photo witnesses a moment. A painting gets there more slowly and with more subjective elements. It is not something that is taken from our world. It is something that is put in.

Eric Fischl

George Romney, Lady Wray, c. 1780

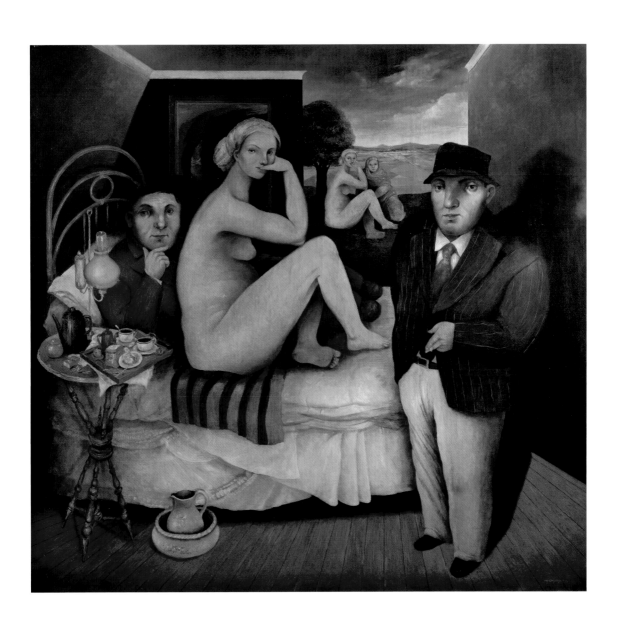

Gonzalo Cienfuegos, 1977

116 David Hockney, 1972

Art doesn't transform. It just plain forms.
Roy Lichtenstein

Sculpture

A saddled horse - tang dynasty art

Funerary Sculpture Representing a Saddled, Bridled Horse Standing Foursquare, Its Head Raised to Neigh

The late Sherman E. Lee, renowned art historian, esteemed connoisseur of Asian art, and revered former director of The Cleveland Museum of Art, once quipped that only a few Tang horses and camels actually rise to the level of work of art, the rest now best serving humanity as lamps and ornaments on grand pianos. The magnificent chestnut steed in the collection of Joseph M. Cohen not only rises to the level of work of art but stands as a signal masterpiece of the genre. The Cohen horse is special on five counts: its superior modeling, unusual stance with head raised high to neigh, descriptive use of color, embellishment with cobalt-blue glaze, and successful control of glazes of multiple colors.

The horse, more specifically, the Mongolian pony, which is also called Takhi, or Przewalski's horse,[1] was known in China in remote antiquity and had been domesticated by late Neolithic times.[2] The early Chinese used horses as animals of traction, to pull the vehicles of ministers and the chariots of warriors. By the late fourth century B.C., the Chinese had learned to ride and soon thereafter mastered the art of equestrian warfare. Late in the second century B.C., the Han Emperor Wudi secured a number of large and magnificent steeds from Ferghana (in modern-day Uzbekistan, Kyrgyzstan and Tajikistan). Noble mounts indeed, they were akin to today's Arabian horses. From the Han dynasty (206 B.C.–A.D. 220) on, ownership of fine horses conferred great status. Regarded as semidivine in origin and as a vehicle for carrying the spirit on its journey to the next world, the horse began to be portrayed among tomb sculptures during the Warring States period (481–221 B.C.) and remained a popular subject through the Tang dynasty (618–907).[3]

Like most horses included in the repertory of ancient Chinese funerary sculptures, the horse in the Cohen Collection depicts a descendant of the grand *qianli ma,* or "thousand-league

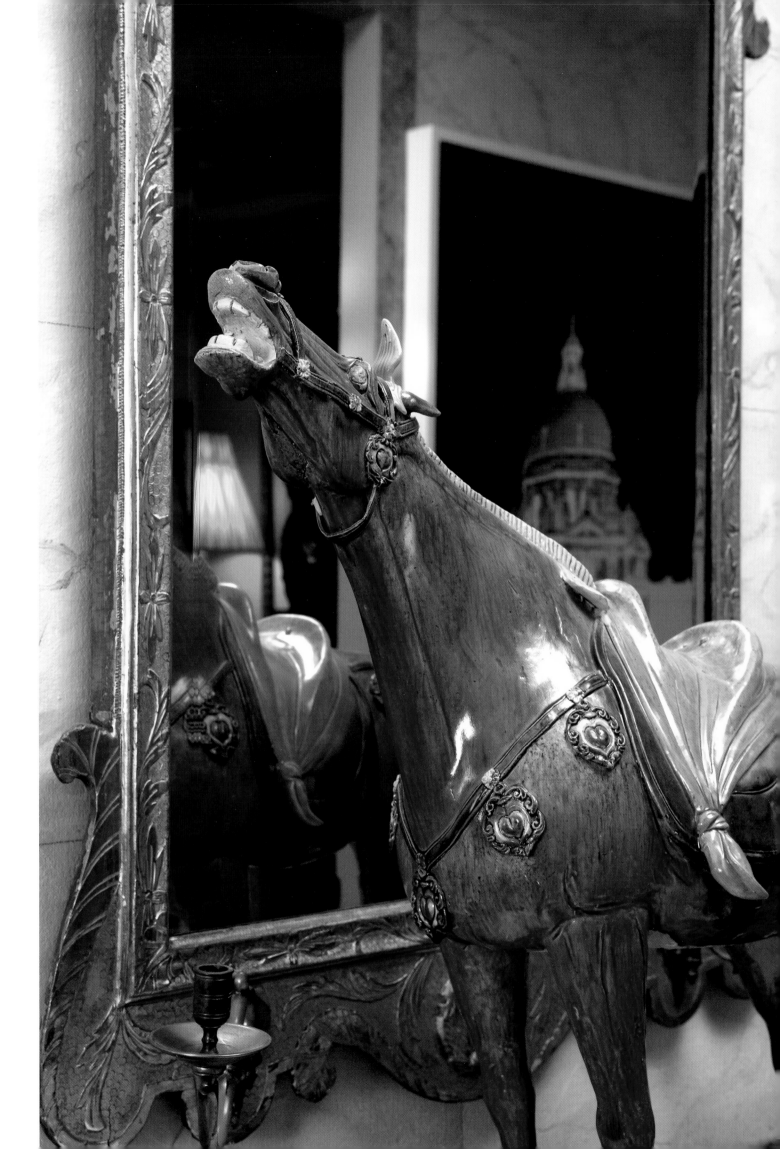

horses," imported from Ferghana in the second century B.C. [4] Much larger and stronger than the Mongolian ponies previously used in China, the horses from Ferghana gave the Chinese military superiority over their enemies, so that such horses came to symbolize power and authority. Of course, the high cost of such horses quickly established them as emblems of wealth as well. During the Han and Tang periods, the majority of the imported horses and their descendants — which doubtless numbered fewer than 10,000 at any given time — belonged to the imperial stables. A small number were in the hands of selected noble and aristocratic families, ownership perhaps granted in recognition of military valor or service to the emperor.

The size, the quality and the presence of the rare cobalt-blue glaze all suggest that the Cohen Collection horse must have come from the tomb of a high official who lived during the Tang dynasty. The official doubtless owned spirited chargers of foreign ancestry, precisely the type that inspired this sculpture.

The use of cobalt-blue glaze, in particular, is the most telling evidence for dating this horse to the first half of the eighth century. Though cobalt was known as a mineral long before the Tang dynasty, Chinese potters discovered its potential as a coloring agent for creating blue glazes only at the end of the seventh century. The pure, high-quality cobalt used for ceramic glazes imported into China from the Near and Middle East was very expensive. Yet many families impoverished themselves through the lavish provisioning of tombs for their departed members — particularly with vessels and sculptures sporting costly cobalt-blue glazes. As a result, the government enacted sumptuary laws in the mid-eighth century to curtail the use of these glazes, so that most blue-glazed pieces can be dated to the first half of the eighth century. The results of a thermoluminescence test performed on a sample taken from the Cohen horse are consistent with the eighth-century dating proposed here. [5]

The Cohen sculpture's relaxed naturalism and elegant proportions also point to the first half of the eighth century, as do the blocked mane, dressed tail, small rectangular base and white earthenware body. In characteristic Tang fashion, the horse is fully charged with life; though standing foursquare, the magnificent steed raises its head high to trumpet a neigh, evincing an inner life. Characteristically molded in gray earthenware,[6] funerary sculptures of earlier periods tend to be stylized and somewhat abstract, emphasizing geometry of form. In addition, they generally represent animals as types rather than as individualized beings, just as they typically portray horses in conventionalized stances — standing or galloping, for example. By contrast, Tang pictorial arts — whether Buddhist sculptures, secular paintings, or burial figurines — strive for naturalistic representation and the projection of a "personality" through specific actions associated with a particular animal; thus, a dog might bite a paw to relieve an itch or a horse might stamp the ground in anticipation of a swift gallop. The Cohen horse raises its head to neigh, perhaps to acknowledge the presence of its master or to communicate with a mate. Although such observed actions are an integral element of Tang art, the depiction of a horse in the act of neighing is quite rare. In fact, only one other glazed example is known: a standing horse in the collection of the Nelson-Atkins Museum of Art, Kansas City, Missouri.[7]

Chinese potters began the widespread use of lead-fluxed glazes during the Eastern Han period (25–220), creating emerald-green and caramel-brown glazes that they applied to low-fired funerary wares, mainly to vessels but occasionally also to burial sculptures.[8] Low-firing, lead-fluxed glazes fell from favor after the collapse of the Han dynasty in 220 but were revived in north China during the second half of the sixth century. In the sixth century, lead glazes, as they are informally known, were applied to burial wares — mostly to vessels but occasionally to sculptures — and they typically were monochrome, with straw-yellow predominating but also with emerald-green and caramel-brown. Tang potters not only

This molded, glazed funerary sculpture represents a large chestnut-hued, Arabian-type horse standing foursquare, its neck outstretched, its head raised, and its mouth open to neigh. The alert steed looks forward, its elevated head, arched eyebrows, and open mouth imbuing the animal with vitality. The spirited stallion's tail has been dressed and bound, his mane blocked, and his forelock combed in a single hornlike tuft. Naturalistically modeled and descriptively colored, the horse's body boasts a coating of caramel-brown glaze, while his mane, forelock, tail, and hooves sport an application of pale, straw-yellow glaze. Details of the saddle are indistinct because of the ochre-yellow cloth carefully placed over it to cushion the seat; knotted at either side, the cloth constricts to reveal the emerald-green saddle blanket below. The interior of the horse's mouth might well have been cold-painted—that is, embellished with mineral pigments after firing, the pigments adhered with hide glue—though no trace of such embellishment remains today. The bridle and the chest and crupper straps exhibit cobalt-blue glaze and feature foliate medallions in cobalt-blue and emerald-green, the medallions showing meticulously defined elements within that appear white because they sport clear, colorless glaze that reveals the underlying white earthenware body. The horse's head, legs, forelock, mane, and tail are solid, while its neck and body are hollow; the long rectangular opening in the belly—concealed from view by the horse's full, rounded sides—affords access to the interior and allowed the potter to press the moist clay into the mold's hollows. Indeed, the potter's finger- and palm-prints are visible in the unglazed clay of the cavity's walls. Acting as a brace, or strut, the small, rectangular base lends strength and structural stability to the sculpture, which otherwise would rest only on its four slender legs; the unglazed base shows localized areas of glaze that pooled there after running down the legs during firing. As with most Chinese funerary sculptures, this horse has been damaged and repaired.

Fine Chinese Ceramics, Paintings and Works of Art, catalogue of an auction held at Christie's, New York, on 21 March 2001; sale number 9388, lot 275.

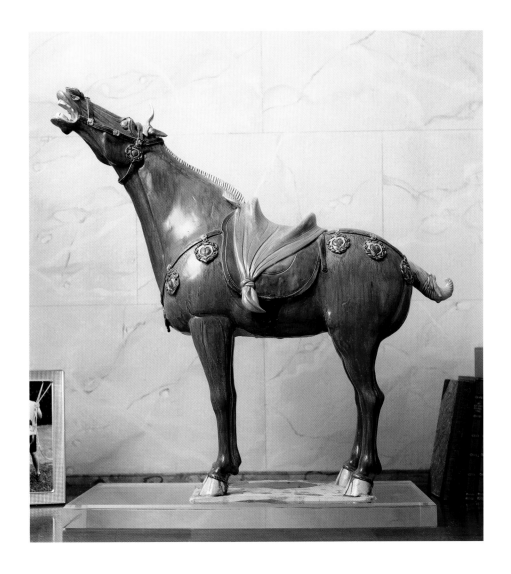

continued but increased the use of lead glazes for tomb sculptures and vessels alike. In addition, by the late seventh century, they had begun to embellish individual pieces with glazes of several different colors to create the so-called *sancai,* or "three-color," glazes.[9]

In addition to their numerous monochrome lead-glazed horses, Tang potters also produced *sancai*-glazed horses during the eighth century, the *sancai* examples often exhibiting pale straw-yellow glazes splashed with caramel-brown but also, and very improbably, sometimes with emerald-green or cobalt-blue splashes. Only rarely were multicolored glazes deployed in such a naturalistic and descriptive manner as in the Cohen horse.

Apart from lowering a glaze's melting temperature and intensifying its color, lead fluxes had the disadvantage of reducing a glaze's stability, thereby increasing its tendency to run and

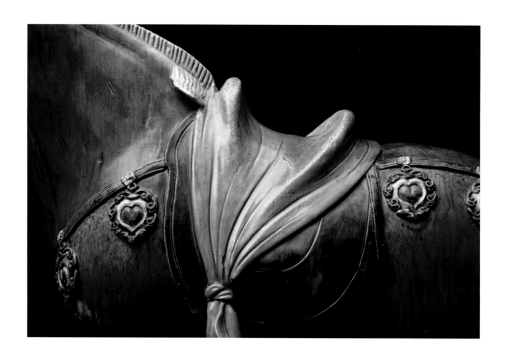

drip as it melted during firing. The splashes of color in *sancai* glazes thus typically have ir-regular, blurred edges and, at least in some instances, colors run together — sometimes with happy results, sometimes not. It doubtless was the difficulty of keeping colored glazes in their proper places and separate from one another that delayed the descriptive use of *sancai* glazes until the Jin dynasty (1115–1234), except in the most unusual circumstances, as in the Cohen horse.

To control lead-fluxed glazes during firing, Tang potters typically incorporated intaglio ele-ments and appliqué ornaments, particularly on vertical surfaces. The intaglio lines and the relief appliqués arrested the flow of a melting glaze and effectively acted as barriers between glazes of different colors. In the Cohen horse, for example, the chest and crupper straps, which stand in relief, retard the downward movement of the caramel-brown glaze. The incised lines bordering the bridle and the chest and crupper straps contain the cobalt-blue glaze, and the foliate medallions' thick, molded borders serve to hold the blue and green glazes in their proper places. In addition, the intaglio lines bordering the inner and outer edges of the saddle blanket contain the ocher-yellow and emerald-green glazes. Even so, green glaze has run from the saddle blanket onto the horse's belly, just as blue glaze has run from the bridle onto the horse's proper left cheek. Caramel-brown glaze has run onto the lowermost foliate medallion on the horse's chest, overwhelming the medallion's blue, green and clear glazes. Most noticeable of all, the lack of any intaglio or relief elements allowed the caramel-brown glaze to cascade down the horse's long legs, over the hooves and onto the rectangular base, where it pooled. But in the context of Tang *sancai*-glazed funerary sculptures, the Cohen horse's melding of glazes is but a minor transgression. In fact, the unusual stance, superior modeling, descriptive use of color and successful control of glazes of multiple colors distinguish the Cohen horse from other Tang horses and elevate it to the rank of masterpiece.

Associated with death and burial, rather than with art, and almost unknown elsewhere before the late nineteenth century, Chinese ceramic funerary sculptures came to world attention over the course of the twentieth century, brought to light by chance discovery and controlled excavation. Today, virtually everyone interested in art recognizes Tang horses and the life-size terra cotta warriors from the trenches surrounding the tomb of Qin Shi Huangdi, the first emperor of the Qin dynasty (221–206 B.C.).[10]

From earliest times, the reasons for provisioning tombs with burial goods were four: to provide food, water and wine to sustain the spirit of the deceased in the next life; to provide a variety of humans and animals to serve, entertain and amuse the deceased; to provide guardians to protect the corpse and the spirit of the deceased on its journey to the next world, and to protect the tomb itself from invasion, desecration and robbery; and to provide a sufficiently great quantity of food, sculptures, and luxury and other burial goods to establish beyond all doubt the wealth, importance and elevated status of the deceased — whatever that status actually was in the temporal world — so that he or she would not only repose in glory but also be appropriately received in the next world. During the Neolithic period, provisioning the grave with food and drink seems to have been of paramount concern. However, by the Shang dynasty (c. 1600–c. 1050 B.C.), the other functions rapidly ascended in importance. With its thousands of life-size horses and armor-clad warriors, the so-called terra cotta army buried around the monumental tomb of Qin Shi Huangdi, near present-day Xi'an, in Shaanxi province, reflects an early preoccupation with protecting the tomb from demons, evil spirits and human intruders.

Already in Neolithic times, graves had been furnished with vessels filled with grain, water and wine to nourish the spirit of the deceased. By the Shang and Zhou dynasties (c. 1050–221 B.C.), elaborate funerary ceremonies had evolved that required the use of jade

implements and bronze ritual vessels. Shang ceremonies sometimes involved human and animal sacrifices as well, the animals including elephants, rhinoceroses, horses, oxen, pigs and dogs, among others. In fact, remains of two- and four-horse teams hitched to chariots have been excavated from Shang-dynasty royal tombs at Anyang, Henan province. Burial figurines of wood were used in the south during the Warring States period (481–221 B.C.), perhaps as substitutes for the sacrificial victims of earlier times. Burial sculptures of fired ceramic ware, used infrequently in the north in the fifth and sixth centuries B.C., became a standard feature of tomb furnishings in the north in the late third century B.C. That date marks the beginning of a long, continuous tradition of provisioning tombs with ceramic funerary sculptures, a tradition that would persist into the Tang dynasty.

The earliest ceramic tomb sculptures produced in any quantity — those of the Qin and Han dynasties — represent warriors and horses. Intended to protect the tomb from demons and intruders while at the same time symbolizing the wealth, political power and military might of the tomb occupant, they depict ethnically Chinese figures in native attire. The repertory of subjects expanded during the Han dynasty to include court attendants, entertainers and barnyard animals. By the sixth century, not only had the range of subject matter expanded further, but it reflected influences from India, Persia and Central Asia that reached China via the Silk Route. Those influences manifest themselves most forcefully in the foreign faces and clothing styles of the guardians, merchants and grooms represented and also in such ornamental details as the foliate medallions that embellish the bridle and the chest and crupper straps of the Cohen horse. All of these elements reflect a cosmopolitanism that culminated in the exceptionally naturalistic sculptures from the Tang dynasty.

During the Tang dynasty, China was the undisputed leader of the world, and her capital, Chang'an (present-day Xi'an), the world's largest, richest, most cosmopolitan city. As a

wealthy, sophisticated metropolis and as the eastern terminus of the Silk Route, Chang'an was a magnet for a multitude of non-Chinese visitors, traders and religious mendicants. Chang'an had not only great Buddhist temples and monasteries but sizable communities of Muslims, Jews and Nestorian Christians as well, adding to the religious and intellectual fervor of the day.

Major changes in burial customs after the Tang dynasty led to a significant decrease in the use of funerary sculptures. The Chinese began to burn paper replicas of the goods they wished to offer the deceased, in the belief that the smoke from the burnt offering would convey to the next world the essence of the image burned, whether a horse, guardian warrior or gold ingot — or, in contemporary times, a Mercedes, laptop computer, mobile phone or satchel brimming with "play money." Thus, what had been a major tradition for more than a thousand years suddenly became a minor tradition, with a commensurate decrease in the artistic vitality of the later sculptures. The long period from Han through Tang thus represents the "Golden Age" of the Chinese funerary sculpture tradition, with sculptures of the eighth century, and particularly the first half of that century, standing as the culmination of that tradition.

Robert D. Mowry

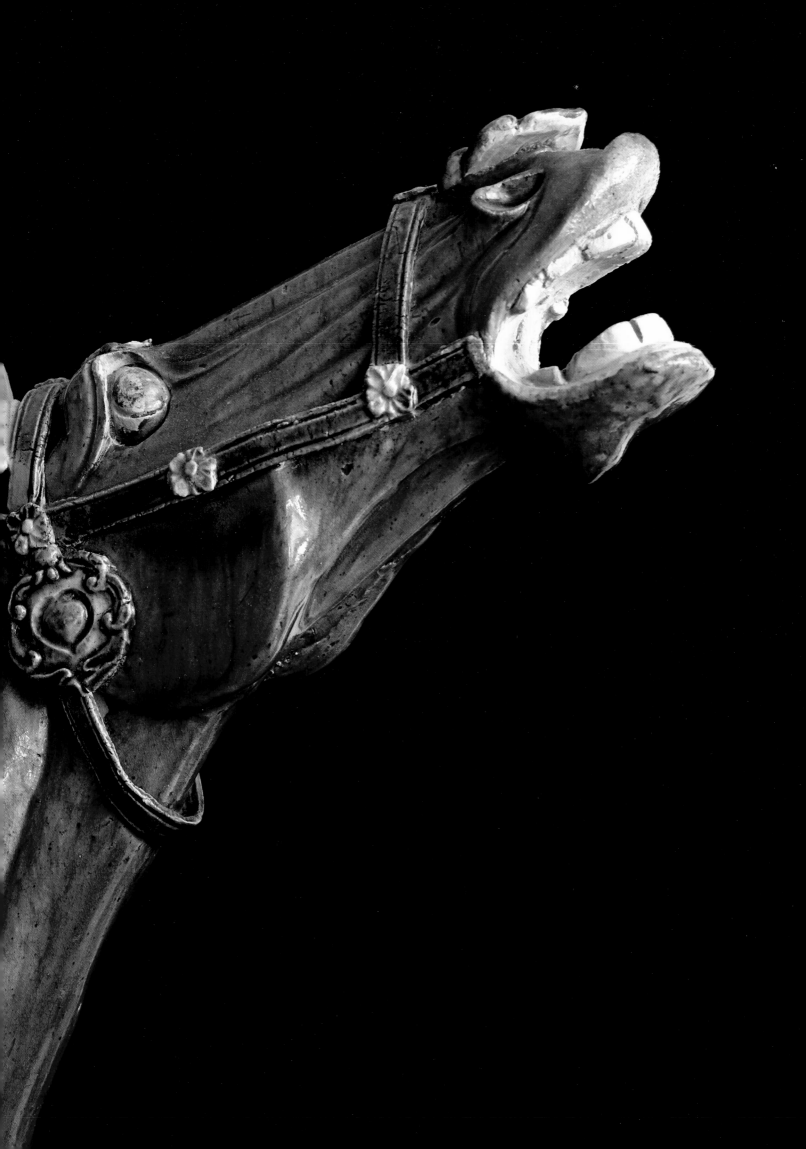

ENDNOTES

1. Although the Russian geographer and explorer of Central and Eastern Asia Nikolay Mikhaylovich Przhevalsky (1839-1888) spelled his surname as indicated here, the species of wild horse that he described and that is named in his honor is generally termed Przewalski's horse.

2. For information on the history of the horse in China, see Edward H. Schafer, *The Golden Peaches of Samarkand: A Study of T'ang Exotics* (Berkeley, Los Angeles, and London, 1963), pp. 58-70; Herrlee Glessner Creel, "The Role of the Horse in Chinese History," *What Is Taoism? and Other Studies in Chinese Cultural History* (Chicago and London, 1970), pp. 160-186; Robert E. Harrist and Virginia L. Bower, *Power and Virtue: The Horse in Chinese Art,* exh. cat., China Institute Gallery, China Institute in America (New York, 1997); International Museum of the Horse, compiler, *Imperial China: The Art of the Horse in Chinese History,* exh. cat., Kentucky Horse Park and International Museum of the Horse (Lexington, Ky., 2000).

3. See Barbara C. Banks, "The Magical Powers of the Horse as Revealed in the Archaeological Explorations of Early China," unpublished doctoral dissertation, University of Chicago (December 1989).

4. In Han-dynasty texts, such horses sometimes were also referred to as *tian ma,* or "heavenly horses," and as *hanxue ma,* or "blood-sweating horses."

5. TL tested at Oxford Authentication Ltd., Oxford, England, U.K., sample number C199h20.

6. Generally fired in the range of 800 to 900 degrees Celsius, earthenware employs relatively humble clays and is considered low-fired ceramic ware. Earthenware comes in a range of earth tones but typically is gray or buff in color but occasionally is white (due to the use of pure white clay) or black (due to the utilization of special firing techniques, particularly carbon saturation). Whether shaped as vessel or sculpture, unglazed earthenware is porous; by contrast, the bodies of such high-fired ceramics as stoneware (fired at 1100-1200˚C) and porcelain (fired at 1300-1400˚C) vitrify during firing so that they are impervious to liquids, even without glaze.

7. See Nelson-Atkins Museum of Art, compiler, *The Nelson-Atkins Museum of Art: A Handbook of the Collection* (New York and Kansas City, Mo., 1993).

8. As a fluxing agent, a compound of lead added to the glaze slurry in small measure both lowers the firing temperature of the resulting glaze mixture and intensifies the glaze color. The primary function of the fluxing agent, though, is to lower the firing temperature, so that low-firing earthenwares can be coated with colorful glazes.

9. In literal translation, *san* means "three" and *cai* means "color," hence the English-language term "three-color glaze" for "*sancai* glaze." It should be noted, however, that in this context *san* means "several" or "limited number" rather than "three," so that *sancai* also could be properly translated as "variegated." Thus, *sancai*-glazed wares do not necessarily exhibit three colors; rather, they may have two colors, just as they may have three or four. The glazes range from colorless (read as white when over a white earthenware body), green (from copper as coloring agent), blue (from cobalt), and straw-yellow, caramel-yellow, and dark brown (all from varying amounts of iron).

10. For information on the history of Chinese funerary sculptures, see Ezekiel Schloss, *Ancient Chinese Ceramic Sculpture from Han through T'ang* (Stamford, Conn., 1977); Robert D. Mowry and Virginia L. Bower, *From Court to Caravan: Chinese Tomb Sculptures from the Collection of Anthony M. Solomon,* exh. cat., Arthur M. Sackler Museum, Harvard University Art Museums (Cambridge, Mass., and New Haven, Conn., 2002).

Renewal and sensibility

One of the most satisfying endeavors for a collector of sculpture is to view a relationship of diversely imaginative forms within the context of a carefully designated three-dimensional space. Whether these forms (and installations) are placed out-of-doors or indoors or between doors, straddling on the edge of perception, intelligent works created through the medium of sculpture hold the capacity to satisfy the human eye. They satisfy the human eye as physical forms as they exist autonomously in the world of actual space and time. Sculptures can exist either within nature or within a culturally activated urban metropolis. They may be part of the constructed environment in a public space, such as an office lobby or museum gallery, or, on the contrary, they may be enjoyed within the intimacy of one's domicile. There are few limits as to where sculpture can be placed. While some artists work with multiple forms within a site-specific context, others produce singular or relational forms within the context of their studios or factories. In either case, what distinguishes a good collection of sculpture also varies according to intention.

Some collectors are interested in abstract forms, whether reductive, formal, or maximal, while others go for a type of representation that encompasses oblique stylizations of the human-animal figures. Such stylizations may be volumetric or linear, obtuse or expressive, narrative or allegorical. Still others focus on minimal and site-specific sculpture that began in the sixties and seventies and has continued to evolve and influence new hybrid forms and

Nicola Hicks, French Bulldog, 2003
Left: Tony Cragg, 1997

materials in the twenty-first century. The history of contemporary sculpture over the past half century has led to an "open proposition" — a term I first encountered through the American sculptor Richard Serra — where the structure of materials moves in many directions simultaneously. Sculpture can now be permanent or temporary, synthetic or natural, linguistic or existential, romantic or classical, hard or soft, opaque or resplendent, static or kinetic, or any variation or permutation in between. In contrast to the sculpture of the past, there are no restraints as to the definition of what constitutes sculpture.

Yet an open proposition in sculpture does not necessarily relinquish the need for a clear sense of criteria in determining what is significant. With an evolved multiculturalism based in multiethnic roots, it is inevitable that sculpture will remain to some extent an open proposition. This plurality of differences has been evidenced in recent biennials ranging from Venice to São Paulo, from Documenta to Istanbul, from Gwangiu to Yokohama, from Dubai to Shanghai. The mixture is both serious and extravagant, both focused and self-indulgent. One problem with this new openness is the lack of a historical understanding of the various cultures where artists live or have lived in the process of producing these forms.

Even in Europe and the United States there are traditions and movements that belong to modernism still not well recognized or understood by some viewers, including those who write detailed and abstruse theoretical texts about them. As a result, works based on standards of real significance are often put aside in favor of trendsetting works that include mediocre spectacles sanctified by enormous prices at the recent auctions. While important historical works from the late twentieth century will sell in the hundreds of thousands, "postmodern" works from the destabilized twenty-first century may sell in the hundreds of millions. This suggests the absence of a clear sense of criteria in art between the two

James Jackson Burt, 1990

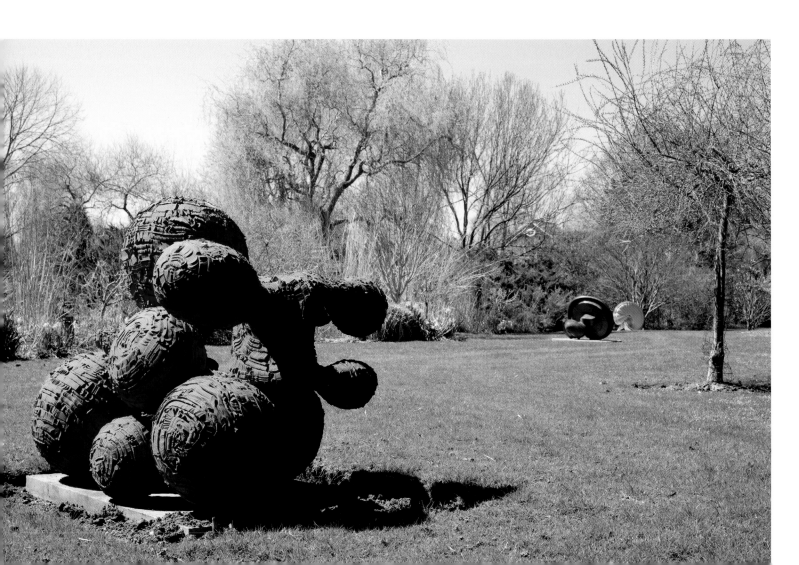

*I always have rules about what I'm doing and the game has
become to break the rules, but on my own terms.*

Tony Cragg

centuries, the absence of a bridge that enables aesthetic values to pass seamlessly from one generation to another. Late modernism appears to have been diminished by over-emphasizing the information media as a source of understanding aesthetic significance in works of art. While it appears the majority of trends will not last, important works of sculpture are often cited by the critical news media as if they are on the defensive.

Even so, the history of contemporary sculpture is moving forward with brilliant artists producing some of the best works of their careers. I mention this within the context of the Cohen Collection, because I have little doubt as to its importance. Mr. Cohen is impressed by neither superficial trends nor high prices. Rather he focuses his collection on what he likes, not in the sense of an arbitrary opinion, but through reflection and time. He makes actual judgments — what used to be called criticism — before agreeing to bring a new sculpture into the fold of his collection. He will often assimilate works by artists he likes — Tony Cragg, George Rickey, Barry Flanagan — rather than splintering his collection into fragments. He is less interested in a particular style than in identifying the various visual and conceptual threads that are woven into the fabric of his collection, threads that connect the disparate works into a unified whole. The result of this magnanimous effort is to create a collection that resonates (to employ a good "modernist" word) with feeling and thus surprises viewers who may not be familiar with some of the sculptors or the works that he collects.

I first met Joseph Cohen at a reception for the sculptor Tony Cragg sponsored by gallery owner Marian Goodman. Joe was seated at a large table across from the artist. I introduced

myself and was invited to sit down next to them. An animated conversation on art began that continued throughout the dinner. While people often exchange business cards at these affairs with every intention of meeting again, I have discovered it is rare that these well-intended meetings ever occur. Much to my satisfaction, Cohen and I began to meet on a regular basis, undeterred by our relatively frequent travel schedules. Given the opportunities I have had to view his collection, I have come to respect his point of view as a collector and to understand his passion toward the objects he collects.

Beginning with Cragg, there are five works in the Cohen Collection, ranging over a decade from 1997 to 2007, each in bronze. In his work Cragg attempts to close the gap between the formal and conceptual languages in art through a commitment to recent technological advances. He believes that we are at an evolutionary stage where artists are "thinking with materials," that is, thinking in the act of manipulating material processes as an extension of language. In one of his lectures from 1995, Cragg explains: "The material is what we are a result of, this is where we came from and this is where we find ourselves; we define ourselves and our cultures in the material."

In the early eighties, Cragg was making morphological scatter pieces — fragments of broken colored plastic, either placed on the wall or floor as installations. In more recent years, he has gravitated toward casting singular or bifurcated forms in bronze. This suggests a transition from conceptual impermanence to the formal permanence. His interest in painted or textured bronze is revealed in three of the five forms in the collection. The two that are not painted include the earliest, *Wirbelsaule* (1997), and another, *Tall Bronze Head* (2002). Each unpainted bronze is a vertical stack of discs of varying diameters adhered together as single whirling, tornadolike forms.

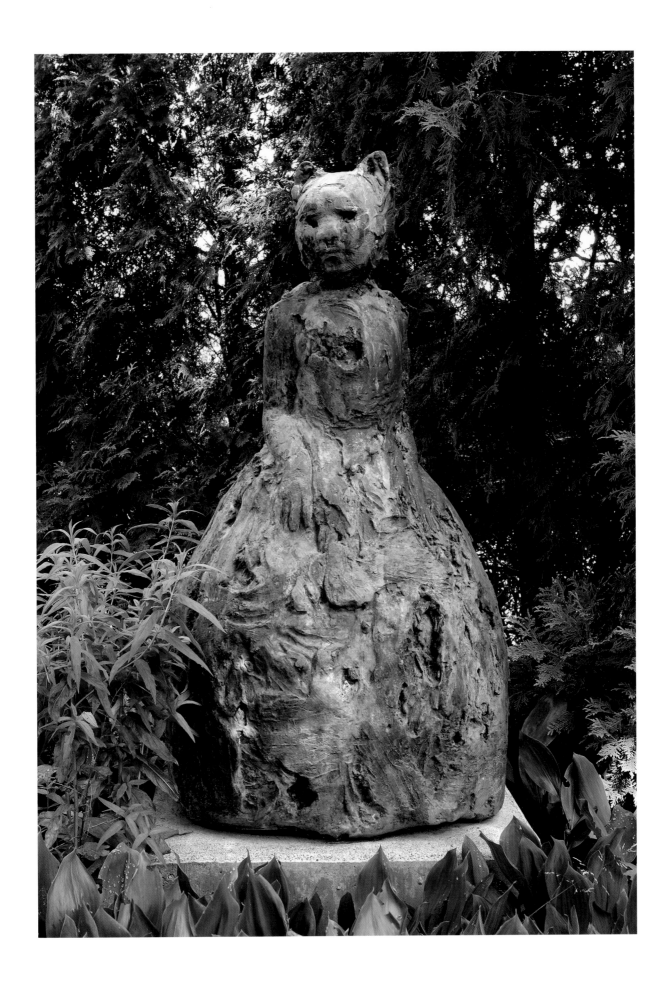

Nicola Hicks, 1998

There is a nice story about the hare. Among all the animals, given his position in the Japanese moon, the hare is revered. As a favor for the gods, who demanded some sacrifice from him, the hare made a barbecue of himself. Imaginative solutions love mystery.

Barry Flanagan

Barry Flanagan, 1994 (detail)

Tall Bronze Head is a more distended sculpture in that the discs are more exaggerated and more involved with trying to create an illusion of a profile, an idea that was also present in Italian Futurist sculpture in the early twentieth century.

As for the three painted bronzes — *Formulation (Right Turning, Left Turning)* (2000), *Green Early Forms* (2003) and *Outspan* (2007) — Joe has placed them equidistantly in an open yard space that gives them a sequential relationship as the eye reads them as biomorphic, alien, sci-fi components within the realm of nature. In essence, the five Craggs are all abstract. One can, of course, make interpretative associations as in *Tall Bronze Head* or the nipple podlike forms in *Formulation*, but the final result of these readings is still more about abstract form or the tension between abstraction and representation than any narrative or allegorical content.

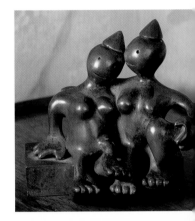

Other bronze works are those by Tom Otterness, Barry Flanagan, Henry Moore, Nicola Hicks and César. The five works by Otterness are relatively small and are placed on tables. Like the cast miniature caricatures of urban dwellers commissioned for a subway station at Eighth and Fourteenth in Manhattan, works such as *Man Sitting on Pennies* (1990) and *Couple with Pennies* (1990) suggest an allegorical impulse, a fractured metaphor of American wealth and frugality that is both ironic and absurd in its displacement from the twenty-first century. Rather than the

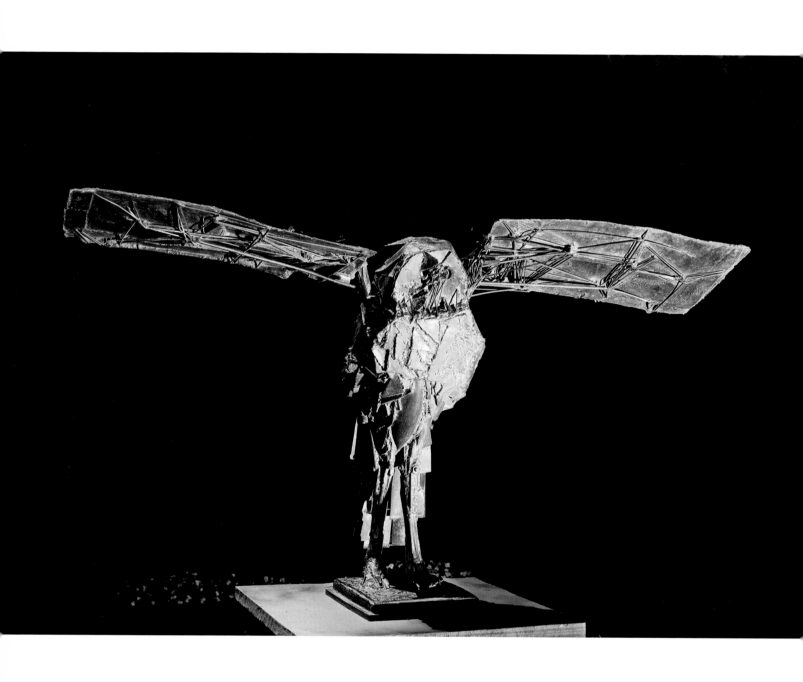

César Baldaccini, Hibou Aile, 1955

Frank Stella, Verdun, 1994

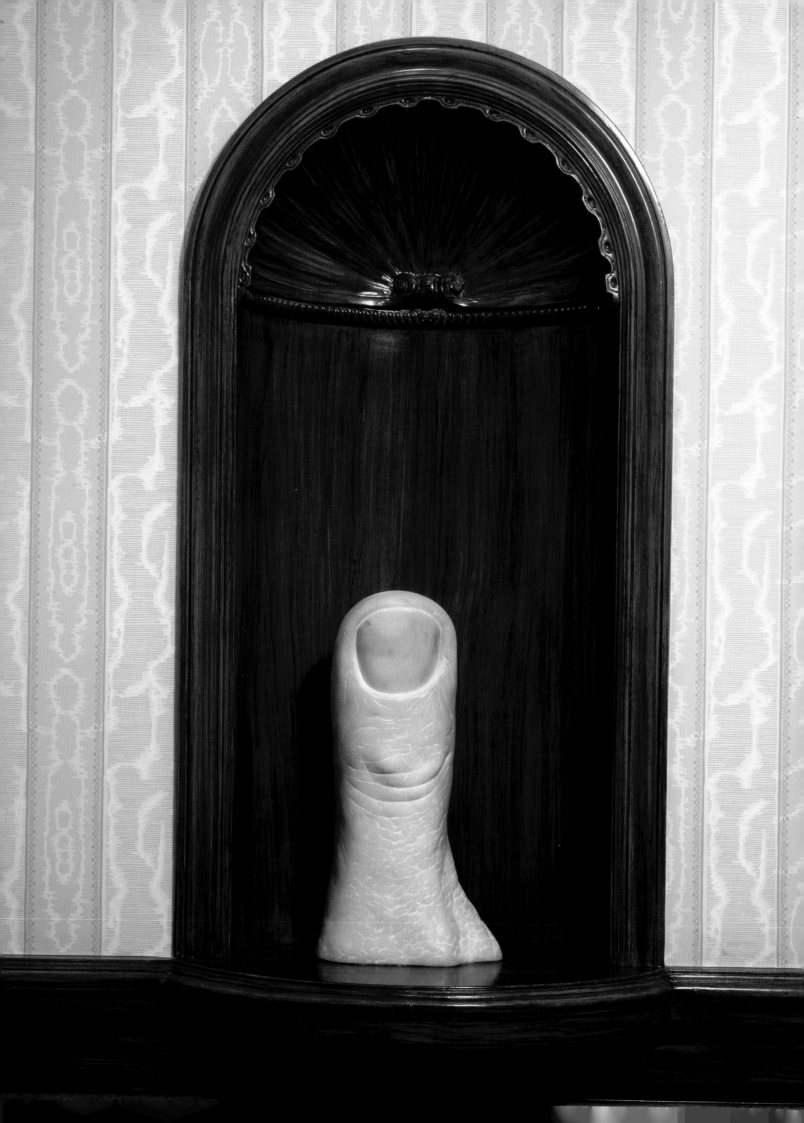

formal values depicted in the works of Cragg, those of Otterness return to innocent fables of life in the big city. In contrast to both of these sculptors, the Welsh-born Barry Flanagan began his artistic career with sculptural installations involving coal sacks. By the late eighties he abandoned these works and became interested in representing legendary animals, primarily the hare, a wild animal with totemic and shamanistic qualities. Differing from the more conceptual and politically conscious performance works of the late German artist Joseph Beuys, also known for his use of hares, Flanagan made cartoonlike representations of this floppy-eared creature, standing upright and cast in bronze.

Of the five Flanagan works in the Cohen Collection, four involve this kind of image, the most subtle being a relatively small hare sitting atop the head of a prancing bronze horse, titled *The Tinker* (1985). Other hare sculptures include *Untitled (Dancing Hare)* (1989), *Hare with Ball* (1994) and *Left-Handed Drummer* (1997). A monumental version of the

latter work was shown ten years later at Union Square in lower Manhattan. In Flanagan's *Unicorn & Oak Tree* (1989), the mythic horned beast stands on hind legs as if caught in the branches of a tree. This might be read as a metaphor, as many of Flanagan's sculptures are, by suggesting the manner in which the human imagination limits its creative potential as it struggles against its own nature.

Two others artists, Henry Moore (United Kingdom) and César (France), are also represented with bronze castings. The more classical sculptor, Moore, reveals a distended female figure reclining to the left. Moore is a gatherer of stones and bones, flora and fauna, including fossils, in the natural landscape. He carefully observes these forms and uses them as the basis for his clay models. Both a draftsman and a clay modeler, Moore plots the structure of human form. He experiments with the appearance based on the body's relationship to

Joel Shapiro, 1986

gravity as it assumes various positions — sitting, standing, lying down. Moore's simplification and exaggeration of the human form suggest expressionist content. The spatial apertures between the arms and legs, sometimes extending into the torso, allow these forms to reveal an emotional structure that transcends the classical mannerism of more traditional sculptors. César, on the other hand, is more given to the psychic interior — the turmoil and angst — within the human soul. His mysterious *Hibou Aile* ("Winged Owl"), initially made of welded scraps of iron (1955) — later cast in bronze (1982) — is perched on a square brick pedestal near the entrance to the Cohen house. César was a member of the Nouveaux Realistes, founded by the French critic Pierre Restany and the painter Yves Klein in Nice in 1960. César's concept was to work with found objects — scraps of metals, including crushed automobiles, which he called "Compressions." *Hibou Aile* is a great work, a masterwork, in the artist's career. It offers a foresight into the direction of his work, as the winged creature that hoots in the night is suddenly ready to escape from his hidden branches and to command the space around him.

While César eloquently dealt with the existential and psychological trepidations in post–World War II France, he also maintained a profound and original sense of humor. This is no better expressed than in *Le Pouce* ("The Thumb") (1978). He produced *Le Pouce* in three different scales — small, medium and large — usually casting them in bronze. The example in the Cohen

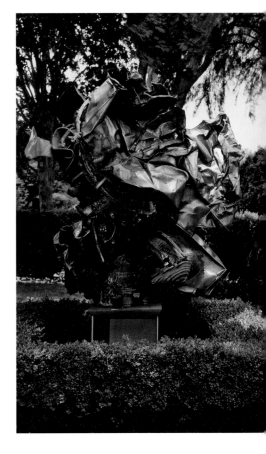

Collection, however, is carved in marble. As for interpretations, there are several. From an art historical perspective, the thumb is associated with Plein Air painting in the mid-nineteenth century. Landscape painters would carry their easels, paints and brushes out into the countryside and set up shop. Often the first gesture would be to adjust the horizon line on the canvas to the scenery being painted. Thus the artist in his proverbial smock would extend an arm with raised thumb to measure the vanishing point on the horizon. This somewhat arbitrary process of thumbing the horizon soon became an inextricable ritual among Naturalist painters. Yet the thumb never appears in their paintings. César's late sculptural achievement was to restore the thumb to the landscape. Linguistically, "le pouce" is also a vernacular stand-in for the phallus. For example, in circumcision when the prepuce is removed, the puce or "le pouce" is hypothetically left standing. One might consider the bathers in Cezanne's late paintings in this regard. A view of the landscape may have slightly altered the bather's member in response to the trees billowing on the horizon.

Frank Stella, Mark di Suvero and Joel Shapiro represent a very different formalist point of view in abstract sculpture. Stella's *Verdun* (1994) is a crushed stainless steel sculpture that weighs close to two tons. In some ways, Stella's crushed complex machine gestures to the highly ordered stainless steel *Cubi* series of David Smith from the mid-sixties. Stella's sculpture is less concerned with a reply to formalism than with opening a new trajectory that moves from

Tony Cragg, 2000 (detail)

the wall to real space. For more than three decades, Stella's work was stuck on the wall arguing a point with Clement Greenberg concerning the values of flatness as stated by the latter's famous essay on "Modernist Painting" (1963). Stella decided to move in a new direction, one less concerned with form than with content.

Joel Shapiro's piece consisting of four beams exists on the precipice of his transition between miniature floor pieces and his eventual move toward Neo-Supremacist figuration. Mark di Suvero's *Link-Up* (1994), welded the same year as Stella's *Verdun*, is a relatively small steel and stainless steel work in which the forms of utilitarian materials are suddenly repealed by stasis. Di Suvero has the capacity to make kinetic forms appear static and static forms appear kinetic. *Link-Up* offers an insight into the penumbra between the two. It appears kinetic but is, in fact, static. This is no small achievement given Di Suvero's remarkable ability to stay within the framework of the singular abstract object, even when on a monumental scale. In contrast to the dense assemblage of mechanical shapes in Di Suvero, Fletcher Benton's *Blocks Construct Zig Zag* (1996) offers a more stoic, poetic presence. Three cubic steel forms are placed atop one another with an open space between the bottom shape and the two above it. Benton's dynamic equilibrium allows the geometric elements to appear suspended. This alleviates the burden of gravity and creates a static moment in which light and air pierce through the structural elements, giving the piece a sense of classical form and unity.

But not all sculpture in the history of Modernism is static, a point eloquently made by Robert Hughes while speaking of Futurism in his television series *The Shock of the New* (1980). For sculpture to move, it requires a certain quality of lightness. It is this quality that George Rickey brought to his work in the early sixties — a quality that he continued to pursue throughout his career. While the basic structure in Rickey's work evolves from Constructivism, which is static, the turn toward a kinetic involvement with balance, light, gravity and motion involved a nearly scientific attitude toward experimentation. In *Unstable Rhombus and Square* (1989), a small sculpture in silicon over bronze, there are eight spires placed symmetrically on a tilted axis. As the axis moves from one side to the other, the spires move accordingly. A large standing piece, *Two Conical Segments Gyratory II* (1979), made ten years earlier in stainless steel, is placed out of doors and is directly affected by the currents of air that move through it. The elements in *Spiral of Six Squares* (1996), also in stainless steel, are mounted on vertical rods and float horizontally at different heights.

Other sculptors with an affinity to Rickey include Ken Bortolazzo, Pedro de Movellan and Fré Ilgen. In each case there is a reference to movement, to the galaxy, to the physical axis upon which planetary space revolves. Time and motion are essential ingredients in these works. De Movellan's aluminum, stainless steel and brass *Tango* (1999) depends on a fulcrum that is raised and lowered according to the motion incited by two elliptical forms set on a counter axis. Bortolazzo's stainless steel *Conversation* (2008) is symmetrically balanced with two planar elements that rock from front to back at either side. Ilgen's *Helen of Troy* in wood, acrylic paint and stainless steel also carries planetary references with elements that imply motion but are in fact static unless the steel band that encompasses them is made to rock from one side to the other. In all three sculptures, the complexity is less apparent than in the sculpture of George Rickey. Still, the emphasis is upon the relationship of forms in three-dimensional space on a diminutive scale.

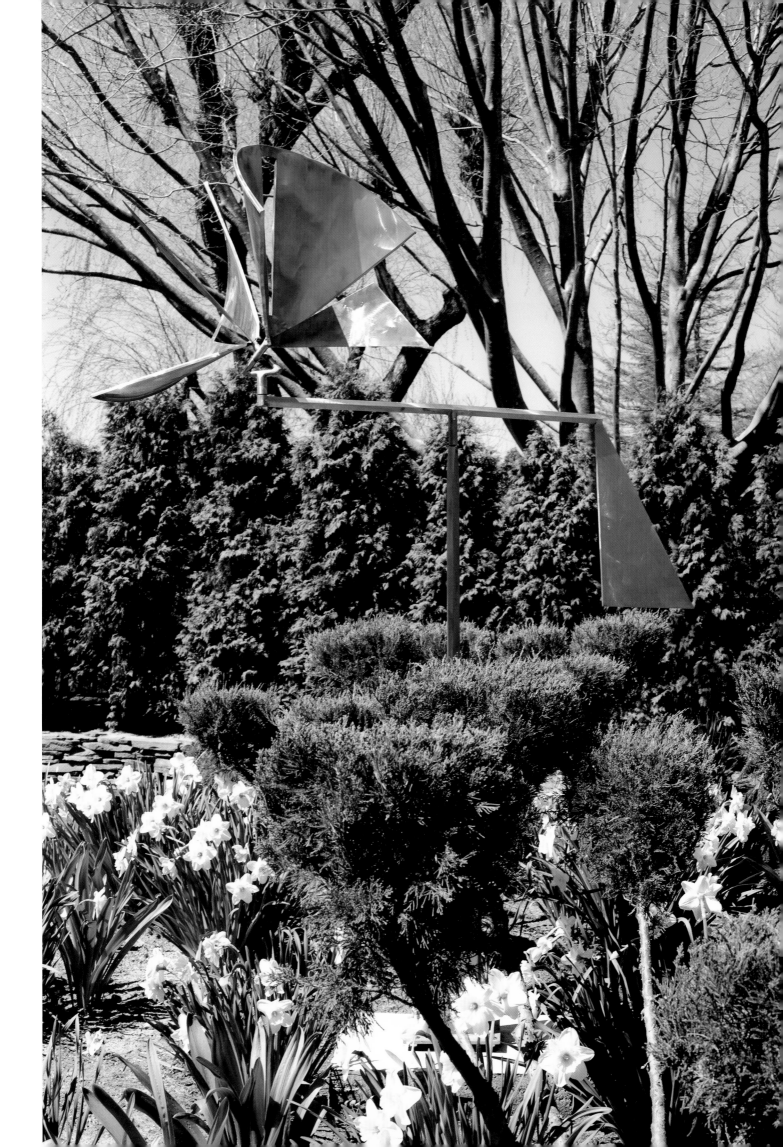

Richard Deacon's *Venice Pale Green/Pink/Sky Blue Traces* (2007) is a twisted biomorphic glazed ceramic form that hangs on the wall with a steel hook. While the continuous contour suggests the work of Hans Arp, the glazes transform it into a modality that exists on its own terms. Deacon's work employs the space of the wall not only as its support but also as part of the work both within and around the twisted circumference of this delightful form. In fact, one might speak of a renewal of form and sensibility in this work. It would appear to reveal a certain tacit revelation as to the purpose of sculpture and what sculpture means as a structural form.

The sculpture in the Cohen Collection is precisely this: a series of works that point in the direction of a renewal of form and sensibility. They are works that contain a meaning that is beyond utility. Their purpose is to offer an aesthetic experience to the viewer through a tactile relationship to three-dimensional space. By tactile, I refer to the arbitrary sense of touch that these works suggest. Put another way, one might say that a tactile sensation in sculpture is both physical and emotional. We feel something in relation to art of this caliber. It is not merely entertainment. It is a more deeply intended and deeply felt human experience. Cohen has put together an extraordinary body of work from many divergent sources. When viewed as an ensemble, the contrasting forms are also capable of being transformed into a series of complementary representations that express the universe of the human spirit at large.

Robert C. Morgan

I have always been drawn to sculpture. I bought my first Cragg from Marion Goodman at an art fair. I knew instinctively where it would go. I then met him at Art Basel and accepted an invitation to visit him at his studio in Germany. When I acquired two more painted bronze works, I placed them all in a straight line. I loved to go out and look at them. Another one of my Craggs I placed next to my living room window. From the inside it looks like a silhouette of a man. I think of it as just another guest in the garden.

Tony Cragg, 2007

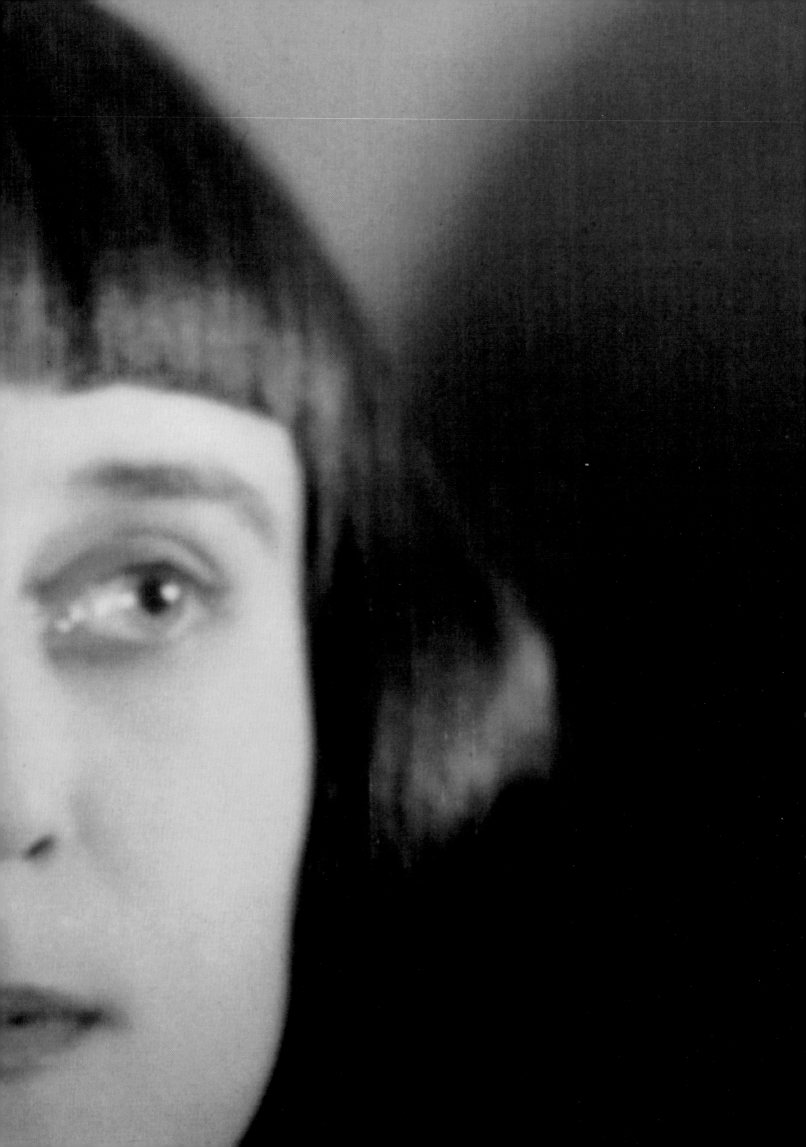

Photography

László Moholy-Nagy, Photogram, 1925

Seventy years ago, László Moholy-Nagy prophesied that in the future photography would be so important that the illiterates of the world would be those "ignorant of the use of the camera as well as the pen." Unfortunately, that time has yet to come, for the power of photography is still not fully understood by many. Photographic illiteracy may well still be the norm rather than the exception. Some see photography merely as a potent tool for manipulation, yet the very best images – whether they be amateur or professional – possess a power infinitely greater than that for they have the capacity to enliven and ennoble our lives.

Ray Merritt

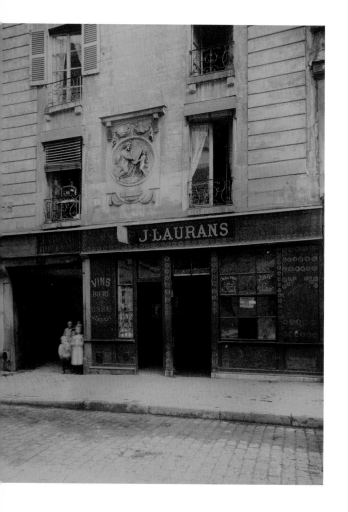

Eugène Atget, rue Cherche Midi, Paris, n.d.
Eugène Atget, rue Cherche Midi, Paris, 1908

Eugène Atget, Le Quai Port de l'Hotel de Ville, Paris, 1908
Eugène Atget, Hotel des Invalides Porte, Paris, n.d.

Everything is a subject.
Every subject has a rhythm.

André Kertész

André Kertész, Wandering Blind Violinist, Abony, Hungary, 1921
Following pages: Walker Evans, Selma, Alabama, 1936

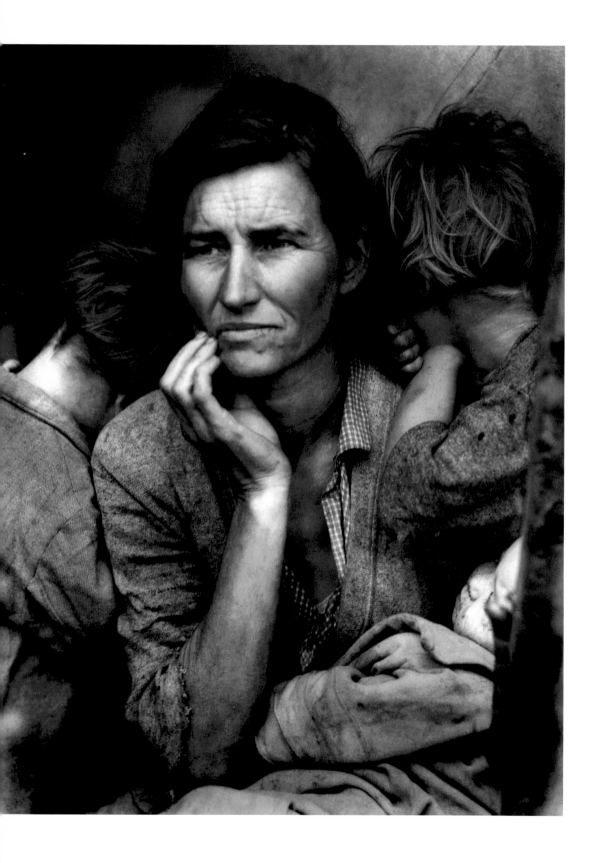

Photography takes an instant out of time, altering life by holding it still.

Dorothea Lange

Dorothea Lange, Migrant Mother, 1936

Reluctant icon

One of the most intriguing stories of the Depression is the saga of Florence Owens Thompson, Dorothea Lange's most famous subject. The members of Mrs. Thompson's family were indeed immigrants in their own country. A full-blooded Cherokee Indian, Florence married her teenage love at seventeen and together they journeyed from Oklahoma to California. Unfortunately, her husband died young, and she and her seven children continued to support themselves as "harvest gypsies" — California's crop-pickers. They journeyed by car from harvest to harvest, but when the Depression came, finding work became difficult. The influx of thousands of needy people made employment scarce. Nevertheless, she held her family together.

One fateful day, a "fancy lady with a limp," as Florence later described her, asked for permission to photograph her. The woman did not inquire as to her name or history. Frustrated at her inability to move to the next crop (her car was in need of repair) and disappointed that no money was offered by the photographer, she nevertheless acquiesced when told that the pictures might help gain aid for transient camps. The next day her image appeared on the cover of the local newspaper. Florence would not know until later that the "fancy lady" was Dorothea Lange, and that the picture taken that day would come to represent the best in American photo-documentation. Although Florence lived a full life, content in the knowledge that her children went on to better ones, she always resented her image as the beatific "Migrant Mother." She was a survivor and did not want or need charity, perhaps evidencing a bit of her Cherokee independence.

Lange had captured Florence looking beyond the camera, her children clinging to her with their faces turned away. The image is profoundly enigmatic. Some see shame and despair, others see unhappiness and fatigue. Most, however, view it as the transcendent image of the Depression family. While registering hardship and pain, it clearly resonates with its subject's

inner strength. By removing the background detail, Lange created a tableau that was not about physical loss as much as it was about human suffering. Lange was able to etch in silver the entire Depression in that one photograph.

The image would over time take on nearly mythic proportions as the icon of that era. There was a reverence for tradition and religion during the Depression. Both were perceived as antidotes for bad times and Lange understood that. Her sorrowful Madonna clearly spoke of cleansing and rebirth. In this one image, she captured everything about the times — survival, anxiety, family unity, the destruction of old and cherished ways in the face of urbanization and the craving for reassurance that, through all this, basic beliefs and traditions would prevail. Although the image portrays a full palette of emotions, it manifests a certain grace. What comes through most vividly is the sense that humankind will survive and flourish.

Ray Merritt

Vik Muniz's work tells us that seeing is not quite believing, that perceiving . . . and understanding are balancing acts, that experience itself is a seesaw.
Vicki Goldberg

Walter Rosenblum, D-Day Rescue, Omaha Beach, Normandy, 1944
Left: Edward Steichen, Homeless Women, New York, 1932

Susan Paulsen, Block Island, 2003

Jill Mathis, 1998

Robert Rauschenberg, Charleston Street, 1952

*The artist's job is to be a witness to
his time in history.*

Robert Rauschenberg

The creative act lasts but a brief moment, a lightning instant of give and take.

Henri Cartier-Bresson

Henri Cartier-Bresson, Valencia, 1933

Lost once more

Many a midtown Manhattan office has a fine view, but sit in Joe Cohen's desk chair and it's easy to ignore the skyscrapers out the windows to the right. The amazing view is straight ahead — a god's-eye view of an inviting expanse of soft sand and turquoise sea, dotted with sunbathers, swimmers and surfers. It would be easy to become lost in daydreams, eavesdropping on an imagined conversation of a couple at the water's edge, worrying whether there's enough sunscreen on the naked tyke running about, or wondering which kid the mom with arms akimbo is keeping watch over. The eye wanders from the beach back to the office. An impossibly long-legged, elegant Venus climbs a grand staircase off to the left and it's hard not to want to follow. Back to work! Stern-faced and commanding, J. P. Morgan glares as if to warn that no financial empire will be built by a daydreamer. But a small boy behind Joe's chair smiles broadly, and one begins to feel that this impish lad whispering in Joe's ear has more sway than the fierce Morgan. Those presences are, of course, all photographs — pictures by Richard Misrach, Helmut Newton, Edward Steichen and Richard Avedon; sharing the space of JMCohen&Co, these and others throughout the warren of offices make themselves fully felt.

*I am looking for a kind of purity, something
essential from human beings.... I believe in
a sort of magic.*

Rineke Dijkstra

Ralph Gibson, 2007

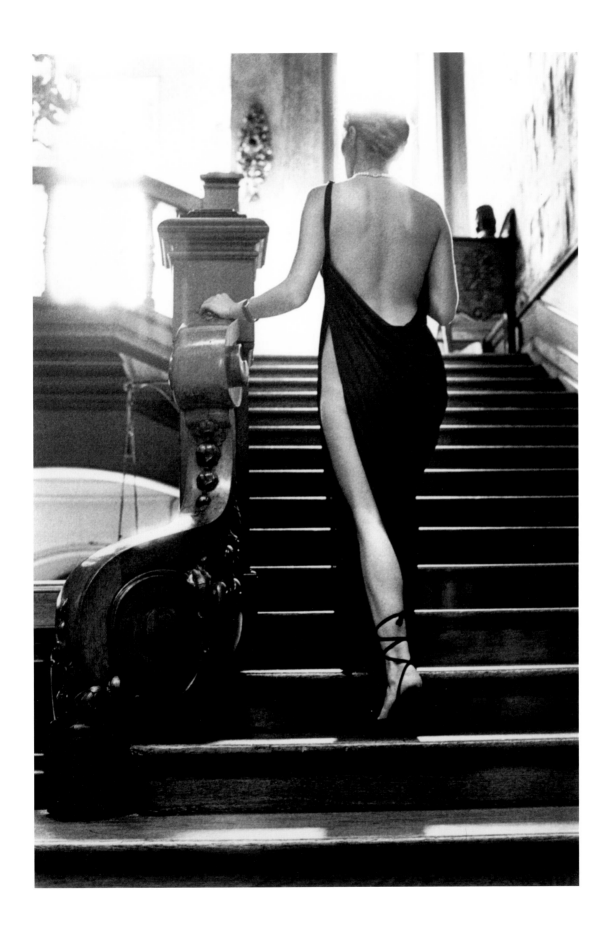

Helmut Newton, 1975

If, even late in the evening, one feels surrounded by good company in Joe's office or apartment, it is because so many of his photographs, which span the twentieth century into the twenty-first, are portraits: Man Ray's *André Breton*, Hiroshi Sugimoto's *Napoleon Bonaparte* (via Madame Tussaud), Arnold Newman's portraits of Mondrian, Picasso and Krupp, refugees photographed by Fazal Sheikh, and self-portraits by Rineke Dijkstra, André Kertész, Edward Steichen, Alfred Stieglitz and Edward Weston. But for the collector, many of the photographs in the office and in his home also evoke presences beyond the people represented: the first photograph he bought, an Atget, was a gift for Babs, his beloved wife; his business partners presented Joe with a photograph by Laura Gilpin on the twentieth anniversary of Cowen & Company; nearly a dozen photographs by Ralph Gibson testify to a long friendship prompted by an introduction from Ray Merritt, the artist's lawyer and Joe's close friend; and trusted dealers have steered important photographs his way.

The artists themselves are sometimes present too. Among the contemporary photographers whose company and conversation Joe enjoys and recalls in front of the pictures, Vera Lutter is one of those to whom he is most committed. Her photographs — enormous one-of-a-kind negative prints made in a room-sized pinhole camera with day-long exposures — seduce one with a mental game of tonal and spatial reversals and with smooth continuous tone and mesmerizing detail. They are not Venice, New York,

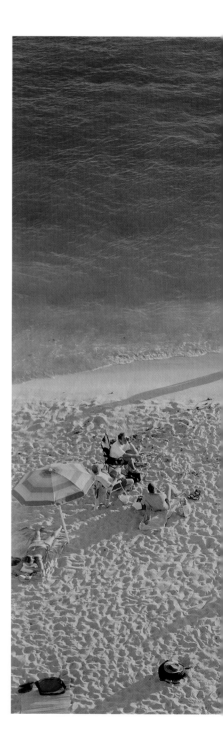

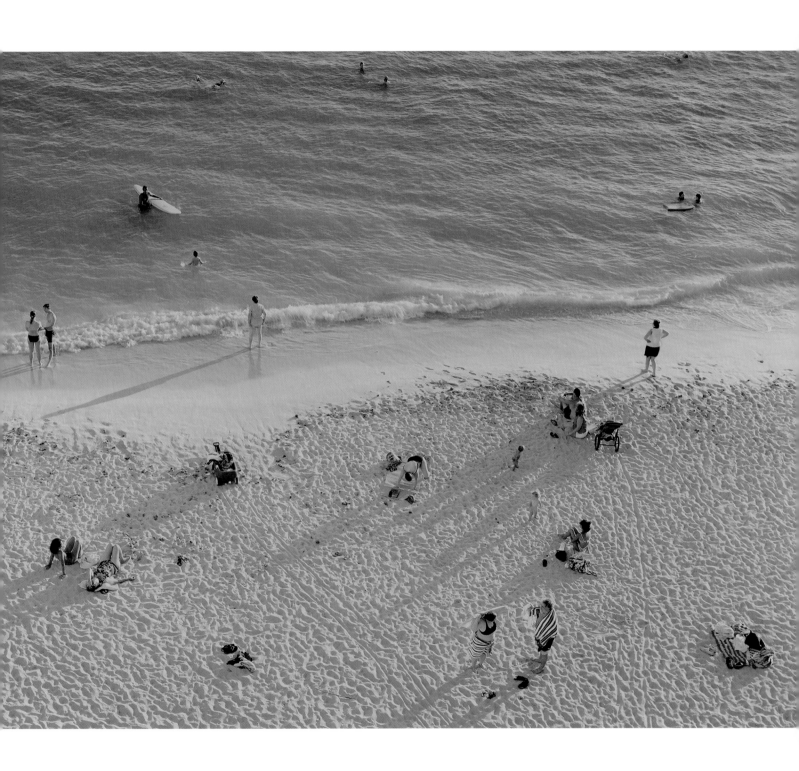

Richard Misrach, 2002

Jan Groover, 1990

Chicago or the Frankfurt airport, where they were made, but rather a dream of Venice, an eerie recollection of New York, a trace of Chicago, a ghost of a hulking aircraft at Frankfurt.

It is the impish voice in Joe's own head, no doubt, that allows him to move with equal pleasure from the sublime to the ridiculous, from Lutter's mammoth images to Harold Edgerton's stroboscopic study of a milk droplet and Vik Muniz's humorous riff on Edgerton's classic. Exactingly drawn with lusciously goopy chocolate syrup, Muniz's picture is another sort of visual game: Is it a picture of chocolate? Of another picture? Of a milk drop? And even as the mind puzzles, it is hard not to giggle as it all dissolves into a smiling thought of chocolate milk.

If there is a bottom line, Joe says, it is that he collects photographs "for their pure beauty," and that idea is evident throughout: in the lush, tropical vegetation of Thomas Struth's *Paradise 6*, in the peeling splendor of Robert Polidori's *Señora Faxas Residence, Miramar, Havana*, in the serene palette of Jan Groover's still life of beige bottles, and in the simple calligraphic lines of Harry Callahan's *Grasses in Snow, Detroit*. This is certainly the case as well with Desiree Dolron's moody twilit portraits — among Joe's favorites — that seem plucked out of some old Netherlandish painting and with Thomas Struth's *National Gallery, London*, in which just such a Vermeer hovers in the darkness.

Each photograph brings pleasure in its own way — the pleasure of beauty, of humor, of historical resonance, of personal association. And so the mind wanders again, away from the workaday world and back through a mosaic of friendships and visual delights to an old stone house in Brittany, a flooded street in New Orleans, a Depression-era storefront in Selma, a reclining nude, a memorable face . . . and we are happily lost once more.

Malcolm Daniel

Alfred Stieglitz, New York, c. 1927

The artist's world is limitless. It can be found anywhere, far from where he lives or a few feet away. It's always on his doorstep.

Paul Strand

Paul Strand, France, 1950

Richard Misrach, Cloud, 1993

Richard Misrach, Stonehenge, 1976

At one point while I was at Cowen & Company, my partners wanted to surprise me with a Rolls-Royce for my birthday. Babs got wind of the idea and put a stop to it. She told them I'd prefer some great photos instead. So they gave me three Laura Gilpins.

Richard Misrach, Desert Fire, 1985

Laura Gilpin, 1924

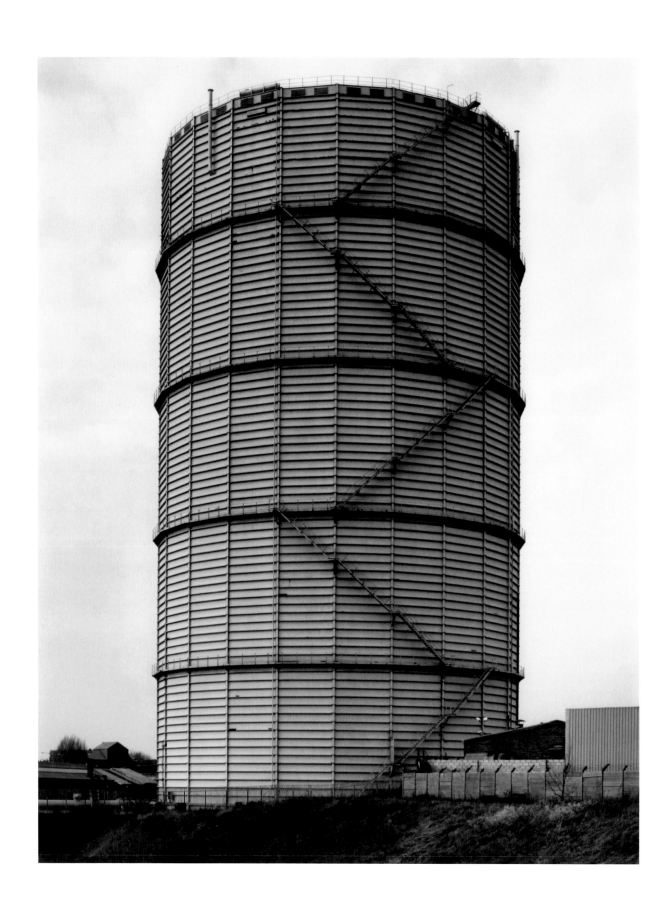

Bernd and Hilla Becher, Gas Tank, St. Helens, GB, 1997

I am fascinated by the Bechers' devotion to perfection and their desire to capture more than just history. Their Tank and Tower series is among my favorites. There is something very conceptual about them. I think they say a lot about art and show that a very mundane subject can resonate with feeling. I learned that they were also renowned teachers and that many of their students have gone on to be great contemporary artists like Candida Höfer and Thomas Struth. The success of their students may say it all.

Caleb Cain Marcus, Con Edison Building, 2007

Andrew Moore, Hanoi, 2006

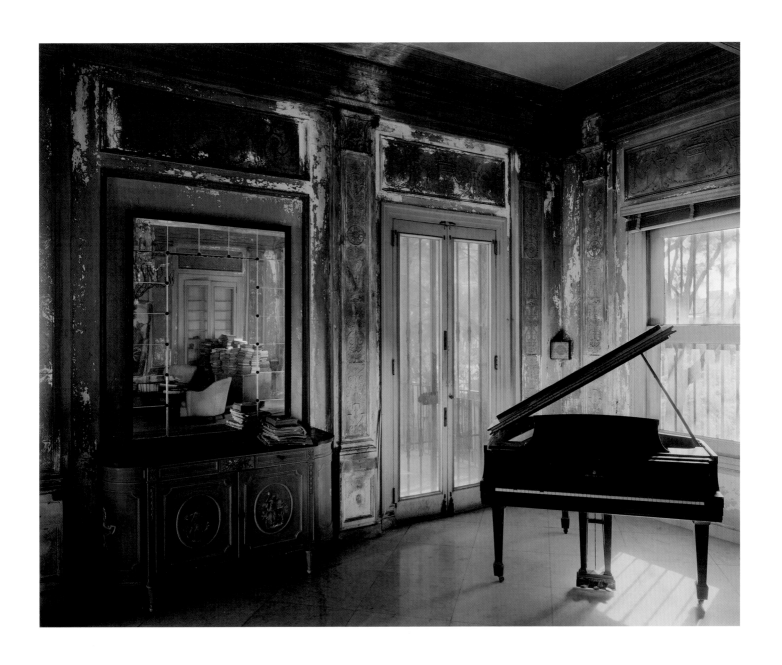

Robert Polidori, Havana, 1997

Robert Polidori, New Orleans, 2005

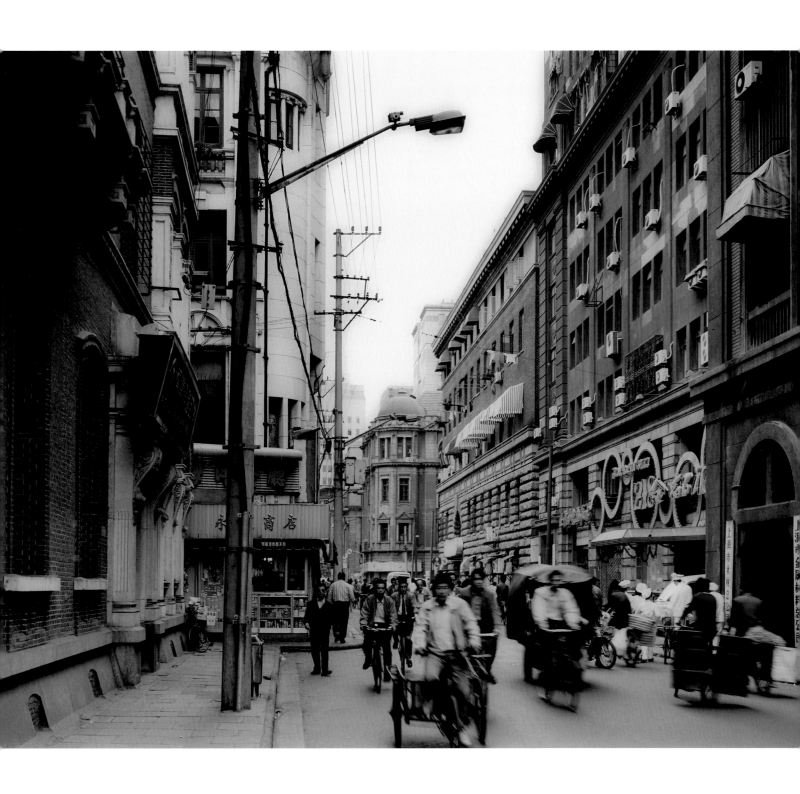

Thomas Struth, Shanghai, 1998

Hiroshi Sugimoto, Michigan, 1980

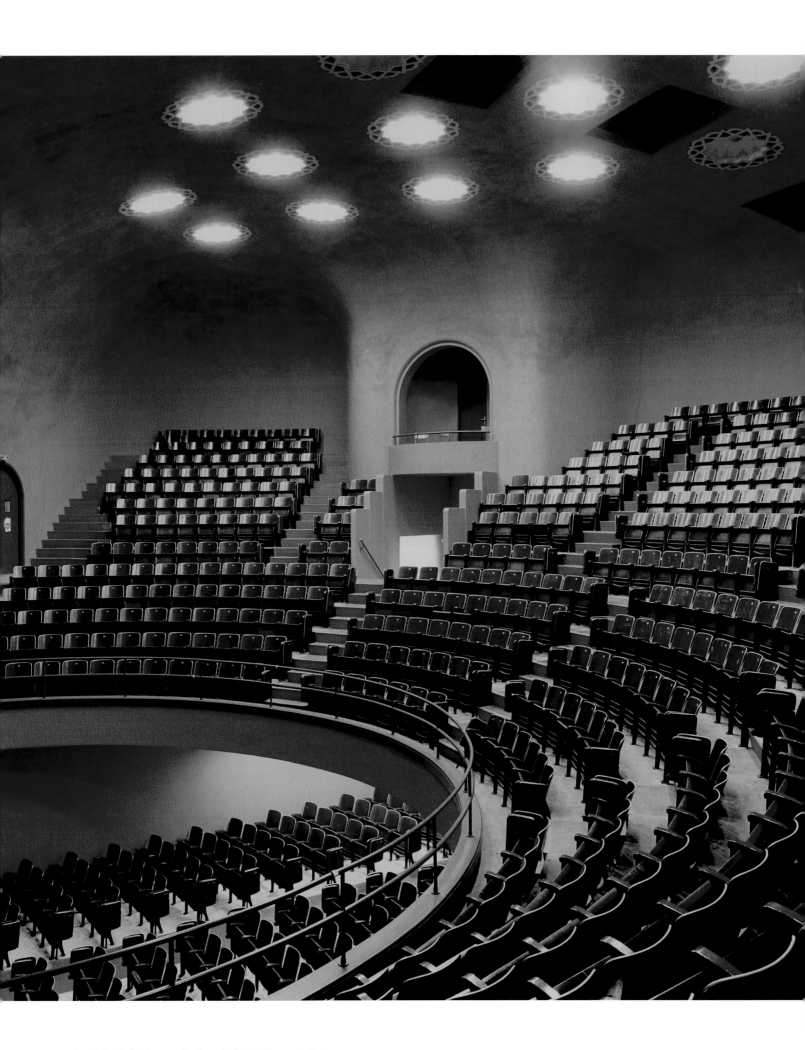

Candida Höfer, Bourse du Travail, Calais, France, 2001

Picturing the self

"The self is a text —it has to be deciphered," the noted author Susan Sontag once wrote, but she also added, "the self is a project, something to be built." This dual nature of self-portraiture, as both the investigation of self and the construction of identity, strikes to the heart of both the act of making a picture of oneself and its enduring appeal for artists and public alike. Since the Renaissance, painters and draftsmen have been captivated with depicting themselves, seeing it as a way to sign and promote their art, elevate their persona and tell stories, as well as an arena in which to explore more experimental ideas about sight and depiction.

Since the birth of the medium in the late 1830s, photographers too have shared this fascination and, perhaps because of the ease of the process and its relative cheapness, as well as the ready availability of the model, they have made innumerable self-portraits. Their intentions and concerns have been similar to those of artists before them. However, because photographers must literally put themselves in front of their lenses, their self-portraits, unlike so many other photographs, are not casual depictions of chance encounters or even studied renditions of carefully selected places and things but deliberately staged constructions. While some photographers go to great lengths to minimize or even conceal this sense of staging and others self-consciously exploit it, that artificiality lies at the root of the photographic self-portrait's meaning and the source of its frisson.

Several of the earliest self-portraits in the Cohen Collection speak to this duality. The first is by and of a very young Alfred Stieglitz. Made in the 1880s, it presents the American-born Stieglitz while he was a student in Berlin, studying photographic chemistry with the famed scientist Hermann Wilhelm Vogel. Positioning himself at an angle and looking off to the side, Stieglitz is stiff but unpresupposing and presents the air of a diligent student, perhaps performing a class exercise, and not the fiercely self-confident avatar of modernism that he

*In photography there is a reality so subtle
that it becomes more than reality.*

Alfred Stieglitz

Alfred Stieglitz, Self-portrait, c. 1880

Edward Weston, Self-portrait, 1914

later became. Only his unruly hair and cape, which remained one of his signatures through-out his life and here is casually slung over one shoulder, hint at the dramatic and imposing personality of the older man.

If Stieglitz's self-portrait appears as unaffected as an anonymous studio portrait, then André Kertész's early study of himself seems as casual as a snapshot. Displaying both a remarkably sophisticated understanding of the power of photography to construct a persona and a sly sense of humor, one of his most affecting self-portraits was made in 1915, only three years after Kertész began to photograph. Using a tripod and a crude self-timer, he constructed an image of himself as a soldier in the Austro-Hungarian Army during World War I. However, although he wears the cap of his uniform, he depicted himself engaged not in a heroic military action or even at work behind the lines to support the efforts of his comrades, but seated in his underwear, attentively picking at his clothing. (Kertész later told us he was

removing lice from his underwear.) The scene is so matter-of-fact, Kertész's posture and attitude so casual, his actions so humble, we might easily assume, were it not for its claimed authorship, that this is simply a snapshot of one soldier made by another.

Edward Weston's self-portrait was also made early in his career. Although born in Illinois in 1886, he moved to California and set up a commercial portrait studio in 1911 in Tropico (now Glendale), near Los Angeles. Deeply influenced by both Symbolism and Pictorialism, the then-favored style of fine art photography, he often utilized dramatic lighting to make softly-focused depictions of his sitters and friends, many of whom were members of the city's vibrant artistic and literary community. Yet his own self-portrait is far less effusive and far more subdued than his studies of others. Positioning himself against a plain backdrop, with his hand on his hip and staring directly into the camera, Weston presents a confident if youthful image of himself. Only his foppish tie, knotted in a bow, denotes the self-consciously artistic stance of his other portraits of the time. Unlike Stieglitz's or Kertész's self-portrait, Weston stares directly at the viewer, as if asking us to trust him with depicting our own persona.

Edward Steichen's self-portrait shows no such restraint. An artist with many facets to his long career, Steichen aspired to be a painter at the turn of the century but instead achieved great fame for both his highly manipulated photographs of renowned painters, poets and authors, and his work with Stieglitz to introduce modern European art to America. After World War I, he abandoned painting, severed his connections with Stieglitz, and in 1923 became the chief photographer for Condé Nast publications. He won great acclaim for his fashion photographs and especially his penetrating, artfully constructed portraits of such celebrities as Greta Garbo and Charlie Chaplin, which were frequently published in *Vogue* and *Vanity Fair*. His own self-portrait is just as carefully considered. Whereas at the turn of

Edward Steichen, Self-portrait, 1929

the century he had made a photograph of himself in painter's garb, holding a brush and palette, in this self-portrait from 1929 Steichen posed himself in the Condé Nast studio with the paraphernalia of his new trade as a professional studio photographer — lights, screens, a large view camera, and even an assistant, who is discreetly presented only as a shadow, pressing the cable release. Crouching down, as if ready to spring into action the moment he spies something of interest, Steichen himself does not look at the camera and ask us to join him in this world, but instead directs his gaze intently off to one side, as if to suggest he was always on the lookout for the next new thing.

Yet perhaps the most striking of all these early self-portraits in the Cohen Collection is Frantisek Drtikol's. Trained as a painter and influenced by both Symbolism and Art Nouveau, Drtikol supported himself as a photographer and established a portrait studio in the 1920s in Prague that became one of the most successful in Europe. In a series of highly acclaimed studies of nudes made in the 1920s and early 1930s, he reinvigorated the genre by synthesizing elements of dance, silent films, Cubism, Futurism, and Art Deco design. Most are studies of anonymous female nudes but he also occasionally photographed himself. Stripping off his clothes, which so often define a persona, Drtikol daringly presents his long lithe body, arms fully extended, legs slightly turned, in a pose similar to one he often used when photographing women. The photograph displays an unusual willingness to lay himself bare both literally and metaphorically. Like all self-portraits, it is also perfumed with narcissism and punctuated with voyeurism.

Sarah Greenough

Frantisek Drtikol, Self-portrait, 1930

The minute I started working with Polaroid I realized that as soon as I got a print that I thought I wanted to work from, there was no reason to make more versions. I began to take photographs that I had really no intention of making a painting from. So I reluctantly began to accept the fact that if I'm making photographs, then golly, I must be a photographer.

Chuck Close

Chuck Close, Self-portrait, 2007

Dieter Appelt, Self-portrait, 2001

Peter Keetman, Self-portrait, 1950

Arnold Newman, Self-portrait, 1939

Weegee, Self-portrait, c. 1950

Jaromir Funke, c. 1930
Right: Otto Steinert, 1952

Fazal Sheikh, Brazil, 2001

Goethe once wrote, "The happiest man in all of the world is the collector." I must agree. I am sure that Joe feels as blessed as I to be able to collect. Doing so makes your life more complete.

Henry M. Buhl

222

Adam Fuss, 1999

Sally Mann, 1991

Irving Penn, *Cuzco children, Peru, 1948*

Sally Mann, Virginia at 4, 1989

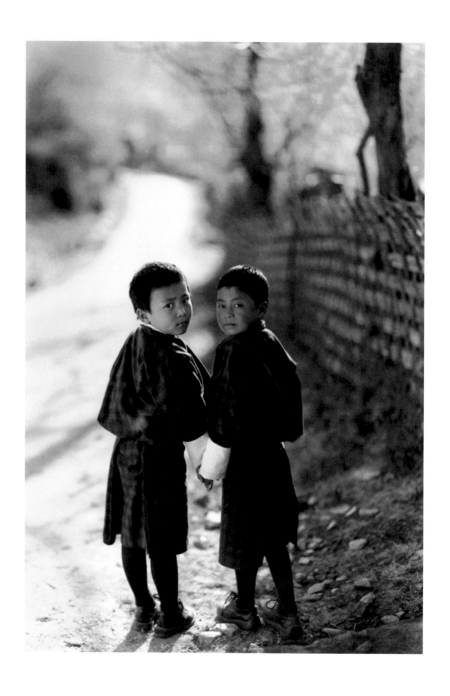

Kenro Izu, Bhutan, 2007

Walter Rosenblum, Pitt Street N.Y., 1938

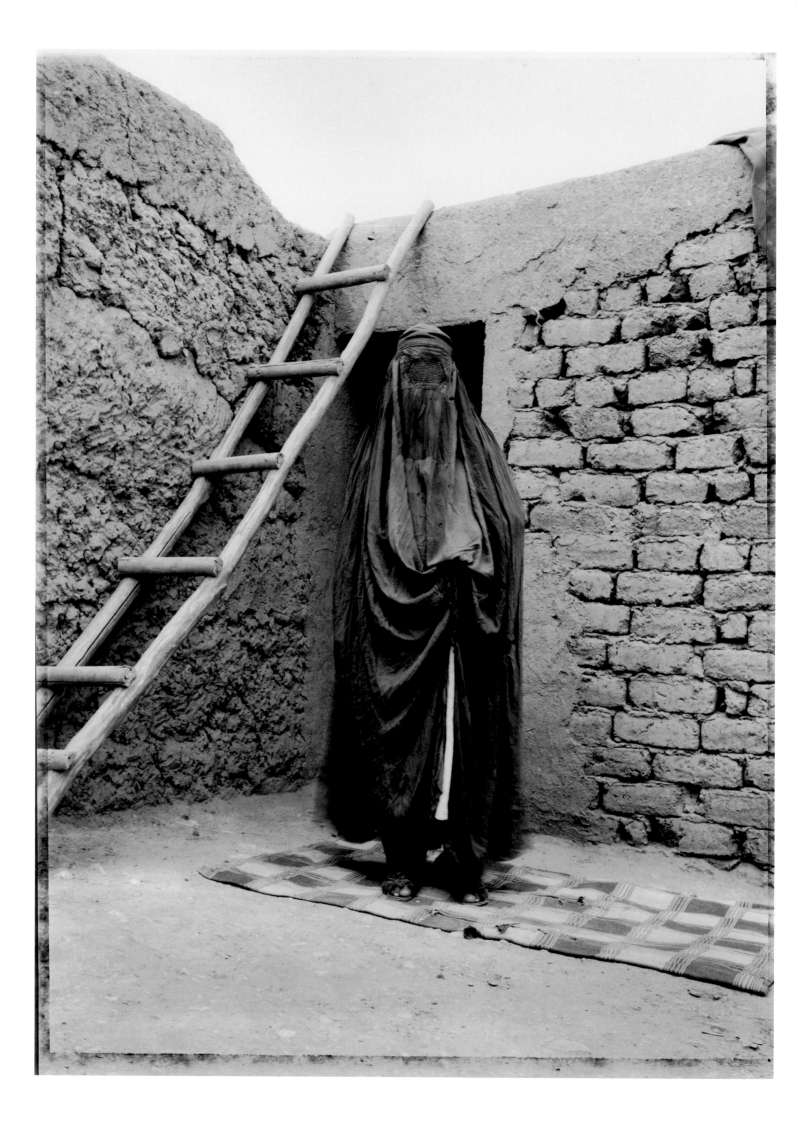

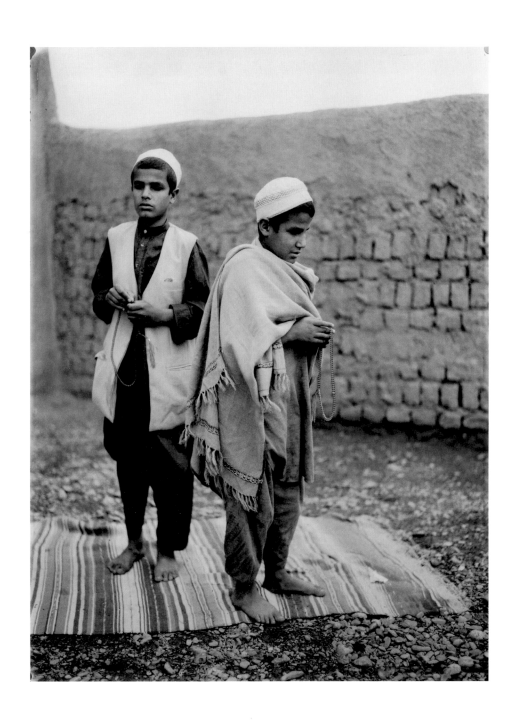

Fazal Sheikh, Blind "Gari" brothers, Afghan refugee village, Pakistan, 1996

Left: Fazal Sheikh, Afghan refugee village, Pakistan, 1997

At first I did not relate to these images, but I came back to them again and again. Finally I acquired them. I really like images that tell a story and I have grown to appreciate them.

Allen Ginsberg, photograph of Peter Orlovsky, Jack Kerouac, William Burroughs, 1957

Duane Michals, The Fallen Angel, 1968

Irving Penn, Patissiers, Paris, 1950

Irving Penn, Charwomen, London, 1950

Edward Steichen, Shoes and Reflection, 1927

Irving Penn, Jean Patchett, Peru, 1948

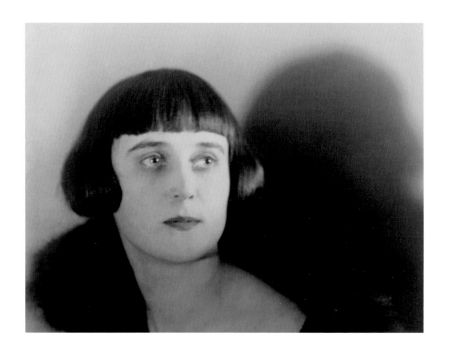

I couldn't resist this image. Some say it looks like Babs. I didn't see that at first, but sometimes I think they might be right. I love images of people. I think they help a person frame a view of life. I look at the photographs of children in my collection and often wonder what their lives will be like when they grow up. Photographs really do make you think. Every day they keep my mind working.

Jaromir Funke, c. 1929

Frantisek Drtikol, c. 1927

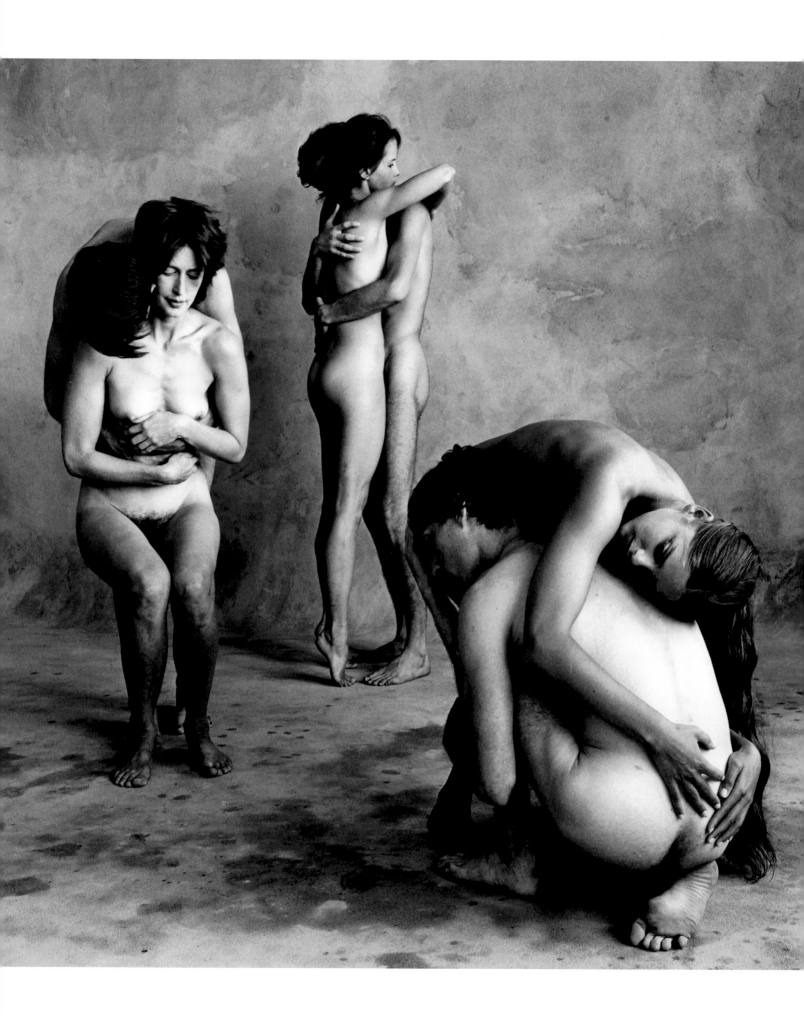

238 Irving Penn, Dancers' workshop, 1999

Irving Penn, 1949

I share with many people the feeling that there is a sweetness and constancy to light that falls into a studio from the north sky that sets it beyond any other illumination.

Irving Penn

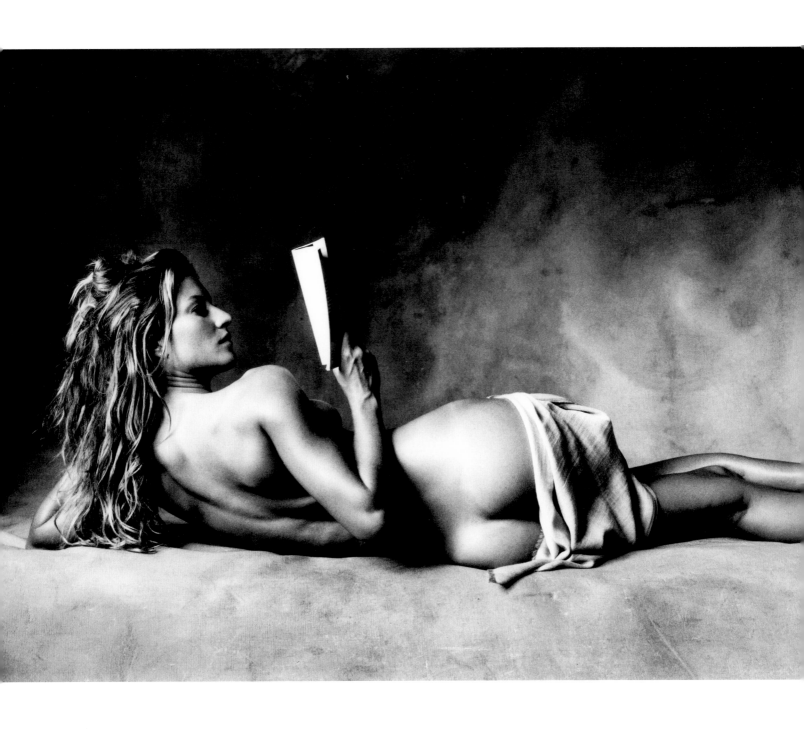

Irving Penn, New York, 2006

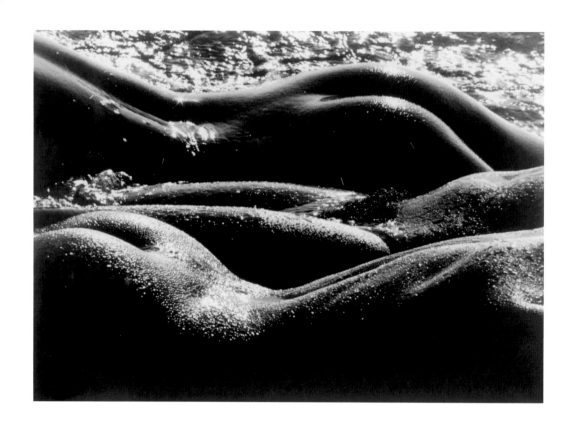

Lucien Clergue, Les Géantes, 1978

André Kertész, Distortion, 1984

Jeff Cowen, Oxana, 2007

Joel Meyerowitz, Heidi, Ballston Beach, 1981

Pierre Gonnord, 2008

Photographic images of children are the most common, the most sacred and at times the most controversial images of our time. They are, like all photographs, paradoxical objects – concrete yet abstract. They have the power to communicate, to affect our feelings and our behavior, and to shape our values.

Ray Merritt

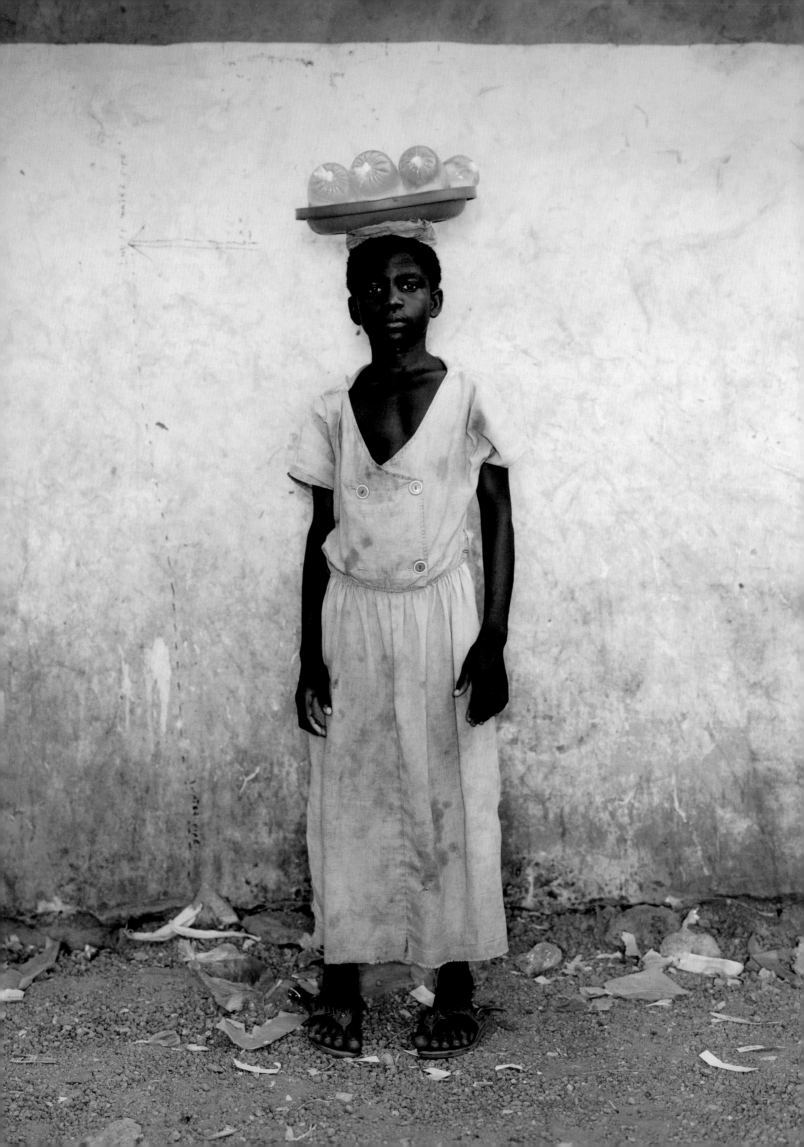

Annie Leibovitz, Las Vegas, 1996
Left: Rineke Dijkstra, Ghana, 1996

I first saw the work of this Dutch artist at AIPAD in New York and immediately got one. Then later I met her in Paris where we had lunch and dinner. She explained the laborious process of her printmaking. The effect is perfection – luminously clear and sensuous. There is a wonderful stillness and subtlety about them. To me they have the feeling of fine paintings. I already have four and I know more will come.

Desiree Dolron, 2001–2008

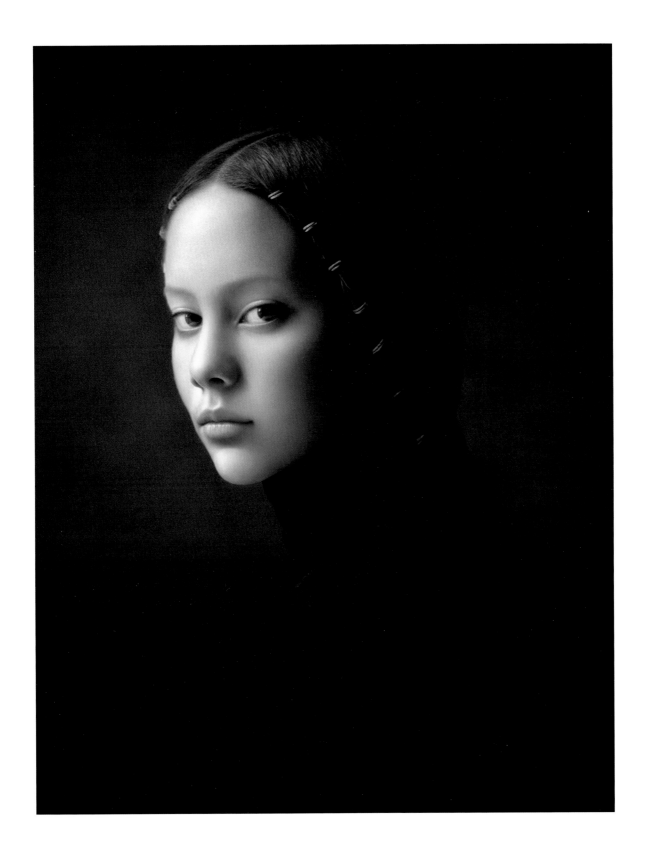

Desiree Dolron, 2001–2008

Robert Rauschenberg, 1952

Richard Avedon, Truman Capote, 1999

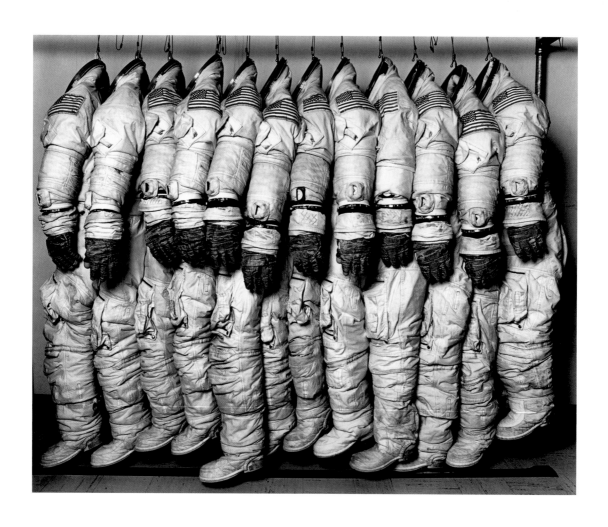

Hiro, Apollo Spaceflight Training Suits, Houston, Texas, 1978

Philip-Lorca diCorcia, 1978

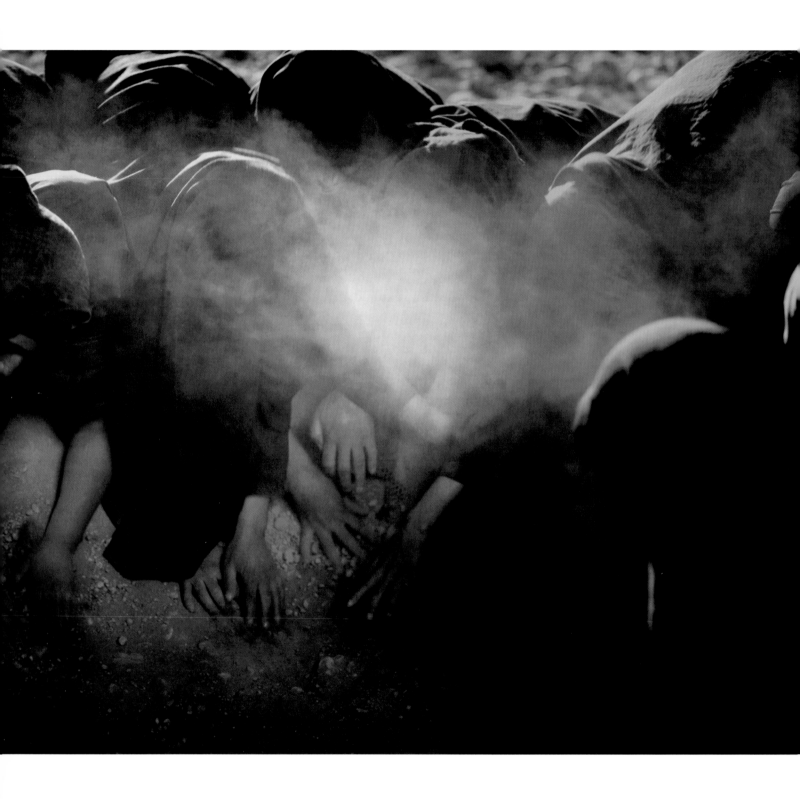

Shirin Neshat, 2001

When I saw this image by Man Ray of André Breton I became mesmerized. It was at AIPAD, the annual photo show in New York. I found the solarized edges quite haunting. You can almost see the intensity of his thought process – perhaps that is what surrealism is really about. I kept returning to take another look at it. I brought my friends to see it. I knew I needed it. It is a wonderful addition to my family of photographs.

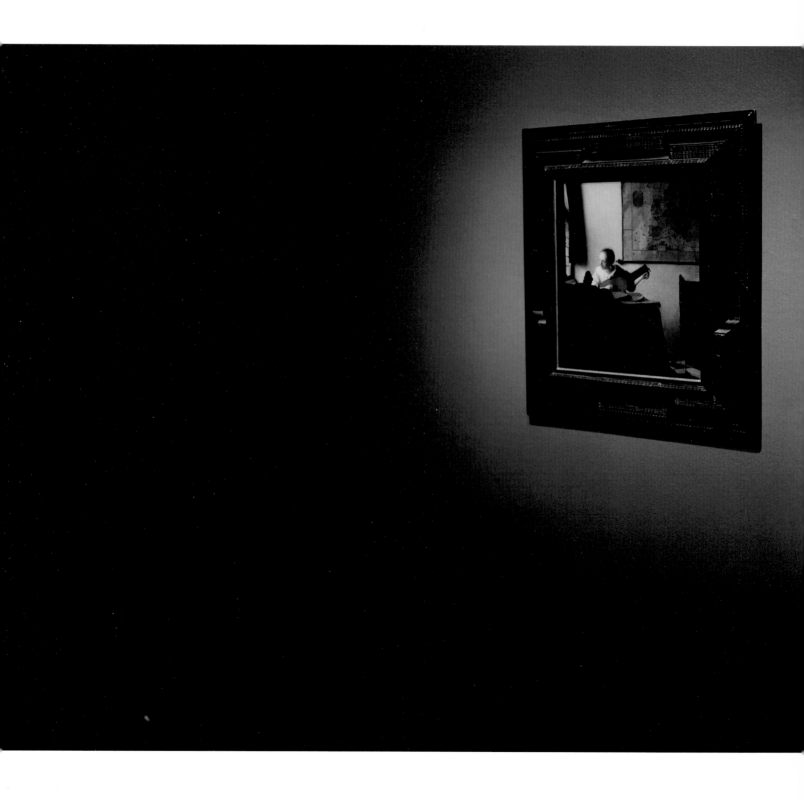

Thomas Struth, National Gallery 2 (Vermeer), London, 2001

Cool, calm and collected

Why do people collect art? Years ago, Kenneth Clark — the late art historian and television personality who was seldom at a loss for words — found the question difficult to respond to concisely. It was, he said, unanswerable, like trying to pin down why it is that people fall in love. What we know with certainty is that collecting has been with us a long time; think of Noah assembling pairs of living creatures and herding them up a ramp and into the Ark. And since then, as individuals and the institutions they create have gone on to collect this and/or that, historians, anthropologists, sociologists, clinical psychologists and cultural critics have all tried to understand the motivations for and the impact of what clearly is a primal urge.

Freudians point to collecting as a mechanism for handling primary loss, a symbolic way to strive toward "completeness," and as a means to escape from the complexities and disappointments of human relationships into a world of objects over which control can be exerted. Less psychically fraught explanations for collecting suggest other causes and effects. Collecting is fun, an activity that provides excitement and enjoyment. It is a way to explore one's interest in or connection to history. It's a social activity that creates opportunities for mingling with and learning from those who share common interests. Collecting is rewarding, figuratively and literally. There are aesthetic and financial profits to be derived from material objects that are assembled, arranged and contemplated by one person and valued and desired by others. And in today's overheated art market, collectors are industry players; dealers, artists, curators, museum directors, and auction houses court them. Collectors influence the art that gets made, exhibited, talked about, bought and sold, and then gets bought and sold again.

The point of this short essay is neither to survey the history of collecting nor to excavate the deeper roots of Joseph Cohen's collecting interests. Still, it's hard to look at all of this artwork and not wonder, just a little, what might have prompted him to purchase and live with the

August Sander, c. 1920

In photography there are no shadows
that cannot be illuminated.

August Sander

Edward Steichen, Pola Negri, 1925

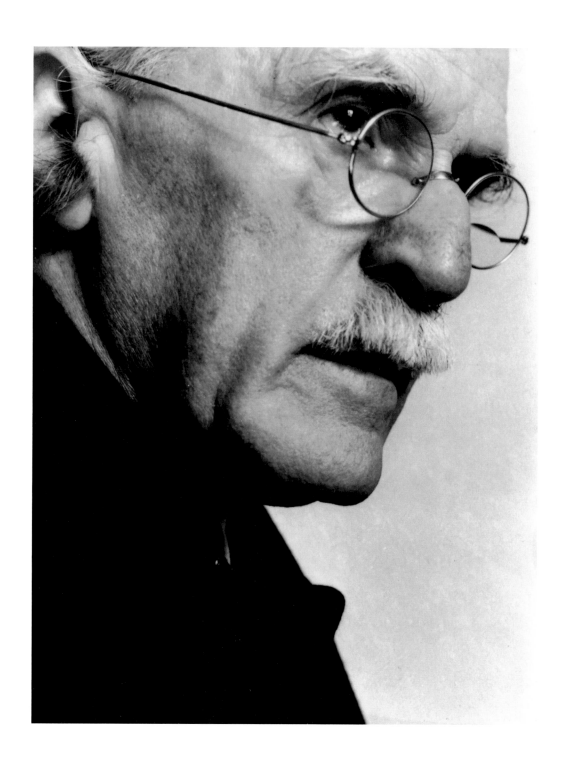

Dorothy Norman, Alfred Stieglitz, 1934

When Joe walks through the door, the gallery brightens with his energy. He loves pictures. Within seconds his quick glance scans the room and we are off conversing about the picture, the artist, and other concerns immediately brought to mind. Then another and, usually, another.

Howard Greenberg

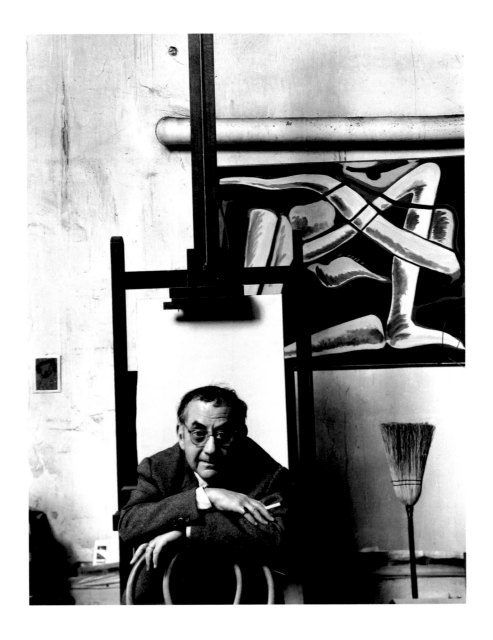

Arnold Newman, Man Ray, 1960

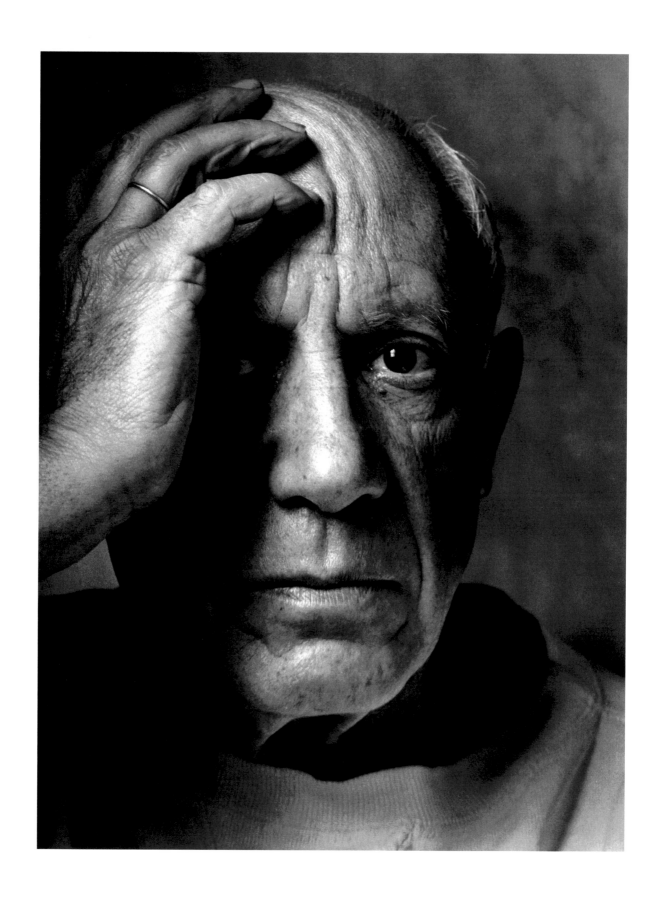

Arnold Newman, Picasso, 1954

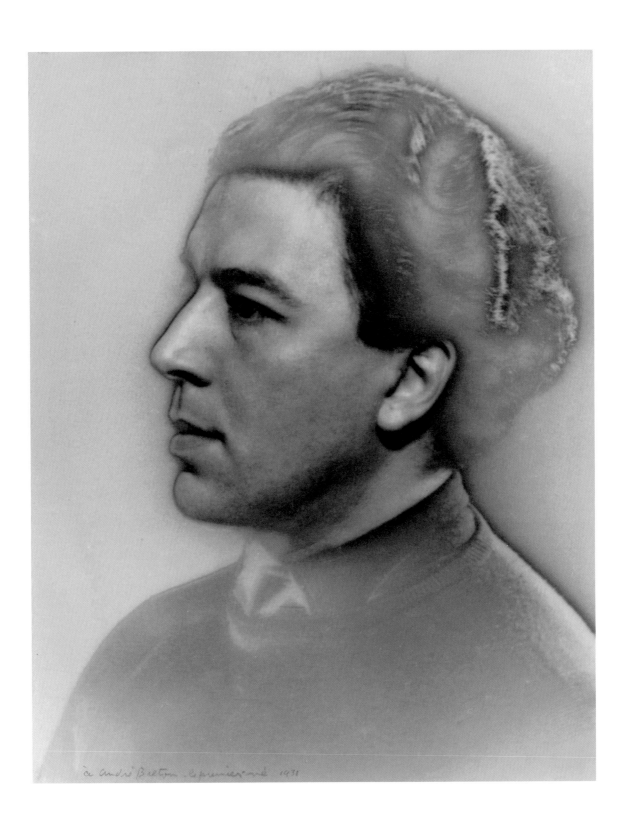

Man Ray, Portrait of André Breton, c. 1929

art on his walls. Or why Cohen, who has the interest and the means to acquire wonderful paintings and sculptures, seems drawn, time and time again, to photographic works of art. Is there some connection to be made between the urge to collect and collecting photography?

On the most basic of levels, photography itself is an extraordinary and unrivaled medium of collection. Point a camera toward anyone or anything, open the lens, and in a fraction of a second data floods in, more than optic nerves can handle, more than brains can tally and assess. Photography impresses and amazes us because cameras are, for the most part, mindless, meticulous, and the most insatiable of collectors; they accumulate detailed evidence of everything that light bounces off of. The vast amount of information gathered up in the process of image-making explains, to a large extent, why photographs satisfy and fascinate us, and why they can sustain intense and repeated viewings. Within the borders of every photographic image, we are as relieved as we are thrilled to see the world — or at least a representation of it — stopped in its tracks, reigned in, and neatened up.

We rely and depend upon photography to validate who we are, what we see, where we go, what we want, what we do and what we remember. But there are certain photographs that function differently, photographs that, no matter how often or closely we look at them, elude or keep on surprising us. Most often, those photographs are consciously made to encourage and even force us to actively consider what it is that we are looking at or looking for. Those are the kinds of photographs that can not be taken at face value, that raise more questions than they answer. And those are the kinds of photographs that Joe Cohen seems drawn to and taken with.

If art, for some people, is what Henri Matisse described as "a good armchair in which to rest from physical fatigue," many of the photographic works in the Cohen Collection suggest

an edgier set of interactions and benefits. Some reassure us that things are fine and as they should be. But the most interesting pieces stir up thoughts about things big or small, fast or slow, simple or complex or just too odd to take in easily. The sensuality and lushness that characterize the works in the Cohen Collection remind us that he, like most of us, responds to photography's seductive powers. But quite a number of the photographs are, in their self-conscious and quiet elegance, unsettling. Vera Lutter's camera-obscura negative images, bold and graphically striking, are hardly reassuring; they provocatively turn day into night and everyday experience inside out. Look long enough at Thomas Struth's oversized photograph of a lovely little Vermeer painting — isolated and spot lit on a deeply colored wall — and whatever sense of calm it might seem, at first, to represent dissolves into thoughts about vulnerability and cultural booty. Massive and gorgeous as the icebergs depicted in Lynn Davis's

Robert Frank, 1951

photograph are, they summon up images and phenomena far less magisterial or pristine: the sinking of the *Titanic* and the effects of global warming come to mind, almost simultaneously.

In fact, themes of uncertainty, abjection, fragility and risk recur with regularity in this collection. It is impossible to encounter Jeff Wall's slick and impressive light box without pondering why he's drawn attention to a spectacular, back-lit color transparency of something drab and decidedly unglamorous — a tree trunk ringed by cigarette butts and the stubble of saplings that have been chopped down. The men in Ruth Orkin's much smaller and quieter image, bundled up in heavy overcoats and pictured in the midst of a heavy snowstorm, may have only been waiting for a traffic light to change, but something sad, inevitable, and even more humbling seems to be in the offing.

Images of historical figures always interested me. Especially how they are posed. They reveal them as if naked. Newman's image of Krupp captured his malignity; Sugimoto's image of a wax statue of Napoleon showed his charisma. You can learn a lot from photos like these.

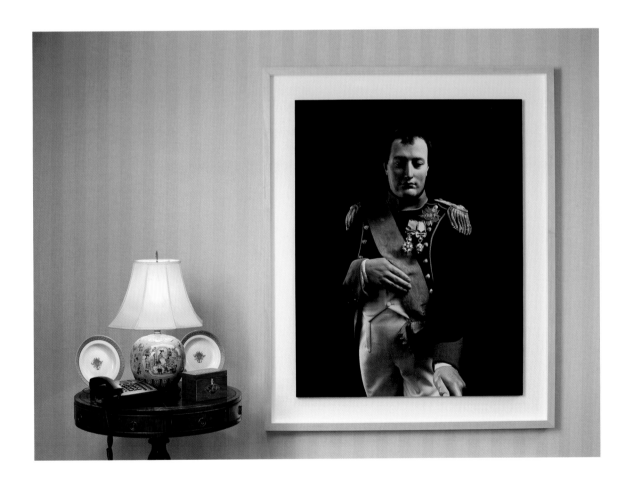

Hiroshi Sugimoto, Napoleon, 1999
Left: Arnold Newman, Alfried Krupp, 1963

Large photographic collections put together by men often include portraits of "great men," and Cohen's does too, but there are more than a few stately representations of historical figures whose accomplishments and character types are less than ennobling: Hiroshi Sugimoto's imposing yet creepy image of a wax figure of Napoleon; Arnold Newman's cool but ghoulish portrait of Alfried Krupp, Hitler's munitions mastermind; Steichen's celebrated image of financier and art collector J. P. Morgan, whose discomfort and simmering rage seem ready to boil up and burst through the picture plane.

In the Cohen Collection, even photographs that, at first glance, appear conventional in form and content inevitably seem to veer off into curious places. Commercial and fashion photographer Irving Penn's work shrewdly plays with and against expectations in elegantly crafted images, like his color still life filled with symbols of risk and addiction. André Kertész, one of twentieth-century photography's most lyrical and beloved romantics, produced his share of distorted and surrealistic images that reject the conventions that govern most nude studies of women. And Robert Mapplethorpe, best known for his etiquette-challenging, hypersexualized nude studies of men, is represented by flower studies so calculatedly unthreatening that they suggest the cynicism of a picture maker less concerned with classical timelessness than with testing what people will and will not buy or put up on their walls.

If there is a single message to be drawn from Cohen's photographic collection, it is that the photography is satisfying for both its specificity and its open-endedness. When we look at photographs, especially the ones we find ourselves returning to again and again, we pay homage to their specificity and the changing meanings we extract from or project onto them. Susan Sontag described this phenomenon in her classic book *On Photography*: "The ultimate wisdom of the photographic image is to say: 'There is the surface. Now think — or rather feel, intuit — what is beyond it, what the reality must be like if it looks this way.'

Photographs, which cannot themselves explain anything, are inexhaustible invitations to deduction, speculation, and fantasy." What better reason is there to collect photographs than that?

Marvin Heiferman

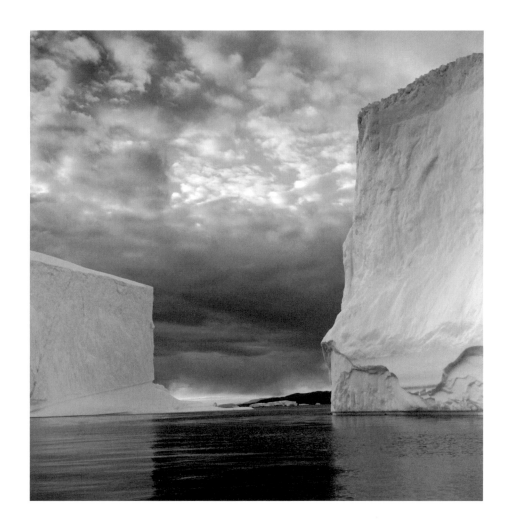

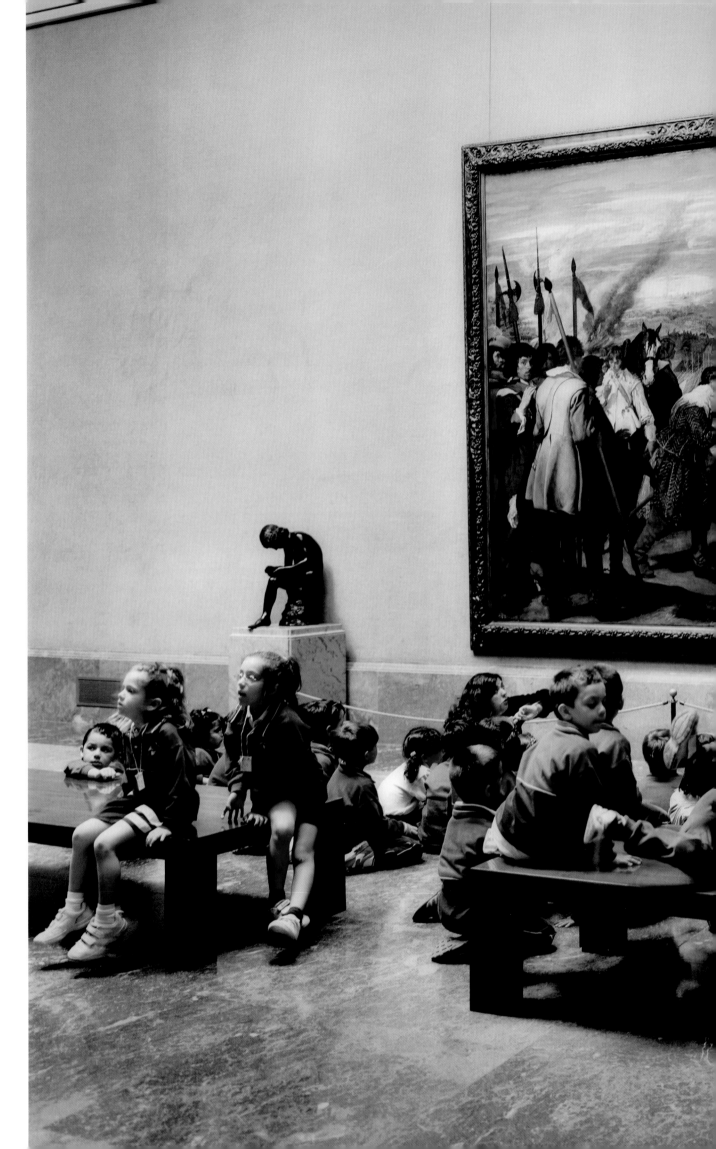

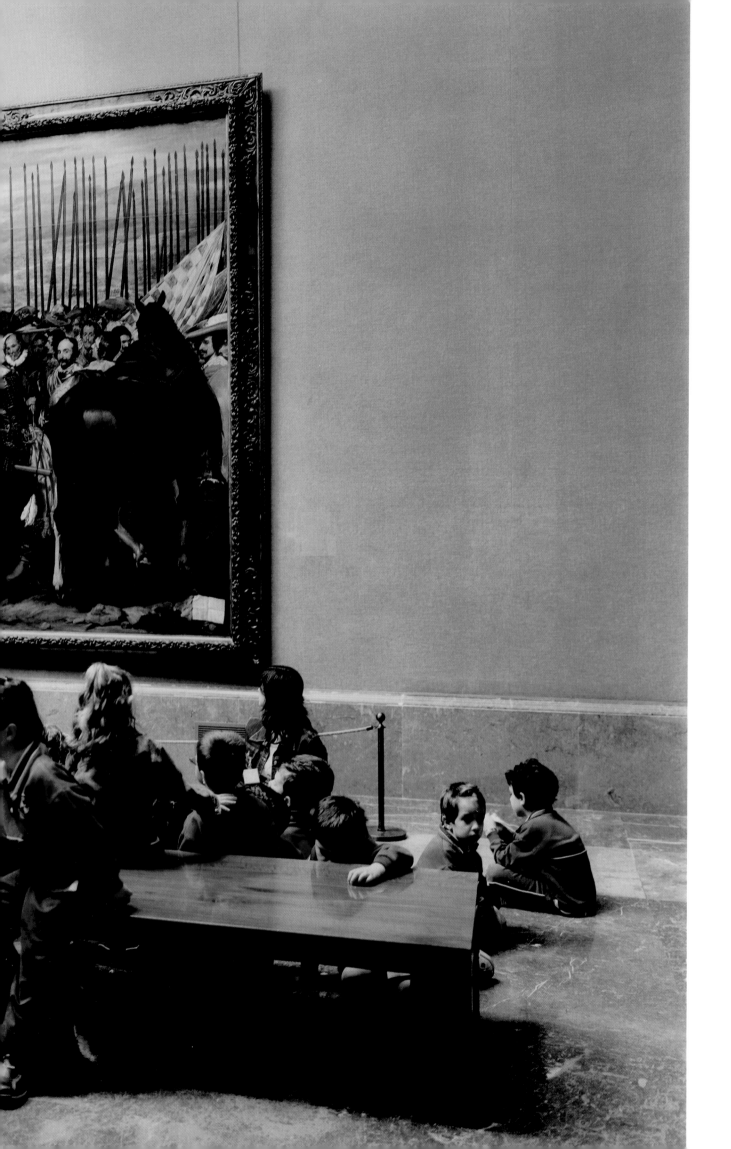

Afterword

I am often asked why I collect. That is the essential question of this book. I have had some difficulty in explaining it. I know it is an effort that gives me, and those around me, continuous pleasure. I am sure that the stimuli discussed in this book are all present in my continuing desire to seek and find objects of artistic excellence.

There is no medium that I am not drawn to, for it is not so much the package as the message that excites me. In recent years, it has been photography's message that has attracted my attention. I love this medium. I find it accessible and yet demanding. New artists arrive, established artists make new work. Yet, it is a medium I feel comfortable with. A week hardly ever passes that I do not visit a museum or gallery, review catalogues, peruse art books. In fact, hardly a day has passed when I haven't done this.

Living with art makes it an indispensable part of your life. Whether in New York or the country, I am greeted by it when I awake and comforted by it at day's end. Collecting also permits me to gather together new acquaintances — artists, dealers, museum curators and collectors. They add new dimensions and new vantage points to my thinking.

This is particularly true in the case of this book's editor. I have known Ray Merritt for over forty years. During that period, my respect, admiration and affection for him has grown. His steady hand has been invaluable in helping me navigate the rocky shoals of high finance. Over the years, I have grown more familiar with him and, I might add, dependent on him as my legal adviser. At some point, I learned of his other passion: art photography. I was thrilled when he agreed to undertake the task of creating this book. I had no idea of the magnitude of such a project and am enormously appreciative of the scholarship, energy and graciousness he has brought to that undertaking and of his shared passion for my collection. I have come to understand the depth of his ongoing commitment to the arts, particularly photography.

Irving Penn, 2007

What so fascinates me is what I have learned about the history and provenance of the works in my collection. I am often attracted to a work of art without fully appreciating where it fits into the artist's oeuvre or the medium itself. Often there is a backstory that imbues the art with an historical luster that makes it resonate. That was the unexpected dividend of participating in the prodigious efforts that went into preparing this book. That dividend included learning about the artists, the mediums and the quality of my collection. It necessitated travel, meetings and reading that would never have occurred except for the research and diligence this project required.

I also appreciate the generosity of those artists, dealers and curators who have helped me enhance my collection. I would particularly like to thank those who contributed their scholarship in the form of their excellent essays. In addition to Ray Merritt, they include Ward Bissell, Malcolm Daniel, Diane Dewey, Sarah Greenough, Marvin Heiferman, Robert Morgan, Robert Mowry, Sabine Rewald and Roger Ward.

Special thanks are in order for Caleb Cain Marcus. His contribution was substantial, his enthusiasm contagious. And I would be remiss if I did not thank those in my office — Linda, Michelle and Irene — as well as Marie Lillis, Cathy McCandless and Paula Glatzer for their tireless efforts.

Finally, I want to thank my sons as well as my daughters-in-law for their support of my passion. I know that their children will continue to be enhanced by the presence of art. I expect that this book will help in that process.

Joseph M. Cohen

Harry Callahan, Grasses in Snow, Detroit, 1943

About the artists Diane Dewey

Dieter Appelt (Danish, b. 1935)

Within Dieter Appelt's imagery, serial manifestations of built objects —
constructs that may later become sculptures — document movement.
Rings in water or patterns in stone that suggest a dynamic through time
are his muse. In the mid-'50s Appelt studied music, particularly the non-
traditional rhythmic patterns of Arnold Schoenberg. He met the experi-
mental photographer Heinz Hajek-Halke at the Academy of Fine Arts in
Berlin and first exhibited there in the mid-'70s. Appelt lives and works
in Berlin.

Eugène Atget (French, 1857-1927)

Eugène Atget, who was orphaned as a boy and educated by an uncle,
settled in Paris to sell his photographs of street life and buildings to
artists, architects and publishers as "documents" from which to work.
His bohemian sensibility and humanist interest in tradespeople, who
have been left behind by modernization, endured. Atget preferred a
nostalgic and dreamlike vision, enhanced by repositioning the lens
to create blurred figures, long exposures that resulted in wan light,
and an emptiness ensured by photographing in the early morning
before pedestrian traffic. The viewer is allowed to enter Atget's set-
tings alone and to experience them for what they are.

Richard Avedon (American, 1923-2004)

Richard Avedon quit high school and began taking photographs while
in the Merchant Marine. A year after his return to New York City, he
was hired as a fashion photographer. At the age of 23, he established
his own studio and went on to contribute to high-profile publications
from *Vogue* to *The New Yorker*. Avedon was known for photographing
his subjects at close range before a white background; antecedents are
seen in this early work, where the tension between the self-image the
sitter is trying to project and Avedon's response to that image provides
emotional content.

César Baldaccini (French, 1921-1998)

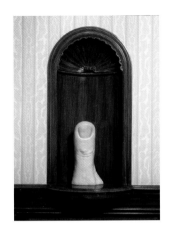

César was recognized late in life as France's representative at the 1995 Venice Biennale and had his first retrospective at the Jeu de Paume in 1997. Two of his seminal public sculptures, *Le Pouce*, a 40-foot-high replication of his thumb, and *Centaur-Homage to Picasso*, stand in Paris today. He originally studied at the Ecole des Beaux-Arts, Marseilles, and then entered the Ecole des Beaux-Arts in Paris in 1943. Beginning in 1965, compressions of cars and expansions, in polyurethane foam molds, of human imprints defined his oeuvre and solidified his stature as one of the foremost French sculptors. The Tate Gallery and the National Galleries of Scotland are among notable museums that have acquired his works.

Balthus (French, 1908-2001)

Although Balthus's paintings were meticulously crafted — often requiring over forty sittings — he felt they were sensed intuitively and irreducible. Mysteriousness was a cloak; the artist deliberately made his own identity nebulous. From the literary, intellectual and artistic salon that was his Paris home, Balthus engaged Rainer Maria Rilke as the catalyst to his career. Providing the book for his illustrations of felines, Gustave Courbet became his inspiration. Balthus's subtle control and matte renderings depicting precocious, adolescent female nudes stand as his most important body of work. Balthus served as director of the Villa Medici in Rome. His work was bequeathed to the Louvre through Picasso's collection.

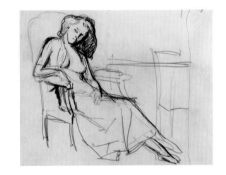

Antoine-Louis Barye (French, 1796-1875)

An epiphany occurred for Antoine-Louis Barye when his sculpture, *Tiger Devouring a Crocodile*, a departure from the human figures customarily exhibited, won a prize at an 1831 Paris show. Trained as a goldsmith, his early drawn animal studies transmuted to both large and small-scale sculpture. Barye imparted majesty, protectiveness and empathy for his lions. Admitted to the Ecole des Beaux Arts in 1818, following service in Napoleon's army, Barye's monumental works include *War, Peace, Strength and Order* and *Lion of the Column of July*. He was elected to the Academy of Fine Arts in 1868 and worked as a keeper of plaster casts at the Louvre. His works appear publicly at the Hermitage Museum, the J. Paul Getty Museum and The Metropolitan Museum of Art, New York.

Bernd Becher (German, 1931–2007)
Hilla Becher (German, b. 1934)

Bernd and Hilla Becher enrolled in the Dusseldorf Academy of Art during the German Socialist state that created the Berlin Wall. They developed an industrial archaeological record through their photography of "Lime Kilns," "Cooling Towers," "Blast Furnaces," "Winding Towers," "Water Towers," "Gas Tanks" and "Silos," chapter titles from their first book, *Anonymous Sculptures.* Both their subject matter and photography were engineered, not designed, and refused sentimentality, ideology and ornamentation. The couple married in 1961. Bernd and Hilla became renowned and influential teachers of photography. Some of their students have become preeminent photographers.

Fletcher Benton (American, b. 1931)

A member of San Francisco's Beat Generation during the 1950s, Fletcher Benton showed early paintings at The Place, and motorized three-dimensional paintings of nudes at Gump's, which closed the exhibition as obscene. Benton integrated kinetics, sculpture and paint, which represented his breakthrough to the vanguard of minimalist and motorized sculpture. *Blocks on Blocks,* his series done in the late 1990s, controls the effect of mass through positive and negative space and paint density. Benton began as a sign painter, graduating with a BFA from the University of Miami, Oxford, Ohio. Permanent collections include the San Francisco Museum of Modern Art, the Whitney Museum of American Art and the Neuberger Museum of Art.

Victor Brauner (Romanian, 1903-1966)

Victor Brauner perfected his oeuvre during his last decades when he synthesized surrealist genres and his lexicon of multicultural symbols into a modernist style. Brauner attended the School of Fine Arts, Bucharest and published the Dadaist review *75 HP*. Moving to Paris brought Brauner into contact with the Surrealists. His flight from Nazi persecution produced incised, encaustic works likened to Lascaux cave paintings. From the '50s, when Brauner exhibited in New York and at the Venice Biennale and resettled in Normandy, his aesthetic resolution of oneness and otherness transpired. "Each painting that I make is projected from the deepest sources of my anxiety," Brauner said. Permanent collections include The Metropolitan Museum of Art, the Peggy Guggenheim Collection and The Museum of Modern Art.

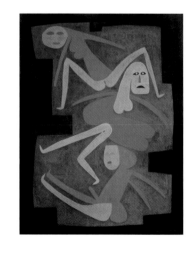

James Jackson Burt (American, 1954-1998)

Jamie Burt's sculpture is likened to the armature of a conceptual vessel; he began as a well-regarded ceramist who then gravitated toward sculpture. While there are metaphorical references in his work, Burt extends the tradition of David Smith's articulated ribcage in *Royal Bird*, 1948, remaining non-representational, and producing concave cradles of emotion or husks shed in nature. Following his education at the Studio School, New York, and abroad, solo exhibitions were mounted in Manhattan and Bridgehampton.

Caleb Cain Marcus (American, b. 1978)

The photographs of Caleb Cain Marcus calmly, quietly and deliberately protest the excess of an image-laden culture and offer a rich and tranquil alternative space. His work is as much about finding passion, beauty and the surreal in everyday life, as seeking it. Cain Marcus has worked with photographers such as Robert Frank, Dodo Jin Ming and Ralph Gibson to create his vision. This involves presence through absence, a twilight ambience and a sense of the spiritual that he captures as a small wonder. His work is included in the collections of the Norton Museum of Art, Delaware Art Museum and Lyman Allyn Art Museum.

Harry Callahan (American, 1912-1999)

Harry Callahan bought his first camera in 1938 and joined the Chrysler Camera Club where he worked in Detroit. Despite becoming an American photography icon, Callahan retained an unaffected perspective. His imagery vacillates between the personal and the epic, the narrative and the formal. He said, "I saw some grasses in the snow and photographed them . . . anti what Ansel was talking about, not at all classic." Callahan died in Atlanta in 1999. He left behind over 100,000 negatives and over 10,000 prints. The Center for Creative Photography at the University of Arizona maintains his archives.

Henri Cartier-Bresson (French, 1908-2004)

Henri Cartier-Bresson, the son of a wealthy textile manufacturer, studied in Paris with the cubist painter André Lhote, gaining an appreciation for surrealism and juxtaposition. "Photographic works are the simultaneous recognition of the significance of an event as well as of a precise organization of forms which give its proper expression." Cartier-Bresson traveled widely, recording the lives of ordinary people, with an instinct for the "decisive moment" that arrested time in fleeting images. In 1936, Cartier-Bresson collaborated with the French film director Jean Renoir, honing his sense of the dramatic. He joined the French Resistance, documenting the German occupation and its retreat. Together with Robert Capa and others, Cartier-Bresson founded Magnum Photos.

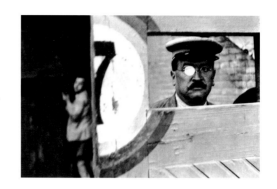

Marc Chagall (Russian, 1887-1985)

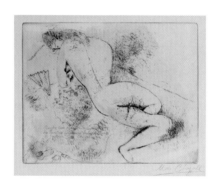

Marc Chagall moved from St. Petersburg to Paris in 1910 where he embraced the Cubist, Impressionist and Fauvist influences he studied. Referring to his Belarusian folk themes and dreamscapes, he declared, "I am out to introduce a psychic shock into my painting, one that is always motivated by pictorial reasoning; that is to say, a fourth dimension." This effect is evident in his nude drawings, gazing forward and back — future to past — secured on a torqued fecund body. Chagall also created famed public works testifying to persecution and war.

William Christenberry (American, b. 1936)

William Christenberry was born the same year that Walker Evans and James Agee toured the South. Almost thirty years later, Evans encouraged Christenberry to take his photographs seriously and not consider them simply as memory resources for his paintings. Christenberry became a master chronicler of his time and place — southern barns, storefronts, churches and signage. As a photographer, painter and sculptor, his work is personal and often reflects mythical themes. A series of 18 photographs called *Green Warehouse, Newbern, Alabama* were made between 1973 and 2004. He also memorialized that subject in a painting (1998) and sculpture (1978-79), documenting a building that has remained, miraculously, unchanged.

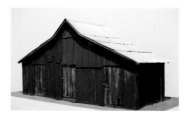

Gonzalo Cienfuegos (Chilean, b. 1949)

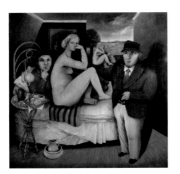

Gonzalo Cienfuegos exhibited at the São Paulo Brazil Biennal in 1989, when he received the Art Critics Circle Award, and has continuously exhibited in Chile, Argentina, France, Mexico and the U.S. His highly compressed interiors recall the Italian Renaissance. Alluding freely to historical art figures and embedding references to Goya, Magritte and Matisse, his compositions make for thoughtful meditation on past and present psychological themes. Cienfuegos studied at the School of Fine Arts, University of Chile.

Lucien Clergue (French, b. 1934)

Lucien Clergue is an archetypical Renaissance man who studied under Roland Barthes, received his doctorate from the University of Provence, Marseilles, and produced books, films and photographs. The camera was a way out of an adolescence that included the World War II bombing of his home and subsequent death of his mother. In the '50s and the '70s, Clergue made his signature nude photographs of undulating torsos. That physicality was replicated in bullfight images and later studies of organic fragments connoting loss and decay. Picasso endorsed his work; Cocteau and other artists joined with him to form an intellectual corps.

Chuck Close (American, b. 1940)

Chuck Close is an artist whose vision was forged early on in a full-fledged synthesis of minimalist, conceptual, and process art practices, combined with his own unique image-making. That has placed him in the center of vanguard art production since the mid-'60s and made him one of the most influential artists of our time. Close first experimented with the Polaroid in the late '70s because of its capacity for immediate feedback. The large-format camera made images that were of great interest to Close: large in scale and with extremely fine resolution. "It was the first time I considered myself a photographer," he says. Beginning in 1988, Close faced personal and artistic changes after suffering a collapsed spinal artery that initially left him paralyzed from the neck down. With time, his condition improved, and, though dependent on a wheelchair, he was able to begin working again.

Jeff Cowen (American, b. 1966)

Jeff Cowen is a photographer known for painterly photo murals, photo collages and street photography. His early images of prostitution in New York City are in the permanent collection of the New-York Historical Society. Cowen's images of the Romanian Revolution appeared on front pages around the world in such papers as *The Guardian* and the *Tel Aviv Post*. He worked as assistant for photographers Larry Clark and Ralph Gibson. Cowen then studied drawing and anatomy at the Art Students League of New York and the New York Studio School. In 2001, he moved to Paris and is currently based in Berlin. Cowen received the Thomas Cooke Award for Photography in 2004.

Tony Cragg (British, b. 1949)

In 1988, Tony Cragg won the Turner Prize for his sculpture and represented Britain at the Venice Biennale. He studied at the Wimbledon School of Art and the Royal College of Art. Cragg moved to an abandoned factory in Wuppertal, Germany, near his teaching post at the Dusseldorf Academy in 1977. He has been described as one of the "best straight-up abstract sculptors now at work in the world" by Peter Schjeldahl, and his works are included in the permanent collections of The Tate Gallery, The Hirshhorn Museum and The Nasher Sculpture Center. Cragg calls his sculptures "fictional entities," abstractions that allude to something we may have seen before or fantasized about.

Lynn Davis (American, b. 1944)

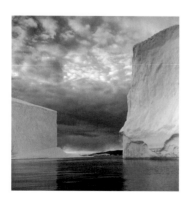

Born in Minnesota, Lynn Davis graduated from the San Francisco Art Institute in 1970, and in 1974 became an apprentice to Berenice Abbott. Davis's first exhibition at the International Center of Photography in 1979 included figurative work. But in 1986, while photographing icebergs in Greenland, she reached an aesthetic epiphany using monumental landscapes, architectural forms and, subsequently, cultural and architectural icons as her subject matter. Davis often utilizes vintage cameras and employs split-toning to produce a restrained but majestic look.

Maurice-Quentin de La Tour (French, 1704-1788)

A famed portraitist of the French aristocracy, Maurice-Quentin de La Tour's enduring legacy began when he entered the studio of Jacques Spoede at the age of 15 and, in 1727, emerged with a precise style in pastel that captured his subjects in thoughtful, articulate renderings. His achievements — as documentaries and masterpieces — were exhibited at the Paris Salon in 1737 and remained in favor at court for fifty years. La Tour was granted admission into the Academie de Peinture et de Sculpture in 1746. In addition to sharing his riches through philanthropic art prizes, he bequeathed his works primarily to the Louvre. His work is also part of the permanent collections of The Metropolitan Museum of Art and the Getty Museum.

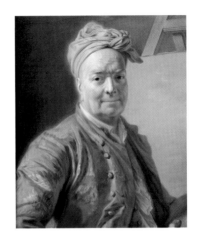

Pedro De Movellan (American, b. 1967)

A kinetic sculptor, Pedro De Movellan explored wooden boat hull construction before attending Rhode Island School of Design, after graduating from the University of Massachusetts. De Movellan creates metallic astrolabes that function as aesthetic objects, two-dimensional wood sculptures in tiger maple, brushed or painted aluminum with magnets that ascend, rotate or move according to their geometric distribution. His "performance mechanisms" have been shown at international art fairs and are included in prestigious private and corporate collections.

Richard Deacon (British, b. 1949)

Richard Deacon's sculptural works range in scale from miniature to monumental — *Moor,* 1990, a public commission, is 810 feet long — combining sensory and intellectual information to create undulating ribbon-like forms or open volumetric shapes. Deacon, who studied at the Royal College of Art, represented Wales at the Venice Biennale, 2007, and won the Turner Prize in 1987. He says there is no hierarchy among structure, material and form in his work. It is part of the permanent collections of the Cass Sculpture Foundation and the San Francisco Museum of Art.

Edgar Degas (French, 1834-1917)

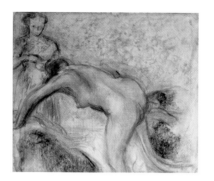

The rendering in art of his fascination with movement — depictions of women in their baths or performing handwork; renderings of ballet and horseracing — exemplifies Edgar Degas's mastery of fluidity. The artist drew late pastels when he was nearly sightless, Japanese-influenced compositions where obliquely positioned figure forms dominate, preserving a sense of intimacy and mystery. "It's a transformation during which the imagination collaborates with the memory . . . their recollections and fantasies are freed from the tyranny exerted by nature," Degas said. Degas attended Lycée Louis-le-Grand and Ecole des Beaux Arts. His Durand-Ruel (1892) solo exhibition ultimately secured his preeminent stature. Permanent collections are housed in the Detroit Institute of Arts, the Städel Museum, the Tate Gallery and other museums worldwide.

Charles Demuth (American, 1883-1935)

"Search the history of American Art and you will discover few watercolors more beautiful than those of Charles Demuth," said Ken Johnson's *New York Times* critique. Demuth's studio overlooked his beloved garden. Trained at Drexel Institute of Art, Science and Industry and the Pennsylvania Academy of the Fine Arts, his life with the avant-garde in Paris and further courses at Académie Colarossi and Académie Julian precipitated the movement Demuth quintessentially manifested — Precisionism, a refinement of Cubism. His work entered the permanent collections of the Fine Arts Museums of San Francisco, the Whitney Museum of American Art, The Phillips Collection and others, some bequested through Georgia O'Keeffe.

Philip-Lorca diCorcia (American, b. 1953)

Known for his formally staged photographs of seemingly offhand scenes a viewer feels he has wandered into, diCorcia attended the School of the Museum of Fine Arts, Boston, then graduated with a master's degree from Yale. His often-unknown subject's presence is integral to his imagery; one becomes a voyeur who happens on a tableau eliciting variable responses — the spontaneity and anonymity of a Rorschach test. "So Baroque and cinematic is the stagecraft here that diCorcia rigged a flashbulb in the fridge so it would go off just at the instant the door opened," wrote art commentator Marlena Donohue.

Rineke Dijkstra (Dutch, b. 1959)

Rineke Dijkstra has emerged as an iconic photographer of her generation with her frank, full-length portraits of subjects posed in the way of their choosing, at once unpretentious and self-conscious. As in her self-portrait in a bathing suit — the artist began swimming to overcome illness — Dijkstra's subjects often appear defenseless and vulnerable. A seminal series of adolescents in wet swimsuits depicts this dichotomy. When the subject is unprotected, the viewer is apt to be compassionate: "I want to awaken definite sympathies for the person I have photographed," Dijkstra said.

Mark di Suvero (American, b. 1933)

Prominent as an abstract expressionist sculptor, Mark di Suvero's work embodies humanity's use of symbols as "a springboard into dreams, poetry and the . . . internal feeling of one's life." Di Suvero constructs found objects in heavy gauge metal, eventually focusing on the I-beam's energy and thrust. His monumental works in the public landscape have generated critical acclaim and a receptive presence for over half a century. Di Suvero studied at the University of California, Berkeley, then moved to New York as a construction worker. Awards include the Lifetime Achievement in Contemporary Sculpture Award from the International Sculpture Center and the Heinz Award in 2005. Permanent collections include the Storm King Art Center, The Museum of Modern Art and The Museum of Fine Arts, Boston.

Desiree Dolron (Dutch, b. 1963)

For several years, Desiree Dolron traveled around the world. Everywhere she went she created with her camera a uniquely personal record. Julia Margaret Cameron's elaborate costuming, as well as old masters portraiture, figure prominently in Dolron's photographic influences. She is recognized for her skill with computer enhancement to create serenely lifelike portraits and vignetted studies. A retrospective of Dolron's work was presented by The Hague Museum of Photography in 2005. Her stark chiaroscuro manifests the subtlety of a period, yet is a compellingly modern vision of youthful beauty.

Frantisek Drtikol (Czech, 1883-1961)

Frantisek Drtikol became an acclaimed portraitist in Prague during the early decades of the twentieth century, following his studies in Munich. This success enabled him to develop the work for which he is known — stylized nude studies that employ contrasting geometric sets and props and refer to Bauhaus aesthetics, many of which were published in the now classic book *Zena ve Svetle* (1930). Drtikol maintained an interest in Theosophy, Buddhism and Anthroposophy, which taught that through the limb's movement we absorb the world's movement, manifesting our spirit. Drtikol gave up photography completely in 1935 to pursue painting, meditation and Oriental philosophy. The first exhibition of his work was held in 1972.

Jean Dubuffet (French, 1901-1985)

Capturing twentieth-century alienation through his Art Brut style, Jean Dubuffet believed that vital instincts should prevail over schooled thought; preservation of raw energy and spontaneity was at the core of his figure painting. Ambivalent about even his own enormous talent, Dubuffet was educated in Le Havre, then enrolled at Academie Julian, but withdrew. He tried business enterprises for a short period, but dedicated himself to art in 1942. Innocents — asylum inmates and children — served as muses; his contempt for notions of beauty "inherited from the Greeks and cultivated by magazine covers" presaged contemporary art. Dubuffet's work was exhibited in worldwide retrospectives during the '50s. His works are in the permanent collections of the National Gallery of Art, the Kuntsmuseum Basel and the Tate Gallery.

Harold Edgerton (American, 1903-1990)

Harold Edgerton experimented with *Milk Drop Coronet* from the '30s through the '50s, seeking to achieve a perfect coronet. The stroboscope equipment he invented and used at MIT to study synchronous motors for his doctoral thesis caught mundane objects in motion. Photographing a stream of water bridged science and aesthetics and posed the question: What are we missing with the naked eye? Edgerton was honored by the Royal Photographic Society (1934) and won the National Medal of Science (1973), and, in 1987, *National Geographic* published an article entitled "Doc Edgerton: The man who made time stand still."

Walker Evans (American, 1903-1975)

Walker Evans began taking photographs in 1930 to avoid writing prose, yet his photographs impart the story of forgotten America. He studied literature at Williams College and the Sorbonne, citing Flaubert and Baudelaire as influences. Evans's photographs implicitly question whether a thing is beautiful. His seminal work for the Farm Security Administration (FSA) — unflinching portraits of American farmers taken primarily with an 8 x 10 camera; expressionless with pain emanating through eyes, skin and pores — earned him a 1971 MoMA retrospective. He is considered one of the most important American photographers of the twentieth century.

Eric Fischl (American, b. 1948)

Eric Fischl is one of America's foremost painters. His subjects — realistic nudes, populated landscapes and interiors — provide a significant gloss on our own experience. Peter Schjeldahl speaks of Fischl's "intimacy and immediacy," relating his significance as "the first great painter of the U.S. in national decline." Fischl's work has been exhibited in innumerable institutions, including the Institute of Contemporary Art and the Stedelijk Museum. Described as a neo-expressionist, Fischl says, "Central to my work is the feeling of awkwardness and self-consciousness . . . in the face of profound emotional events." Countless permanent collections include his work, such as those at the Broad Art Foundation, the Walker Art Center and The Museum of Modern Art, New York.

Barry Flanagan (British, b. 1941)

Since 1973, Barry Flanagan has focused on monumental hare sculptures in bronze that celebrate their sense of freedom and joy. "Choosing the hare to behave as a human does occasionally," Flanagan represented Britain at the Venice Biennale in 1982. His anthropomorphic works are publicly installed internationally. Flanagan was trained at Birmingham College of Arts and Crafts and at St. Martin's School of Art, and had exhibitions at The Museum of Modern Art, New York (1974), Centre Pompidou, Paris (1983) and the Tate Gallery, London (1986). Permanent collections that have his work include the Hirshhorn Museum, the Courtauld Institute and the Walker Art Center.

Mark Francis (British, b. 1962)

Shown in the groundbreaking *Sensation* exhibition at the Royal Academy in 1997, Mark Francis's paintings suggest platelets, alternating transparency and translucence, on which microscopic spores are configured on interspersing grid placements, while others migrate freely, alluding to man-made or natural mapping, time elapse, and integrating/disintegrating processes. Francis combines photo-realist painting, utilizing similar techniques to Gerhard Richter's equally immaculate surfaces, with scientific investigation and poetry. The resulting "mutual metaphor of microscopism as abstraction, abstraction as microscopism" described by the Tate Gallery curator, John-Paul Stonard, has earned Francis the Public Art Development Trust Award. His work is also in the collections of the Saatchi Gallery and The Metropolitan Museum.

(detail)

Robert Frank (Swiss, b. 1924)

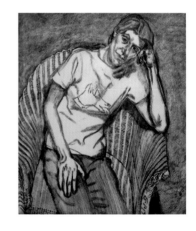

A 23-year-old Robert Frank cast off his family's expectations and immigrated to New York. From his experience as an apprentice to Swiss photographers, he landed a job at *Harper's Bazaar*, where fashion assignments occasioned travel. America provided his lifelong focus; a Guggenheim Fellowship allowed him to produce the imagery contained in the important monograph *The Americans*. Beat writers embraced his work and Frank gained momentum as one of the most influential photographers of his time. Frank once remarked, "You can capture life, but you can't control it." His work is in the collections of the Corcoran Gallery of Art, The Metropolitan Museum of Art and the Whitney Museum of American Art.

Lucien Freud (British, 1922)

Lucien Freud is considered one of the preeminent figure painters of his time. The subject of his paintings from the '50s onward is the body's encoding of signals. Choosing portraiture subjects for "how they happen to be," Freud allows nonverbal messages to flow through skin porosity, texture, posture, mass, comportment and facial attitude. Called "the Ingres of Existentialism" by critic Herbert Read, Freud's works often have a brooding sense and a brutal frankness about them. His works can be found in permanent collections throughout the world, including the Thyssen-Bornemisza Museum, the National Portrait Gallery and The Museum of Modern Art.

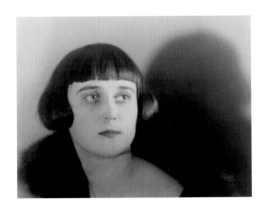

Jaromir Funke (Czech, 1896-1945)

Jaromir Funke became a freelance photographer after abandoning medical and legal studies. He was intellectually drawn to cubism and constructivism, which he sought to interpret through photography. His work was informed by Man Ray's otherworldly photograms and by the constructivist geometries of Frantisek Drtikol. A member of the Czech avant-garde during the '20s and '30s, he cofounded the Czech Photographic Society with Josef Sudek and Adolf Schneeberger. Funke taught photography at the School of Arts and Crafts, Bratislava, and continued to publish the avant-garde journal *Photographic Horizons* for several years after Czechoslovakia fell under Nazi occupation.

Adam Fuss (British, b. 1961)

Adam Fuss moved to New York in 1982 and took up an assortment of odd jobs. He then began his career in photography. He is known for his fleeting imagery in compositions executed in pinhole photographs, photograms and daguerreotypes. The lace tracery of the christening gown forms a visual echo — Fuss's term. A ghostly, luminous presence inhabits his work, which informs it with psychological impact.

Orazio Gentileschi (Italian, 1562-1639)

During Orazio Gentileschi's stay in London at the court of King Charles I, he produced eleven easel paintings in the Royal Collection, nine ceiling paintings in the Queen's House in Greenwich — now Marlborough House — for Queen Henrietta Maria, sister of Louis XIII, and canvases for George Villiers, first Duke of Buckingham, the king's favorite, who brought Gentileschi into his household. It was during this period that Gentileschi painted *Joseph and Potiphar's Wife*. His network of patronage began when he, as one of Caravaggio's most important students, executed splendid public ecclesiastical projects in Rome, Genoa and then in Paris. His works are imbued with classicism, tempered by a warm, satisfying palette.

Ralph Gibson (American, b. 1939)

Renowned for his series *The Somnambulist*, *Days at Sea* and *Deja-Vu*, Ralph Gibson studied at the San Francisco Art Institute and worked as an assistant to Dorothea Lange and, later, to Robert Frank. Gibson is considered a master of surreal photography; his images possess subtlety with a powerful punch line. His cinematic vision — sweeping the viewer into a scene full of innuendo — is included in such public collections as The Metropolitan Museum of Art, The National Gallery of Art, The Museum of Modern Art, the Whitney Museum of American Art, the Norton Museum and the Museum of Fine Arts, Houston.

Laura Gilpin (American, 1891-1979)

Laura Gilpin lived close to the land on her family's ranch in the Rockies until she went to study at the Clarence H. White School of Photography in New York. She shed the soft-focus imagery derived from her pictorial training and took a hard-edged approach to photographing the Southwest landscape and the Pueblo Indians and the ruins of their Anasazi ancestors. Ultimately, it was the Navaho people to whom she devoted her career. *The Enduring Navaho,* published in 1968, was regarded by the Navajo themselves as a truthful and compassionate record of their lives and secured Gilpin her place in anthropological and photographic history.

Allen Ginsberg (American, 1926-1997)

Allen Ginsberg was a poet and collaborator with fellow members of the Beat generation, including Jack Kerouac and William Burroughs, finding common ground through discourse and drugs in San Francisco, New York and Paris with Peter Orlovsky and Gregory Corso. Mentored by William Carlos Williams, Ginsberg read his seminal *Howl* at The Six Gallery in 1955. He published *The Fall of America* and bonded with cult figures: Timothy Leary, Ken Kesey, Rod McKuen and Bob Dylan. Graduating from Columbia University as a Woodberry Poetry Prize winner, Ginsberg embraced Hinduism and Buddhism, espoused opposition to obscenity laws and homophobia, and served as a dissident influence acknowledged by leaders such as Vaclav Havel as an inspiration to pursue freedom.

Pierre Gonnord (French, b. 1963)

Pierre Gonnord was born in France, and has spent the last twenty years working primarily in Spain. His portraiture is gaining international respect. In 2008, his images were featured at Rencontres d'Arles, in an exhibition curated by Christian La Croix. Although his subjects are people, his renderings leave the impression that they are metaphors for the weightiness of life, and those metaphors are measured by his subjects' eyes. There is a Velázquez-like nobility to his photographs. The image in the Cohen Collection, *Los Montayas*, is of two brothers from a hardworking Gypsy family that wanders continuously through Catalonia and the southern extremes of France, an area very important to Gypsy culture.

Arshile Gorky (Armenian, 1904-1948)

Arshile Gorky's family became refugees from the Turkish invasion of Armenia. He left in 1915 and finally arrived in the United States in 1920. He settled in Massachusetts. By 1922, he was teaching at the New School of Design in Boston. In 1925 he moved to New York. Haunting and lyrical, Gorky's figurative works give vent to repressed emotion with the styles reminiscent of Picasso and Cézanne. He found his strongest artistic voice in biomorphic abstraction and an association with the Surrealists, especially André Breton. A succession of personal tragedies, including a fire in his studio that destroyed much of his work, a serious operation and an automobile accident, preceded Gorky's death by suicide in 1948.

Jan Groover (American, b. 1943)

After attending Pratt Institute in Brooklyn and Ohio State University, Jan Groover took a teaching position in painting at the University of Hartford. Her work consisted of minimalist abstractions. Photography, which she discovered in the late '70s using a 4 x 5 camera, led to arrangements of everyday subject matter, particularly the *Kitchen Still Life* series. "With photography," she said, "I didn't have to make things up; everything was already there." She developed a formalist style of photographing, using reflective metals to create painterly effects and illumination.

Nicola Hicks (British, b. 1960)

Nicola Hicks's hybrid animal/human sculptures begin as charcoal drawings, become straw and plaster constructions and are later cast in bronze, a process that retains the artist's gestural process. The underlying straw suggests a gash or stroke. Hicks reminds us of "the qualities we are deeply in touch with sub-consciously" by commingling human psychology with animal instinct, menace, enchantment and fear. She is considered one of her generation's foremost art-ists, having studied at the Chelsea School of Art and the Royal College of Art and garnering the first of many museum exhibitions, *Furtive Imagination*, at the Whitworth Art Gallery in 1996. Permanent collections displaying her work include the Tate Gallery, London, the Chase Manhattan Bank and the Castle Museum, Norwich.

David Hockney (British, b. 1937)

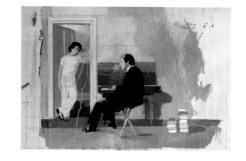

Exhibiting with the Young Contemporaries in 1961, David Hockney became synonymous with the British Pop movement. Hockney reconfigured his intentionally rudimentary style to give expression to his gregarious wit. Moving to Los Angeles in 1963 provided Hockney with the lifestyle and landscape with which he became identified: sophisticated and stylish scenes with iconic swimming pools. Later, his seminal *A Bigger Grand Canyon* series, graphic investigations of geological strata ren-dered in a warm palette, cemented his stature. Set designs for the Royal Court Theatre, La Scala and the Metropolitan Opera in New York exposed Hockney's protean skills. His work is in the permanent collections of The Museum of Contemporary Art, Los Angeles, the J. Paul Getty Museum and The Metro-politan Museum of Art.

Candida Höfer (German, b. 1944)

Candida Höfer's work, a study of vacancy within architectural environments, emerged from the Kunstakademie Dusseldorf and photography classes with Bernd and Hilla Becher. In large-format photographs she projects both the vastness of public spaces and their intimacy. Each space becomes an entity apart from its function. Höfer is considered one of the greats of an inter-national photographic community. Her work is found in the collections of the Centre Pompidou, the Museo Nacional, Centro de Arte Reina Sofia, the Norton Museum of Art and the Getty Museum.

Patrick Hughes (British, b. 1939)

Although Patrick Hughes studied art at Leeds Day College, he cites as his primary influences his hiding, as a youth during the bombing of London, beneath a stairwell that created a reverse perspective, Magritte's paintings for the way they "think," and books by Ionesco, Kafka and Lewis Carroll. Hughes's "stick-out" paintings bridge painting and sculpture. His sculpture, included in the collections of the Denver Art Museum, the Duke University Museum of Art and The British Library, points to paradoxical experience, the impossible happening and to "a sense of the flow of life."

Cristina Iglesias (Spanish, b. 1956)

Returning to work that references the body, either directly or as an "absent presence," Cristina Iglesias incorporates sculpture, drawing, video and photography in installations that envelop the viewer. Her works are documented through large serigraphs integrated into the piece, resonating and adding layers to the complex arrangements. "They . . . evoke a sense of being hedged from life, yet the insulation from devastating passion, suffering and decay seemingly promised by her embracing forms is illusory," writes Barbara Maria Stafford in her essay *Wanting Shelter*, in the catalogue from the Solomon R. Guggenheim exhibition of 1997. Iglesias's work represented Spain at the 1993 Venice Biennale and is found in the permanent collections of The Geffen Contemporary and the Guggenheim Museum in Bilbao.

Fré Ilgen (Dutch, b. 1956)

Fré Ilgen refers to his search for a "New Baroque," engaging the fields of science, philosophy and visual arts in an idiosyncratic blend of gestural painting and geometric sculpture through which he synthesizes Oriental and Occidental sensibilities. Critic Donald Kuspit describes Ilgen's work as "painterly constructions and constructed paintings (his own dissolving of duality)." An art theorist, Ilgen produced his seminal book, *ART? No Thing!* in 2004. Ilgen exhibits internationally and his work is found in the collections of The Museum of Modern Art in Hunfeld, Germany, the Pietzsch Collection, Berlin and the Foundation for Constructive Art in Calgary, Canada.

Kenro Izu (Japanese, b. 1949)

The Sacred Within, Kenro Izu's Bhutanese landscape and portrait photographs — produced by trekking the Himalayas with 300 pounds of cameras, printing onto watercolor paper from 14" x 20" negatives and enhancing the process by adding a light-sensitive platinum chloride solution — deliver an actuality and an aura that create a halo-like effect. The tenderness of his children invites references to Cartier-Bresson. "I try to use my basic instincts, like an animal sensing danger. I want to be as pure, as empty as possible and just try to document the spirituality of the place," Izu says. He studied at Nihon University and through his efforts raised the funds to build and maintain the Angkor Wat Hospital for Children. Some public collections that include his work are the Arthur M. Sackler Gallery, the Boston Museum of Art and the San Francisco Museum of Modern Art.

Peter Keetman (German, 1916-2005)

Peter Keetman's photography examines abstraction and structure — often through the use of wire screens and water nodules. That work established his reputation in *Subjektive Fotografie* and as a leading member of the postwar generation of German photographers. Trained at the Munich Photographic School, he worked in Gertrud Hesse's studio and studied with Adolf Lazi. In 1949 Keetman helped found the group Fotoform, dedicated to photographic innovation.

Ellsworth Kelly (American, b. 1923)

Ellsworth Kelly's compositions have engaged in a dialogue with color since the '50s in Paris, when he created monochromatic "painting – objects." Kelly's sculptural forms — an approach he sees as "more real than depiction" — isolated form as "shaped canvases" that became minimalist sculptures. His crossover philosophy includes compellingly spare drawings from nature: "By removing the content from my work I shifted the visual reality . . . to include the space around it," Kelly says. The artist studied at the Pratt Institute, Ecole des Beaux Arts and the School of the Museum of Fine Arts in Boston. His works are part of the permanent collections of the Art Institute of Chicago, the Dallas Museum of Art and the National Gallery of Art. His goal is to impart "good spirit" through his "love of color in life."

André Kertész (Hungarian, 1894-1985)

Two world wars punctuated the artistic periods of André Kertész's life. An autodidactic photographer whose early subjects were Hungarian peasants, Kertész was serving in the army when a news magazine published his work. A 1925 move to Paris brought success in print publications, an association with the Dadaists and portraits of celebrated figures — Colette, Chagall and Mondrian. Solo exhibitions of Kertész's emotionally charged work ensued. The Nazi threat forced Kertész and his wife's departure to New York. Eventually the Art Institute of Chicago recognized Kertész with an exhibition in 1946, which liberated him from commercial contracts. He was made a Commandeur of the French Ordre des Arts et des Lettres in 1974 and received the Master of Photography Award from the International Center of Photography. In 1984, The Metropolitan Museum of Art purchased 100 Kertész prints, its largest-ever acquisition of works by a living artist at that time.

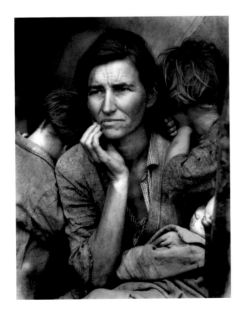

Dorothea Lange (American, 1895-1965)

Dorothea Lange is one of the best of the American photojournalists. Born in Hoboken, New Jersey, she was abandoned by her father and contracted polio at the age of seven. Both events left her scarred for life. The polio left her lame. She worked in the photography studios of Arnold Genthe and Charles H. Davis and attended Clarence White's photography class at Columbia University. She moved to California where she opened a portrait studio in 1919. That business collapsed during the Depression. Lange's imagery potently illustrated the plight of American lives disrupted by economic hardships. In 1935, she joined the federally sponsored Farm Security Administration, working with such notables as Arthur Rothstein, Carl Mydans, Walker Evans and Ben Shahn. While many of her images are iconic, one, *Migrant Mother*, is without equal. Many critics consider it the most important American photograph of the twentieth century. In 1945, she was invited by Ansel Adams to join the faculty of the first art photography department at the California School of Fine Arts. In 1952, Lange cofounded the photographic magazine *Aperture*.

Annie Leibovitz (American, b. 1949)

One of the world's best-known photographers, Annie Leibovitz studied photography while a painting student at the San Francisco Art Institute. *Rolling Stone* hired her and gave her the assignment that symbolized her oeuvre, a cover portrait of John Lennon. Within a decade she had shot 142 covers, published scores of news photo essays and created ad campaigns before joining *Vanity Fair* and *Vogue.* Leibovitz fuels the celebrity drive to concoct public identities and participates in our quest to seek them out. Her free associations led to the staged settings that form her compositions.

Julian Lethbridge (British, b. 1947)

It has been observed that Julian Lethbridge's paintings make time stand still in the sense of inviting closer examination of surface detail; his rhythmic buildup of paint and use of hard gloss and raised edges to form a topography and his extraction of a subject from the whole make him one of the better articulators of abstraction today. His interlocking patterns show an indebtedness to Jasper Johns, yet they also show Lethbridge's interest in exploratory paints, physicalities and process. Lethbridge was schooled at Winchester College and Cambridge University. His works appear in the permanent collections of the National Gallery of Art, The Metropolitan Museum of Art and the Whitney Museum of American Art.

Roy Lichtenstein (American, 1923-1997)

Roy Lichtenstein's iconic paintings engage the more predatory aspects of mass imagery through his appropriation of Benday dots and comic book illustrations to render these themes in a visual onomatopoeia: "The closer my work is to the original, the more . . . critical the content" regarding "things we hate, but which are also powerful in their impingement on us." From the telephone book, he drew inspiration from furniture ads for his interiors series. Lichtenstein attended the Art Students League and Ohio State University. His first one-man show was at the Leo Castelli Gallery (1962). A museum retrospective at the Pasadena Art Museum (1967) followed. Traveling exhibitions throughout Europe culminated in a retrospective at The Solomon R. Guggenheim Museum in New York (1993).

Vera Lutter (German, b. 1960)

Vera Lutter imprints architectural imagery on large-size paper mounted in blackened rooms or shipping containers, which she may inhabit for the hours, days or weeks it takes to engineer her photographs via the camera obscura process. Like an animal caught in headlights, the object is revealed, sometimes iteratively, in an exposure as intimate as an X-ray. Her unique prints oppose instancy yet embrace modernity. Lutter graduated from the School of Visual Arts, New York, and the Academy of Fine Arts, Munich, and received a Guggenheim Fellowship, a Pollock-Krasner Grant and an exhibition at the Museum for Contemporary Photography, Chicago, among many other honors and awards.

Sally Mann (American, b. 1951)

Sally Mann's photographs are statements of time, place and character, exemplified most notably by her pictures of her prepubescent children, which were defiant in both facial expression and their use of nudity. Shot with an 8 x 10 large-format camera, Mann's portraiture is now included in the permanent collections of The Museum of Modern Art, The Metropolitan Museum of Art and the Corcoran Gallery of Art, among others. Mann has published *At Twelve: Portraits of Young Women* (1988)*; Immediate Family* (1992); *Still Time* (1994); *What Remains* (2003); and *Deep South* (2005). She was named Photographer of the Year by *Time* (2001).

Robert Mapplethorpe (American, 1946-1989)

Robert Mapplethorpe approached his photographic subjects as classical studies that were superbly crafted and infused with eroticism. After studying graphic arts at Pratt Institute, he acquired a Hasselblad medium-format camera in the mid-'70s and began photographing friends and acquaintances, including artists, composers and socialites. During the '80s Mapplethorpe created his flower still lifes, which were intricate and symbolically powerful. He was also known for homoerotic images and transgressive photographs, which stirred considerable controversies regarding public funding and in the institutions where they were shown.

Didier Massard (French, b. 1953)

Didier Massard is one of photography's most unique illusionists. His fabricated images, recorded in his studio and meticulously handcrafted, are both beautiful and classic. His genius, according to Roberta Smith, a *New York Times* art critic, is found in his lighting techniques, enhanced by his attention to detail. His work is a photographic response to what is called in painting "Magical Realism," a genre in which magical elements appear in otherwise realistic settings. Massard's work has the feel of Dürer and Oudry — those pristine and primordial feelings one gets from their fairy tale landscapes. Yet in Massard's work the sense of illusion is subtly challenged by scale and space. Massard was born and raised in Paris, where he received his baccalaureate degree in art and archaeology from the University of Paris in 1975.

Jill Mathis (American, b. 1964)

Jill Mathis is from San Antonio, Texas, where she studied photography at the University of Texas in San Antonio and Austin. After working in New York City for five years, four of which were spent as the full-time assistant to photographer Ralph Gibson, she moved to Italy. Mathis currently lives in the lake region of Northern Italy, where she has produced an extensive body of work based on etymology. Her work can be found in many public and private collections, including the Whitney Museum of American Art, the Norton Museum and the Brooklyn Museum.

Henri Matisse (French, 1869-1954)

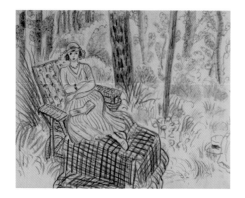

Retrospectively Matisse is considered a giant of twentieth century art. During his day his controversial work was championed by Gertrude Stein's circle in Paris. Regardless of the medium in which he expressed proficiency, Matisse was interested in the memorable concept; even portrait drawings redefine old paradigms. "A young painter who cannot liberate himself from the influence of past generations is digging his own grave," said Matisse. He began to paint in 1889 while recovering from appendicitis, studied at Académie Julian and first exhibited in 1896 at the Salon des Beaux-Arts.

Joel Meyerowitz (American, b. 1938)

Joel Meyerowitz is a street photographer who began photographing in color in 1962 and was an early advocate of the use of color. Along with Stephen Shore and William Eggleston, he became part of the first group of young artists to use color exclusively. Their work, seen and published in America and Europe, influenced the next generation's turn toward color photography. Meyerowitz graduated from Ohio State University in 1959 with a degree in painting and medical illustration. He was inspired by Robert Frank's book *The Americans* and the work of Eugène Atget. "In the pantheon of greats," he said, "there is Robert Frank and there is Atget." Meyerowitz goes on to say, "Those two visions of the world captivated me early on, opened me up." He is a Guggenheim Fellow and a recipient of both the National Endowment for the Arts and the National Endowment for the Humanities awards.

Duane Michals (American, b. 1932)

Duane Michals began making photographic sequences in the '60s, having been self-taught in photography. He studied art at the University of Denver and the Parsons School of Design, became assistant art director for *Dance Magazine* and later photographed commercially for other publications. The sense of action, evolution and development captured in sequences is what established him in a generation of social landscapists. His progressions are tender portrayals of interactivity, often enhanced by the inclusion of his own handwritten commentary.

Richard Misrach (American, b. 1949)

Richard Misrach graduated from the University of California, Berkeley in 1971. His series *Desert Canto* — a thirty-year epic documentation, made from his Volkswagen bus of underground nuclear testing, desert fires rimmed with phantasmagorical color and geomorphic compositions of clouds, stones or plants — showcased his transcendent imagery and affirmed his place in art history. His landmark *Beach* series, photographed with an 8 x 10 camera from a hotel balcony, depicts seemingly miscellaneous bathers. "Maybe some of them are not so safe after all," Misrach observes. His work is included in the collections of the Centre Pompidou and The Metropolitan Museum of Art.

Joan Mitchell (American, 1925-1992)

Joan Mitchell's settlement in France in 1959 ensured her artistic independence from the Abstract Expressionists in New York. There she explored the vibrant palette that became her signature subject — gestural 'windows' reminiscent of late Monet. Subdued masses that were color splashed or smeared marked her seminal '60s work. Mitchell studied at Smith College, The Art Institute of Chicago and Columbia University, then at Hans Hoffman's studio, where she gained traction as a leading artist of the New York School. The Whitney Museum mounted a posthumous 2002 Mitchell retrospective of works that she hoped would "convey the feeling of the dying sunflower."

László Moholy-Nagy (Hungarian, 1895-1946)

Seminal to the Bauhaus movement, László Moholy-Nagy developed a rigorous intellectual approach to his work, a dialectic of space and light, which he observed as similar substances, and put into practice through diverse disciplines. He discovered camera-less photography in 1922 and infused it with a cinematic sense of "superimposition" influenced by constructivism. Photograms by Man Ray and Moholy-Nagy, who integrated the words telegram and photograph, appeared together in 1923. He immigrated to America with his mother and painted while recuperating from war injuries. Decades later he founded the Chicago Institute of Design. His work can be found at the Ludwig Museum and The Metropolitan Museum of Art.

Andrew Moore (American, b. 1957)

Andrew Moore creates mythic, large-format photographs. He has gained unprecedented access to sites in Vietnam, resulting in *Rotunda, University of Hanoi, 2007*, as well as places in Russia and Cuba. His work has a heightened sense of stillness and presence, as he eschews the "coldness" of conceptualism. Moore is a documentary filmmaker, winning the Sundance 2002 Special Jury Prize (with John Walker). His work can be found in the public collections of the Cleveland Museum of Art, the Los Angeles County Museum of Art, the San Francisco Museum of Modern Art and the Philadelphia Museum of Art. Moore teaches, and has been an artist-in-residence, at Dartmouth College and Vassar College.

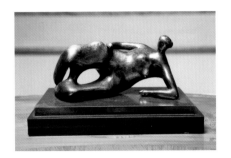

Henry Moore (British, 1898-1986)

Influenced by natural organic shapes, the female form and the African sculpture he saw as a student at Leeds School of Art, Henry Moore became the preeminent abstract sculptor of his time. His undulating bronze nudes, small-scaled or monumental, were frequently pierced, creating pathos. Moore sought the inner essence or "vitality" of his subject. Curator Stephen Nash said, "He was both modern yet humanistic and could be appreciated by the man on the street." Several public commissions ensued, including *Reclining Figure*, for UNESCO in Paris. Over seventy museums and public art galleries worldwide have Moore holdings. He received the British Order of Merit, but turned down a knighthood in 1951. He created the Henry Moore Foundation as his legacy.

Vik Muniz (Brazilian, b. 1961)

Vik Muniz refers to himself as an illusionist, rearranging perceptions to probe their underpinnings. For his *Pictures of Clouds* series, a skywriter drew clouds in the sky, which the artist then photographed in various stages of disintegration. Originally trained as a sculptor, he has meticulously reworked masterpiece paintings in chocolate, a subliminal absurdist commentary. Muniz states of his *Pictures of Dust* series: "Dust is pieces of hair and skin. I think people scratch their heads a lot in museums; that gets mixed with the residue from the artworks themselves. That's the ultimate bond between the museum visitor and the artwork." His work is in the public collections of the Modern Art Museum of Fort Worth and the Neue Galerie, Graz.

Shirin Neshat (Iranian, b. 1957)

Raised by parents who embraced Western traditions, Shirin Neshat completed her MFA at the University of California, Berkeley, while the Iranian revolution took place. She returned to Iran in 1990 and mined the dissonance she sensed, producing her first major body of work, *The Women of Allah*. Using video and photography, Neshat explores contemporary social codes through her art of discerning human characters from facial features, notably with Farsi writing superimposed, and captures mysterious moments to both comment on and transcend her subject matter. She won the International Award of the Venice Biennale (1999) for her *Turbulent* and *Rapture* projects and the Infinity Award from the International Center of Photography.

Arnold Newman (American, 1918-2006)

Although his body of work was diverse, Arnold Newman became one of the most significant portraitists of his time. He created photographs that contain visual information as to the subject's identity and stand alone as art. His landmark exhibition *Artists Look Like This* was acquired by the Philadelphia Museum of Art at the end of its run in 1946. Subsequently he moved to New York and received plum assignments from prominent magazines, culminating in 24 covers for *Life*. His prestige led to the opportunity to photograph the highest-ranking members of government, culture and business. Newman's work can be found in the permanent collections of The Museum of Modern Art and the National Portrait Gallery.

Helmut Newton (German, 1920-2004)

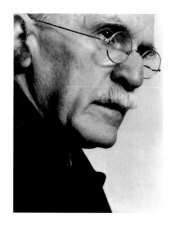

From the time he escaped Nazi Germany as a young man, there was danger, power and secrecy in the newly sexualized Helmut Newton's life. Converging elements — desire and guilt, seduction and shock, and sadomasochism tinged with eroticism — emerged in his photographic work. Newton's voyeuristic images of women — controlled but fully in control — seared into the public consciousness and cemented his place as a major photographer of the twentieth century. He secured assignments from top publications worldwide and published several books, some in collaboration with his wife, June.

Dorothy Norman (American, 1905-1997)

Dorothy Norman interacted with artists and engaged in the arts on many levels. She wrote a *New York Times* column and edited and wrote several books, was mentored by Alfred Stieglitz (who became her lover) and maintained a well-respected artists' salon. By day, Norman managed Stieglitz's renowned gallery, An American Place. Her distinctive voice and sense of composition are notable in the seminal portrait of him. Other subjects include those in her circle — among them, Indira Gandhi, Theodore Dreiser, John Cage and Lewis Mumford. Norman's work is in The Museum of Modern Art, the National Gallery of Art, the Getty Museum of Art and the Boston Museum of Fine Arts.

Ruth Orkin (American, 1921-1985)

Celebrated for her iconic and humanistic *American Girl in Italy* photo, Ruth Orkin produced a seminal body of work, *A World Through My Window* and *More Pictures from My Window*, from her Central Park home. She first exhibited at a California camera store, then undertook a cross-country bicycle trip to the New York World's Fair (1939). Orkin attended The Photo League, worked as a freelance photographer for periodicals, and with her husband, made the films *Little Fugitive*, nominated for Best Picture (1953), and *Lovers and Lollipops*. She was voted one of the Top Ten Women Photographers in the U.S.

Tom Otterness (American, b. 1952)

Tom Otterness is best known as a whimsical sculptor whose works adorn parks, plazas and other public spaces, particularly in New York. The nineteen public commissions Otterness has executed since 1984 are a tribute to his popularity, accessibility and humanity. *Life Underground*, a series installed in a New York subway station, attests to his statement that in "the constant clash between people . . . I see vignettes of meaning." Otterness's particular subjects — individuals engaged in their life stories — are represented by bronze characters with round heads and simplified features devoid of detail holding oversized elements such as coins and pencils.

David Parvin (American, b. 1943)

David Parvin has devoted his career to life casting, which he executes primarily in bronze, but also in wood, concrete, metals, glass and raku. His sculpture is modern in facial expression and surface refinement yet classical in proportion, particularly in its truncated torso configurations. Occasionally Parvin delves into bodily fragments or busts that allude to mythological deities. The artist is essentially autodidactic, lectures widely and is the subject of a tutorial entitled *Casting the Female Torso*. He exhibits in Colorado and California, creating his artwork largely for private commissions.

Susan Paulsen (American, b. 1957)

With a photography and painting degree from Ohio Wesleyan University, Susan Paulsen went on to create a vision of ordinary objects made preternaturally interesting and infused with charm. Typically shooting in American settings — Block Island or Bedford, New York — Paulsen attaches an intimacy to her portraiture and symbolic meaning to an enigmatic crow, a dog's profile or a litter of Labrador puppies. Exhibitions include a 2004 solo show at the Maison Européenne de la Photographie in Paris. She created the photographic imagery for *Tomatoes on the Back Porch*, a book that contains essays by Robert Benton and Jean-Luc Monterosso.

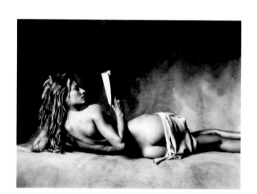

Irving Penn (American, b. 1917)

Preeminent throughout the twentieth century, Irving Penn studied with Alexey Brodovitch at the Philadelphia Museum School, then became assistant to Alexander Liberman at Condé Nast and opened his own studio in 1953. Six decades of refined fashion photography, a distillation of still lifes, nudes replete with narrative and classical portraiture of stellar subjects secured him as an icon. His memorable ethnographic photographic essays for *Vogue,* shot primarily in natural light, reveal his formal yet intimate style. Later works — exquisitely composed, uncontrived object and flower studies — convey especial immediacy and resonance. Venues of major museum exhibitions include The Metropolitan Museum of Art, the National Gallery of Art, the Morgan Library and The J. Paul Getty Museum.

Pablo Picasso (Spanish, 1881-1973)

Born in Spain but living and working primarily in France, Pablo Picasso was among the giants of twentieth-century art. During his long career, he was a protean and prolific creator of paintings, prints, sculptures and ceramics. He is probably best known for his pioneering work in Cubism and his monumental black-and-white depiction of the Spanish Civil War, *Guernica* (1937). The following year, when he drew *Trois Femmes*, Picasso was in various stages of involvement with three different women, Marie-Therese Walter, Olga Khokhlova and Dora Maar. His influence burgeoned when The Museum of Modern Art mounted a major retrospective in 1939.

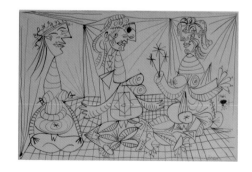

Robert Polidori (Canadian, b. 1951)

Robert Polidori's architectural photographs are immediately identifiable by their grandeur of scope and their romantic palette. The structure may be in ruins, as in the aftermath of Hurricane Katrina (*After the Flood,* 2006), exhibited at The Metropolitan Museum of Art, or Chernobyl (*Zones of Exclusion,* 2003), or near perfection (*Versailles,* 1991). But there is always an emotional luxuriance to even the most shocking images, making them potent examples of both civilization's destruction and its creativity. Considered to be working at the pinnacle of architectural photography, Polidori was twice awarded the Alfred Eisenstaedt Award.

Robert Rauschenberg (American, 1925-2008)

Robert Rauschenberg initially studied art, music and sculpture at Kansas City Art Institute and later at the Academie Julian, Paris. In 1948, at Black Mountain College, he was influenced by his teacher, Josef Albers. Rauschenberg determined to make a break from the Abstract Expressionists and to bridge "the gap between art and life." Using soluble transfer of photographic images, he created an oeuvre juxtaposing daily news events with collage and found objects, called Combines. The heart of his photography is the inverting of relationships of point-counterpoint, absence and presence, and wit and irony, along with elegant expressions of light and darkness in the portraiture. Permanent collections include The Museum of Modern Art, the Guggenheim Museum, The Metropolitan Museum of Art and many others worldwide.

Man Ray (American, 1890-1976)

Man Ray was born in Philadelphia and attended the National Academy of Design, New York, where he met Marcel Duchamp, with whom he founded the Société Anonyme. Man Ray began making Cubist works that evolved into abstract Dadaist paintings and collages that revealed his interest in layering. Produced in 1922, his *Rayographs* were prints made on photographic paper directly exposed to light and objects without the use of a camera. Man Ray's visual invention laid image planes on each other like the glass skins of modern buildings — transparent, yet substantive. He moved to Paris and joined the Surrealist circle, which included André Breton. His photographs have been exhibited at The Museum of Modern Art, The Metropolitan Museum of Art and the National Gallery of Art.

George Rickey (American, 1907-2002)

When he was young, George Rickey sailed the coast of Scotland, which later inspired his unique sculpture process using wind motion, enabled through his design of a universal joint. Rickey cited the classic movements of the ship's motion — pitch, roll and yaw — in his writings, *The Morphology of Movement* and *Constructivism: Origins and Evolution*. At the age of 57, he exhibited the first of his seminal kinetic line sculptures at Documenta. Rickey's departure from Calder's work, distributing his geometric forms in nonhierarchical configurations both random and ordered, earned him places in the permanent collections of the Hirshhorn Museum, the DeCordova Museum and the Walker Art Center. Rickey studied at Balliol College and the Ruskin School at Oxford.

George Romney (British, 1734-1802)

In 1919, *The Beckford Children*, a painting by George Romney, sold for a record price for a British painting at the Duke of Hamilton's sale. In America, Henry Clay Frick acquired Romney's works for The Frick Collection. And in 1935, Andrew Mellon purchased Romney's works from the Hermitage, which purchase helped form the core of the National Gallery of Art's collection. Romney began as a portraitist in 1757, having apprenticed with Christopher Steele, studying art in Rome and Parma, and winning a Royal Society of Arts prize. His muse, Lady Emma Hamilton, posed as heroines from the past; Romney painted her over sixty times. This historical obsession preoccupied his work.

Walter Rosenblum (American, 1919–2006)

A World War II photographer, Walter Rosenblum's iconic imagery of Normandy on D-Day was referenced by filmmaker Steven Spielberg. Humanity was his subject, be it American immigrants, Spanish Civil War refugees, Haitians, or *People of the South Bronx*, an exhibition funded by a Guggenheim Fellowship. Rosenblum likened his photography to "writing a love letter," but the subject would speak for itself. The artist was a student of Lewis Hine and Paul Strand. His work appears in the collections of the Getty Museum, The Metropolitan Museum of Art, The Museum of Modern Art, the Yale Art Gallery and the Detroit Institute of Arts.

Michal Rovner (Israeli, b. 1957)

Michal Rovner's interdisciplinary arts studies culminated at the Bezalei Academy of Art and Design in Jerusalem. She cofounded Israel's leading visual media school, Camera Obscura, in 1978, and moved to the U.S. in 1987. Rovner creates manipulated records of anonymous individuals' peregrinations in nonspecific locations that become emblematic of emotional states. Her artistry, including on video, film, canvas and paper, has been examined through exhibitions at the Art Institute of Chicago, the Whitney Museum of American Art and the Israeli Pavilion at the 2003 Venice Biennale. Her work is in the permanent collections of the Guggenheim Museum, the Museum of Fine Art in Houston and the Whitney Museum of American Art.

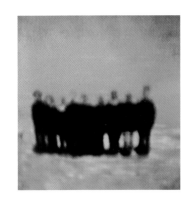

August Sander (German, 1876-1964)

Credited with sociological documentary epitomized by his portrait series *People of the Twentieth Century* — photographs of the German cultural landscape though the physiognomy of its people — August Sander was a giant among his peers. "In landscape, we can recognize the human spirit of an era, which we can capture with the help of a photographic apparatus. This is similar to architecture and industry and to all human works big and small," Sander said. Thomas Zeller wrote that "Sander aimed for a methodical contemplation, a detached understanding, and a thorough reading of landscapes as evidence of human activity."

Joel Shapiro (American, b. 1941)

Joel Shapiro is known for his elegant, spare, geometric sculptures involving beam or block forms in bronze. He has said that his work, which sometimes seems to express human emotion and dynamics, has been informed by the energy of dancers' movements. Shapiro has been the subject of one-man shows, public commissions and retrospectives for almost four decades. The Metropolitan Museum of Art exhibited five of his sculptures on its rooftop in 2001. Shapiro was elected to the American Academy of Arts and Letters and the Swedish Royal Academy and was awarded the Skowhegan Medal for Sculpture (1986). His sculpture and work in other mediums are in the permanent collections of the Dallas Museum of Art, the Fine Arts Museum of San Francisco and The Museum of Modern Art.

Fazal Sheikh (American, b. 1965)

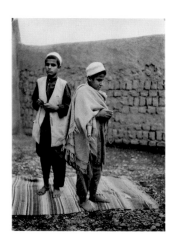

With Allah as his namesake, a Kenyan father and a Pakistani grandfather, Fazal Sheikh is able to access those whose personal displacement and need are telegraphed by their faces, as in his photographs of Somali families seeking refuge. Distributing his books — *A Camel for the Son, Ramadan Moon* and *A Victor Weeps* — through humanitarian institutions, Sheikh states, "We and they are one and the same." He graduated from Princeton University and received a MacArthur Fellowship in 2005. His work can be found in the Corcoran Gallery of Art, the Los Angeles County Museum of Art, the San Francisco Museum of Modern Art and The Metropolitan Museum of Art.

Edward Steichen (American, 1879-1973)

A giant of twentieth-century photography and curatorship, Edward Steichen worked as a lithography apprentice and painter while attending lectures at the Art Students League in New York. The interpretive style of his pictorialist photographs captured the imagination of Alfred Stieglitz, whose Gallery 291, the Intimate Gallery and the journal *Camera Work*, cofounded with Steichen, chronicled his soft imagery. Steichen was at the vanguard of the Photo-Secession movement, derived from Symbolist and Impressionist art, and color photography, with the Lumière Autochrome process. His oeuvre included portraiture of the celebrated — Greta Garbo, Marcel Duchamp, Pola Negri and J. P. Morgan among them. Wartime aerial photography morphed Steichen's style to Modernist tenets that were further honed in his fashion imagery with Condé Nast. After serving as director of the World War II Naval Photographic Institute, Steichen became director of The Museum of Modern Art Photography Department. There he organized the extraordinarily popular exhibition *The Family of Man*, an attempt to explain "man to man and each to himself" through photography. The Getty Museum, the National Gallery of Art and The Museum of Modern Art are among the institutions collecting Steichen's work.

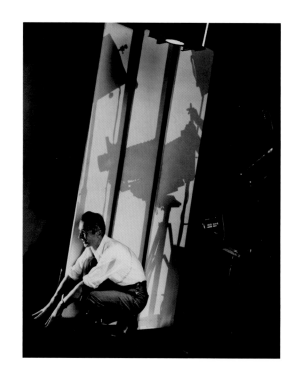

Otto Steinert (German, 1915-1978)

Otto Steinert is one of Germany's most important artistic luminaries. A trained physician and a photographic autodidact, he is considered by many the best-known and most important postwar photographer. He became a key figure in Subjektive Fotografie, a movement that would shape more than a decade of artists. Rather than exploring external realities, subjective photography investigated the complexities of the individual's inner state. It espoused many of the Bauhaus techniques, but worked in an edgier style that resulted in more expressionistic works, often evoking the dream world of the subconscious. Steinert used the camera as a tool to create absolute photographic art, not to produce an objective representation of reality. As such, he is considered a precursor and stimulator of many of today's photographic movements. For the last twenty years of his life, he taught at the design school Folkwang Academy, in Eisen, where he died.

Frank Stella (American, b. 1936)

Frank Stella is one of the few artists honored with two major retrospectives at The Museum of Modern Art (1970, 1987). His exploration of shape continues to evolve through many mediums: painting, printmaking, wall-mountings and, since the '90s, free-standing sculpture. Graduating from Phillips Academy and Princeton University in art history, his studio work was largely self-taught. Stella delivered a Charles Eliot Norton lecture at Harvard University that was subsequently published as *Working Space*, in which he described his work as "space to grow into and expand into," feeling that contemporary minimalist sculpture was too "close-valued" and "too introverted." Stella's work is part of such distinctive collections as those in the Neue Nationalgalerie, Berlin, The Margulies Collection and the Solomon R. Guggenheim Museum.

Alfred Stieglitz (American, 1864-1946)

The long and productive career of Alfred Stieglitz, whose influence defined American artistic photography in the first half of the twentieth century, can be seen as a series of distinct periods. In ten years of photographing the European countryside, Stieglitz garnered awards and attention. Back in America, Stieglitz embraced the Photo-Secessionists — the camera club he organized to give photography the same respect as fine art — who encouraged manipulation of the image, pre- and post-exposure, to affect its tonality. By 1910, Stieglitz exhibited his "straight photography," where he took a noncomparative approach apparent in the straightforward immediacy of his cityscapes. For two decades, from 1916 onward, Stieglitz created portraits of his wife, artist Georgia O'Keeffe, comprising strong visages and fragments. As an impresario, Stieglitz also played many roles: editor of *Camera Notes* and then *Camera Work*, curator of Pictorialist photography exhibitions, and gallery owner at 291, where O'Keeffe gained notoriety, the Modern Gallery, then The Intimate Gallery, and ultimately An American Place, the legendary exhibition space where Stieglitz introduced the work of Ansel Adams. The last years of his life, Stieglitz summered in Lake George, New York, completing his body of photographic work. Permanent collections include the Art Institute of Chicago, the Getty Museum and The Metropolitan Museum of Art.

Paul Strand (American, 1890-1976)

By breaking down prevailing photographic ideals of technique and aesthetics, Paul Strand became outward- or object-focused. Initially he synthesized the work presented at Gallery 291. Later he was championed by Stieglitz in solo exhibitions and featured in several issues of *Camera Work*. Soft-focus to clean-edged "straight" photography preceded Strand's hybrid of realism and abstraction, which he called organic realism. His revolutionary candid portraiture issued "a quality of being" — emotional content through form. He left America for France during the McCarthy era and continued making still photographs. In 1945, The Museum of Modern Art mounted a Strand retrospective, its first for a photographer. It was followed by similar shows at the Philadelphia Museum of Art and the National Gallery of Art.

Thomas Struth (German, b. 1954)

Elements gleaned from the analytical approach of his professors, Bernd and Hilla Becher, and from Gerhard Richter's revered sense of light, emerge throughout Thomas Struth's work. Early, unpopulated cityscapes, entitled *Unconscious Places,* foretold his concern with intimacy and anonymity. His seminal photographs shot inside clerestory-lit cathedrals and museum halls observe personal experience within a vast space and acknowledge the viewer in the process. Regarding Struth's in-depth color saturation and detail, Philippe de Montebello commented, "His *Museum* pictures are especially masterpieces." The Metropolitan Museum of Art mounted a 2003 Struth exhibition. Permanent collections that include Struth's work are in the Tate Gallery, the Broad Art Foundation, the Cleveland Museum of Art and the Hirshhorn Museum.

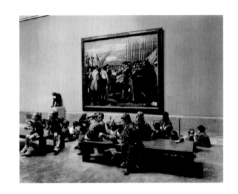

Hiroshi Sugimoto (Japanese, b. 1948)

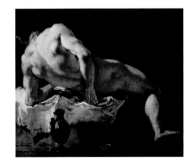

Hiroshi Sugimoto is regarded for extreme technical proficiency rooted in conceptualism. His photographs are "time exposed." In *Theatres,* the film is exposed over the movie's duration so that the audience and movie are lit only by the projector. *Portraits* depicts wax figures in old masters ambience, a replica of a replica that satisfies Sugimoto's affinity with Duchamp multiples.

Giambattista Tiepolo (Italian, 1696-1770)

Renowned for his frescoes, Giambattista Tiepolo rose from humble beginnings to become a master of eighteenth-century Italian painting in the grand tradition. His works exude physical power through compelling depictions in which his subjects seem to leap off the surface. Apprenticed under Gregorio Lazzarini, Tiepolo showed his works independently. The maturation of his oeuvre in the 1720s, with Old Testament scenes painted at the Archbishop's Palace at Udine, embraced the luminous palette and dramatic force of his subjects that became Tiepolo's hallmark. During the 1750s and '60s Tiepolo received royal commissions: the prince's palace in Wurzburg and Charles III's ceiling frescoes at the Madrid Palace. Public collections including his work are at the Art Institute of Chicago and the National Gallery, London.

Anthony van Dyck (Flemish, 1599-1641)

Anthony van Dyck's portraiture had a far-reaching impact on English painting — the epitome of blue-blooded gentry at ease — an influence derived not through tutelage, but through his independent and authoritative style. He began as a young assistant to Rubens and, being less forceful and more sensitive to his model, developed his style and traveled throughout Europe, particularly to Genoa. These trips permitted van Dyck to produce a profound body of work. A portrait of King Charles I posed in equestrian regalia earned him knighthood and immense prestige at court. His drawing of Gentileschi was made in black chalk with a gray wash in the 1630s, shortly before Gentileschi's death. His works are found in the Royal Collection, the Gardner Museum and the Frick Collection.

Jeff Wall (Canadian, b. 1946)

One of the most influential contemporary photographers, Jeff Wall's reach extends to teaching and occasionally writing essays that frame his aesthetic beliefs. A graduate of the University of British Columbia, Wall makes thoughtful and meticulous large-scale Cibachrome transparencies mounted on light boxes — some "performed" cinematically and others unstaged in pre- or post-production — that were the subject of one-man retrospectives at The Museum of Modern Art, New York and the Tate Modern, London. Wall cites Baudelaire's attentiveness to the detail of the everyday and Velázquez as influences. His work is in The Metropolitan Museum of Art and the Hirshhorn Museum.

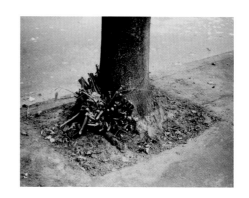

Hiroshi Watanabe (Japanese, b. unknown)

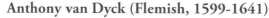

Hiroshi Watanabe casts the photograph as tabula rasa, revealing a calculated yet serendipitous moment: "At times . . . when I actually look through my viewfinder . . . my mind goes blank and I photograph whatever catches my eye." His photographs of Kabuki actors — cited by *The New Yorker* for their "combination of distracted self-consciousness and defiant self-possession" — and images of patients from an Ecuadorian psychiatric hospital, published in *I See Angels Every Day*, show subjects seemingly unaware of the camera. Watanabe graduated from Nihon University with a degree in photography and later studied with Jerry Uelsmann and John Sexton. Permanent collections including his work are at the Houston Museum of Fine Arts, the George Eastman House and the Santa Barbara Museum of Art.

Weegee (American, 1899-1968)

For his uncanny ability to predict the right place and moment for a crime shot or society photograph captured at night with an exploding flash, Arthur Fellig adopted the name Weegee from the Ouija board and stripped it of pretension. For his caricaturized self-portrait, Weegee photographed himself with a kaleidoscopic lens. Hollywood portraiture included Marilyn Monroe, Liberace and Marlene Dietrich, but his subjects also included the dispossessed and disenchanted of the Bowery and postwar Europe. Self-taught and usually using a simple 4 x 5 Speed Graphic, Weegee published four books, including *Naked City* (1945) and *Naked Society* (1953). A considerable body of his work is housed at The Museum of Modern Art and the International Center of Photography.

Edward Weston (American, 1886-1958)

Peripatetic in life and work, Edward Weston ultimately located near Carmel, California, where he photographed halved cabbages, seashells and peppers so close up that they became the essence of line and form. Similarly, his nudes and sand dunes lit starkly from above, shot in 1936, appear inscribed by nature. They secured his place at the artistic pinnacle. Beginning as an itinerant photographer, Weston studied at Illinois College of Photography. He opened his own studio in 1911. In 1922, when Weston moved toward straight photography, he met Stieglitz and his circle and then moved to Mexico City with Tina Modotti. A Guggenheim Fellowship, the first for a photographer, enabled Weston to travel and shoot throughout the Southwest. The Museum of Modern Art launched a major retrospective in 1946; the Smithsonian Institution honored him with a 1956 exhibition.

John H. Wilson (British, 1774-1855)

Part of a generation of artists influenced by John Constable, who eschewed prescriptive formulaic painting in favor of personal response, John Wilson painted inspired scenes of traditional English countryside. His was "a natural incorrupt vision of landscape . . . a guileless sincerity and dogged faithfulness in establishing an unmediated rapport with nature . . . the Wordsworthian recurrence of a familiar landscape over a temporal span of one's life," as scholar Stephen Eisenman points out. Wilson's light tends to be clear and refracted by water, his colors transparent and his subject lushly detailed, viewing the bounty of nature with complete lucidity.

About the authors

R. Ward Bissell enjoys Professor Emeritus status at the University of Michigan at Ann Arbor, where he earned his academic degrees and taught the history of art for thirty-five years following seven years on the faculty of the University of Wisconsin at Madison. A specialist in the Baroque art of Italy and Spain, with particular expertise in Caravaggesque painting, he has lectured widely in the United States and abroad and has worked closely with museum professionals and private collectors. Besides informing his courses, his foremost scholarly efforts have been dedicated to the publication of three major monographs: *Orazio Gentileschi and the Poetic Tradition in Caravaggesque Painting* (1981), *Artemisia Gentileschi and the Authority of Art: Critical Reading and Catalogue Raisonné* (1999) and (with Andria Derstine) The Detroit Institute of Arts' *Masters of Italian Baroque Painting* (2005). Professor Bissell sees himself as an historian of "old" art who is prepared to test the validity of art through a full range of investigations — among them authenticity, quality, socio-cultural context, patronage and reception — while working to avoid imposing a priori, sometimes faddish, positions upon a visual image. He has noted that he "is drawn to those enduring principles, highlighted by Roger Ward in his essay in this book, that have guided Joseph Cohen in the formation of his collection."

Malcolm Daniel is Curator in Charge of the Department of Photographs at The Metropolitan Museum of Art, New York. A specialist in nineteenth-century French and British photography, he received his B.A. from Trinity College, Hartford, and his M.A. and Ph.D. from Princeton University. He joined the staff of the Metropolitan in 1990 and was chosen to lead the Department of Photographs in 2004. His exhibitions and publications at the Metropolitan have included studies of the photographers Edouard Baldus, Eugène Cuvelier, Edgar Degas and Roger Fenton, as well as broader surveys of nineteenth-century photographs, French daguerreotypes and British calotypes.

Diane Dewey was affiliated with the Solomon R. Guggenheim Museum for five years. She worked with some of the finest European and American art collections. Ms. Dewey established an independent appraisal business in 2006, serving primarily American and European private collectors of twentieth-century painting, sculpture and photography. Ms. Dewey holds a B.A., Honors, Arts, from Villanova University, as well as a certificate with honors from the Art Institute of Philadelphia. She has published numerous articles and spoken publicly about art and she is a member of the Swiss American Women's Council and the Salmagundi Art Club in New York.

Sarah Greenough is senior curator of photographs at the National Gallery of Art where in 1990 she was the founding curator of the department of photographs. She has organized numerous award-winning exhibitions at the National Gallery, including *Alfred Stieglitz,* 1983; *Walker Evans: Subways and Streets,* 1991; *Robert Frank: Moving Out,* 1994; *Modern Art and America: Alfred Stieglitz and His New York Galleries,* 2001; *All the Mighty World: The Photographs of Roger Fenton, 1852–1860,* 2004; *André Kertész,* 2005; *Irving Penn: Platinum Prints,* 2005; and *Looking In*: *Robert Frank's "The Americans,"* 2009. In addition, several of her publications have won prestigious awards, including the International Center of Photography Distinguished Photography Book of the Year, 1989 for *On the Art of Fixing a Shadow: 150 Years of Photography*; the George Wittenborn Memorial Award, 2002 for *Alfred Stieglitz: The Key Set*; and the College Art Association, Alfred H. Barr Award for Distinguished Museum Catalogue for *The Art of the American Snapshot, 1888–1978: From the Collection of Robert E. Jackson,* 2007.

Marvin Heiferman is a curator, writer and editor with a particular interest in photographic and visual culture. He specializes in developing exhibitions and publications and strategizes programming for cultural institutions. Currently the Creative Consultant to The Smithsonian Photography Initiative in Washington, D.C., Mr. Heiferman is developing online projects (www.click.si.edu), exhibitions, symposia and educational programming that explore the impact of photographic imagery on our everyday lives. Museum exhibitions curated by Mr. Heiferman include *Bill Wood's Business* (International Center of Photography, 2008), *Now Is Then: Snapshots from the Maresca Collection* (The Newark Museum, 2008), *City Art: New York's Percent for Art Program* (Center for Architecture, 2005), *John Waters: Change of Life* (New Museum, 2004), *Paradise Now: Picturing the Genetic Revolution* (Exit Art, 2000), *Fame After Photography* (The Museum of Modern Art, 1999), *Talking Pictures* (International Center of Photography, 1994) and *Image World: Art and Media Culture* (Whitney Museum of American Art, 1989).

Ray Merritt conceived and edited this book. He also wrote the introductory essay, "Shared Space," as well as "A Tale of Two Paintings" and "Reluctant Icon." Mr. Merritt is active in the world of photography. He has served as a Trustee of the International Center of Photography and as a member of the Photography Committee of the Solomon R. Guggenheim Museum, the Whitney Museum of American Art and the Norton Museum of Art, where he served as Chair of the Photography Committee. He has written or edited over twenty books on an assortment of subjects, including *A Thousand Hounds* (Taschen) and *Full of Grace: A Journey Through the History of Childhood* (Damiani). Mr. Merritt's philanthropic activities include working with the U.S. Fund for UNICEF, where he served as Secretary, Director and member of the Executive Committee, and The Cygnet Foundation, where

he currently serves as Board Chair. He is also a Director of The Buhl Foundation, the Association of Community Employment (ACE) and the Design Trust for Public Space.

Robert Morgan is a critic, artist, curator and lecturer who lives and works primarily in New York City. A contributing editor to *Sculpture Magazine* and the author of several books, catalogs and monographs on contemporary artists, he is currently working on an exhibition of contemporary Chinese abstract painting for the Museum of Fine Arts in Beijing. Professor Morgan has had an extensive academic career. He is currently an Adjunct Professor of Fine Arts in the Graduate School of Fine Arts at Pratt Institute located in Brooklyn, New York.

Robert D. Mowry is Alan J. Dworsky Curator of Chinese Art and Head of the Department of Asian Art at the Harvard Art Museum. He is also Senior Lecturer on Chinese and Korean Art in Harvard's Department of the History of Art and Architecture. Professor Mowry previously served as the founding curator of the Mr. and Mrs. John D. Rockefeller III Collection at The Asia Society, New York, and, before that, as Assistant Curator of Oriental Art at Harvard's Fogg Art Museum. His work as a Peace Corps Volunteer in the Republic of Korea sparked his interest in Asian art and culture. He did his graduate work at the University of Kansas, studying with Laurence Sickman and Chu-tsing Li, after which he spent two years as a curatorial assistant and translator in the Department of Painting and Calligraphy at the National Palace Museum, Taipei. A specialist in Chinese art (particularly painting, ceramics and jades of the Song, Yuan and Ming periods), he also does research on Korean ceramics and paintings. Professor Mowry has published widely in the field of Chinese art.

Sabine Rewald is Jacques and Natasha Gelman Curator in the Department of Nineteenth-Century, Modern, and Contemporary Art at The Metropolitan Museum of Art. She has written on nineteenth- and twentieth-century artists ranging from Caspar David Friedrich and Paul Klee to Otto Dix and Balthus. Her most recent publications are *Glitter and Doom: German Portraits from the 1920s*, a book published for the exhibition of the same title at the Metropolitan Museum in 2006, and *Balthus: Time Suspended: Paintings and Drawings 1932-1960* (2007).

Dr. Roger Ward is Acting Director as well as Chief Curator and Curator of European Art at the Norton Museum of Art in West Palm Beach, where he supervises a wide-ranging and rapidly evolving program of acquisitions, exhibitions and publications. From 1982 to 2001, Dr. Ward was Curator of European Art at the Nelson-Atkins Museum of Art, Kansas City, where his publications included both exhibition catalogs and the award-winning *Handbook of the Collections* (1993). He was also the project director and general editor of the museum's catalogs of European paintings, the first volume (Italian school) appearing in 1996 and the second (early German and Netherlandish artists) in 2005. These endeavors have been supported by numerous grants and subsidies from many sources, including the Getty Grant Program, the Samuel H. Kress Foundation, the National Endowment for the Arts and the Shelby Cullom Davis Foundation. Between 1976 and 1982, he was a Marshall Scholar, a Chester Dale Fellow and a Kress Fellow, while pursuing M.A. and Ph.D. degrees at the Courtauld Institute of Art, University of London. He is perhaps best known for his numerous publications on the Florentine sculptor Baccio Bandinelli (1493-1560), the subject of Mr. Ward's monographic dissertation and also of an exhibition at the Fitzwilliam Museum, Cambridge, in 1988.

Patrick Hughes, 1994

328

Acknowledgments

Producing books involves forming an adopted family made of principal members and assorted others. It is a great pleasure finally to thank them for their generosity and support. Carol Merritt endured the dislocation that a project of this magnitude requires. She did, however, get to enjoy hundreds of engaging images. She also served as the first and last reader of each essay. Her contribution helped shape this book. Others were actively engaged for the project. Caleb Cain Marcus, a gifted photographer young enough to be comfortable with and proficient in the digital age, worked side by side with me laying out the imagery and laying in the words. His talent and energy helped make the book succeed. Marie Lillis, my assistant for more than thirty years, was called into service once again for the harrowing task of bringing order to the project of rendering its many texts into printable form. Without her this effort might have never ended. Added to that mix was a dynamic team of editors who carefully critiqued the book — Cathy McCandless, Paula Glatzer, Joan Cassidy, Susan Manchester and Myra Stennett. Each brought her own very special talent and a large dose of enthusiasm to the project. Others made important contributions as well. Michelle Ramos provided the background information that helped in setting the art template for the book and Linda Nizza watched over us all. Deep respect and appreciation must also go to the contributing writers — Ward Bissell, Malcolm Daniel, Diane Dewey, Sarah Greenough, Marvin Heiferman, Robert Morgan, Robert Mowry, Sabine Rewald and Roger Ward. They graciously provided the fascinating essays that make this book special. They all care deeply about the arts and their efforts attest to that. In addition, I appreciate the support of The Cygnet Foundation in making all of this possible. Through its involvement in projects like this, the Foundation hopes to further its purpose of helping those in need. A big thanks should also go to the artists and dealers who provided the images necessary to complete this book. And, finally, I need to express sincere gratitude to Joe, for letting us share with him the extraordinary works of art that make up the Cohen Collection. Knowing him as I do, this is only the first edition.

Ray Merritt

This book is dedicated to Barbara W. Cohen. Joe's wife Babs was an indispensable partner in the formative years of the Cohen Collection.

Published by:
CYGNET FOUNDATION
870 UN Plaza
New York, NY 10017
rmerritt@willkie.com
http://www.cygnetfoundation.org

Co-Published by:
DAMIANI editore
via Zanardi 376
40131 Bologna, Italy
info@damianieditore.it
http://www.damianieditore.it

Designed by:
LUMINOSITY LAB
343 East 92nd Street
New York, NY 10128
ccm@luminositylab.com
http://www.luminositylab.com

ISBN: 978-88-6208-108-5

Distributed by
D.A.P./Distributed Art Publishers, Inc.
155 Sixth Avenue, 2nd Floor
New York, NY 10013
http://www.artbook.com

End papers: Mark Francis,
Labyrinth, 1988 (detail)

This book presents selections from the Joseph M. Cohen Family Collection. For a complete and current view of the Collection, please visit www.jmcohen.com.

Arshile Gorky, c. 1930

Index of artists

Appelt, Dieter 214

Atget, Eugène 160-61

Avedon, Richard 179, 255

Baldaccini, César 44, 144, 146

Balthus 37, 106-11

Barye, Antoine-Louis 33, 45

Becher, Bernd and Hilla 194

Benton, Fletcher 62

Brauner, Victor 96

Buhl, Henry M. 221

Burt, James Jackson 63, 137

Cain Marcus, Caleb 196-97

Callahan, Harry 283

Cartier-Bresson, Henri 176-77

Chagall, Marc 95

Christenberry, William 21-23

Cienfuegos, Gonzalo 115

Clergue, Lucien 242

Close, Chuck 212-13

Cowen, Jeff 244

Cragg, Tony 61, 134, 138-39, 150, 155

Davis, Lynn 277

de La Tour, Maurice-Quentin 91

De Movellan, Pedro 48

Deacon, Richard 63

Degas, Edgar 89

Demuth, Charles 104

diCorcia, Philip-Lorca 257

Dijkstra, Rineke 178-79, 248

Di Suvero, Mark 63

Dolron, Desiree 250-53

Drtikol, Frantisek 210, 237

Dubuffet, Jean 101

Edgerton, Harold 56

Evans, Walker 164-65

Fischl, Eric 71, 112-13

Flanagan, Barry 32, 42-43, 58, 142

Francis, Mark end papers

Frank, Robert 272

Freud, Lucien 46

Funke, Jaromir 218, 236

Fuss, Adam 222

Gentileschi, Artemisia 28-29

Gentileschi, Orazio 25-31, 74-79, 80-85

Gibson, Ralph 11-12, 49-50, 180, 259

Gilpin, Laura 193

Ginsberg, Allen 230

Goldberg, Vicki 168

Gonnord, Pierre 246

Gorky, Arshile 97, 107, 331

Greenberg, Howard 263

Groover, Jan 184

Hicks, Nicola 35, 69, 135, 141

Hockney, David 86, 116

Höfer, Candida 203

Hughes, Patrick 53, 327

Iglesias, Cristina 66

Ilgen, Fré 53

Izu, Kenro 226

Keetman, Peter 215

Kelly, Ellsworth 86-87

Kertész, André 9, 162-63, 207, 243

Lange, Dorothea 166-69

Leibovitz, Annie 249

Lethbridge, Julian 105

Lichtenstein, Roy 117

Lutter, Vera 54, 57, 64, 270

MacGill, Peter 21

Mann, Sally 223, 225

Mapplethorpe, Robert 43, 48

Massard, Didier 186-87

Mathis, Jill 173

Matisse, Henri 92, 94

Meyerowitz, Joel 245

Michals, Duane 231

Misrach, Richard 182-83, 190-92

Mitchell, Joan 35, 103

Moholy-Nagy, László 158-59

Moore, Andrew 198

Moore, Henry 38-39

Muniz, Vik 56, 169

Neshat, Shirin 258

Newman, Arnold 216, 262-63, 274

Newton, Helmut 181

Norman, Dorothy 264

Orkin, Ruth 175

Otterness, Tom 48, 143

Parvin, David 46

Paulsen, Susan 172

Penn, Irving 221, 224, 232-33, 235, 238-41, 280

Picasso, Pablo 33, 98-99

Polidori, Robert 70, 199-200

Rauschenberg, Robert 174-75, 254

Ray, Man 260-61

Rickey, George 49, 153

Romney, George 114

Rosenblum, Walter 171, 227

Rovner, Michal 51

Sander, August 266-67

Shapiro, Joel 148

Sheikh, Fazal 220, 228-29, 266

Solomonic column 33

Steichen, Edward 55, 170, 209, 234, 265

Steinert, Otto 219

Stella, Frank 102, 138, 145, 149, 151

Stieglitz, Alfred 188, 205

Strand, Paul 189

Struth, Thomas 65, 201, 269, 278, 328

Sugimoto, Hiroshi 53, 202, 275

Tang dynasty horse 120-33

Tiepolo, Giambattista 32, 88

van Dyck, Anthony 76

Wall, Jeff 273

Watanabe, Hiroshi 256

Weegee 217

Weston, Edward 206

Wilson, John H. 36

Woodner, Andrea 11